The FRANCO-AMERICANS OF LEWISTON-AUBURN

· MARY RICE-DeFOSSE & JAMES MYALL ·

Published by The History Press
Charleston, SC 29403
www.historypress.net

Copyright © 2015 by Mary Rice-DeFosse and James Myall
All rights reserved

First published 2015

Manufactured in the United States

ISBN 978.1.62619.460.1

Library of Congress Control Number: 2014953449

Notice: The information in this book is true and complete to the best of our knowledge. It is offered without guarantee on the part of the authors or The History Press. The authors and The History Press disclaim all liability in connection with the use of this book.

All rights reserved. No part of this book may be reproduced or transmitted in any form whatsoever without prior written permission from the publisher except in the case of brief quotations embodied in critical articles and reviews.

To Maggie, Aurelia and Vivienne, for their patience.
—JM

To my Twin Cities natives.
—MRD

Contents

Acknowledgements 7

1. New Arrivals from the North (1860–1890) 9
2. A Franco-American Belle Époque (1890–1914) 37
3. Hard Times (1914–1941) 73
4. New Horizons: Acculturation, Negotiation,
 Affirmation (1941–1970) 103
5. Renaissance and Reinvention (1970–2014) 127

Notes 155
Index 169
About the Authors 175

Acknowledgements

The authors would like to thank all who participated in the work of preserving community history—including those at the Franco-American Collection at the University of Southern Maine's Lewiston-Auburn College, Bates College and the Harward Center for Community Partnerships—and most especially, all those who so generously shared their stories.

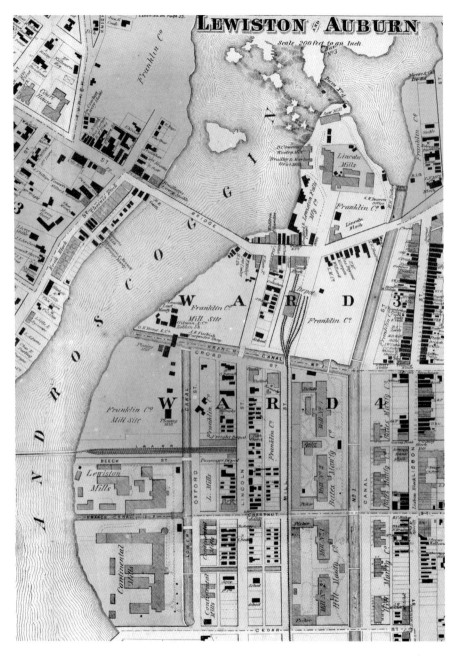

Detail from *Atlas and History of Androscoggin County, Maine*, 1873, showing the beginnings of Lewiston's Little Canada. *Courtesy David Rumsey Map Collection, www.davidrumsey.com.*

1
New Arrivals from the North (1860–1890)

Introduction

Franco-Americans are a unique immigrant group because their roots lie to the north as well as across the Atlantic. While Franco-Americans, like many other immigrants to the United States, are descended from Europeans, their heritage has also been shaped by centuries within North America—both in what is now Canada and in parts of the United States. They are at once European and North American, and the comparatively recent imposition of international boundaries between Canada and the United States is less important than their continental identity. The Franco-Americans of Lewiston and Auburn, the Twin Cities on the Androscoggin River in western-central Maine, were able to maintain that distinctive heritage over several generations, thanks to their proximity to Canada, their dense concentration in the region and their sheer tenacity. Franco-Americans remain the largest ethnic group in Maine (at least 20 percent of the total population).[1] People of Franco-American ancestry compose about 60 percent of the population in Lewiston and over 30 percent of that of Auburn. The history of the Franco-Americans of Lewiston-Auburn represents in many ways the essence of the Franco-American experience. It is the fascinating story of a resilient people with a rich cultural identity.

The term "Franco-American" delineates the history and culture of an ethnic group whose immediate origins lie, for the most part, to the north.

Some scholars prefer the more inclusive term "North American French" to emphasize the ethnic ties between French-speaking populations across North America, among them the Cajuns of Louisiana and those descended from immigrants who came directly to the territory of what is now the United States. These would include, for example, the Revolutionary Patriot Paul Revere, whose Huguenot father, Apollos Rivoire, came to Boston as an adolescent in 1716. One example from the Twin Cities is Lewiston native Dr. Alonzo Garcelon (1813–1906). His paternal roots lay in France, and later reports testify that the first French Canadian immigrants preferred to go to Dr. Garcelon for medical treatment, identifying him as "the French Doctor."[2] However, as early as the eighteenth century, the family had assimilated into Yankee society. His great-grandfather James and his wife, Deliverance, were among the first English-speaking settlers in Lewiston Falls, then a part of the Pejepscot Purchase, tracts of land on both sides of the Androscoggin extending from above the falls to the sea deeded to the region's early English settlers. By the time Alonzo was born, the Garcelons were a prominent family in Lewiston-Auburn. Alonzo Garcelon was a civic leader at the local and state levels and served as surgeon general of Maine during the Civil War, mayor of Lewiston and governor of Maine.[3] Despite his distant roots in France, Alonzo Garcelon's education at Monmouth, Waterville and Newcastle Academies and Bowdoin College; his political and social prominence; and his legacy in the Twin Cities, all mark him as a member of the Yankee elite.

The Franco-Americans in this study have ancestors in France but came to Lewiston-Auburn via what is now Canada. Their historic experience differed greatly from that of families who migrated directly from Europe like the Garcelons. They include Acadians displaced from Nova Scotia by the British between 1755 and 1763 and, if not deported, forced farther into the hinterland. They also include the French-speakers in Quebec who came to be dominated by English-speakers when Great Britain acquired France's North American lands through the 1763 Treaty of Paris. Shifts in territorial possession created a border space that remained fluid even after the American War for Independence since the boundary between Maine and New Brunswick was not officially established until the 1842 Webster-Ashburton Treaty. The Maine-Canada border remained especially permeable well into the twentieth century.

Not all French-speakers immigrated to the Twin Cities directly from the north. The French who settled North America were an especially mobile population, and some French-speaking immigrants to Lewiston-Auburn had

spent time in other cities in New England or other parts of the United States before settling in the region. The cultural traditions that this population brought with it were profoundly shaped by life in Quebec and Acadia, the French colony in the Maritimes that included parts of Nova Scotia, New Brunswick and Maine. Its folkways continue to inform Franco-American culture and identity.

At the same time, the Franco-American community is not culturally or ethnically homogeneous. It possesses the permeability characteristic of many border peoples, allowing it to absorb and appropriate elements from outside. Franco-Americans are a hybrid people whose identity changes as they adapt to new contexts. One theme of Franco-American history, culture and literature is its debt to Native Americans in North America. Likewise, religious orders from continental Europe played an important role in shaping the local Franco-American community. Even today, in Lewiston-Auburn and elsewhere, refugees from French-speaking countries in sub-Saharan Africa have found a home where the language they speak is understood.

LEWISTON-AUBURN

Lewiston and Auburn are situated on either side of the Androscoggin River at the Great Falls. This was an important site for Native Americans and, from 1770, for English-speaking settlers, who used water power for sawmills, gristmills and small textile factories. Water power provided by the falls was key to the development of both communities, although Lewiston was destined to become the more populous and prosperous. Investors from Massachusetts, forming what became the Franklin Company, realized the site's potential and constructed canals that, with the arrival of the railroad in 1849, transformed Lewiston into a major textile producer whose nickname became the "Spindle City."[4]

The first industrial textile factories, the Bates Mill and the Hill Mill, were established in 1850. Their owners were prescient enough to purchase large stocks of cotton at the beginning of the Civil War. As the war dragged on and the price of cotton soared, the Lewiston capitalists' speculation paid off, and Lewiston's mills boomed. The Androscoggin Mill was built in 1861, and the Bates and Hill Mills expanded.[5] By 1889, the properties of the Franklin Company included the Cowan Woolen Mill, the Lincoln Mill, the Dewitt House, several shops and other buildings and several acres of

The Franco-Americans of Lewiston-Auburn

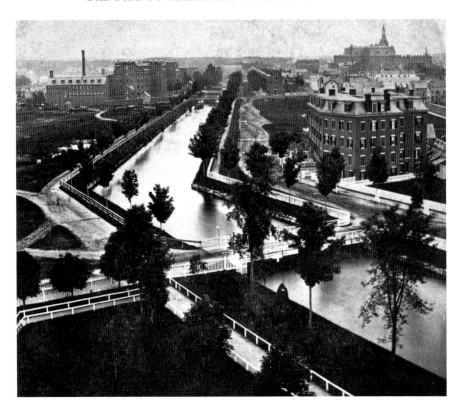

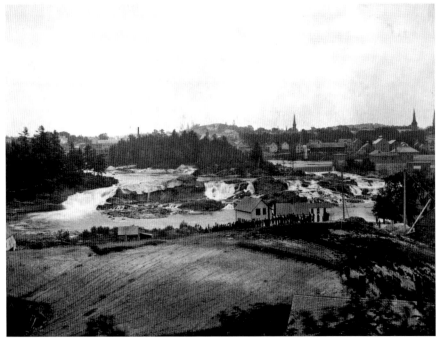

New Arrivals from the North (1860–1890)

land in the heart of the city. Other factories included Continental Mills, Lewiston Mills, Lewiston Bleachery and Dye Works, Lewiston Machine Company, Lewiston Gas-Light Company, woolen mills (Cumberland Mills), sawmills (R.C. Pingree & Company and Barlkers Mills) and a lumber mill (Lewiston Steam Mill Company), as well as "a file-factory; the Morton, Ham and Tarbox grain-mills, loom-harness, belt and roll, seed, last, paper-box, boy's coat and confectionery factories, two carriage and sleigh factories, several carpentry and machine shops, etc."[6] On the other side of the river, Auburn, too, had continued to expand. "Among the chief manufacturing and commercial enterprises now conducted are shoes, for which she has a national reputation, cotton and woolen goods, grain and produce, carriages, iron goods, brick and furniture."[7]

Immigrant Labor

There were many immigrant groups drawn to the economic engine in Lewiston-Auburn. The Irish, whose labor built the canal that diverted the power of the falls to the mills and the railways, were the first major immigrant population. Greeks, Poles, Italians and Jews all eventually made their way to the Twin Cities. The Lewiston School Department census of 1913 (the first available) lists families by race and ethnicity and includes even greater diversity: American, Irish, French, German, Italian, Greek, Jewish, Polish, Dutch, Belgian, Syrian, Albanian, "Canadian" (indicating Anglo- and Irish-Canadians) and "colored." There is only one reference to the category "French Canadian." Most French-speakers are simply identified by "Fr" for French.[8]

The largest ethnic group by far consisted of French-speaking Canadians from the provinces of Quebec, New Brunswick and the other Maritimes, as well as French-speakers from northern Maine, some of whom came from territory disputed between the two nations until 1842. The earliest

Opposite, top: The Lewiston Canal and mills as seen from the Androscoggin Mill, 1877. Detail from a stereoscope card. *Courtesy University of Southern Maine, Franco-American Collection.*

Opposite, bottom: Androscoggin River and Great Falls photographed from the Androscoggin Courthouse, Auburn, May 30, 1889. *Courtesy University of Southern Maine, Franco-American Collection.*

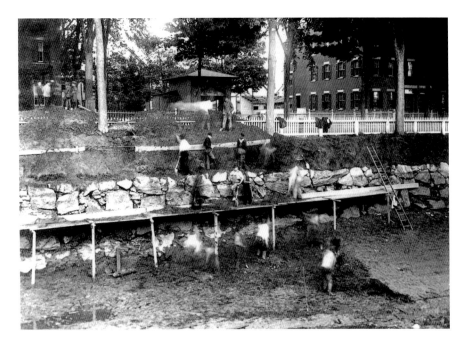

Canal workers in Lewiston, 1880. These workers were probably performing maintenance on the canals, which were constructed in 1845. *Courtesy University of Southern Maine, Franco-American Collection.*

French Canadian immigrants to Lewiston-Auburn may have included individual itinerant workers who went largely unnoticed. One such man was identified on the 1860 census as "Joseph Brooks," born in Ste-Croix, Quebec, in 1818. Arriving in Lewiston in 1845, he had returned to Canada by 1855, when his eldest son was born, but was in Lewiston in 1860 and fought for the Union in the Civil War, becoming a U.S. citizen in 1872. The Anglicized name perhaps indicates that, as one of only a handful of French Canadian immigrants, he assimilated into Yankee culture relatively quickly. Local legend, on the other hand, holds that the first French-speaking immigrants to Lewiston were Georges Carignan and his wife, Emily, née Perrault, who probably came in about 1860. According to James G. Elder's *History of Lewiston*,[9] Carignan was born in Wotton, Quebec, and lived in Peabody, Vermont, where the couple's daughter, Clarisse, was born. In 1870, Clarisse married Joseph E. Leblanc, from Nicolet, Quebec, who had worked as a dyer in Biddeford, Maine; Lewiston; Manchester, New Hampshire; and St. John's, New Brunswick, before returning to Lewiston to settle. He founded the Lewiston Steam

New Arrivals from the North (1860–1890)

Dye House in 1909, a family business that became Leblanc's Cleaners, a Lewiston fixture.[10] The family's story illustrates the movement from place to place typical of the early years of the French Canadians' exodus. In the next few years, four more families of French Canadian origin arrived in Lewiston.

Roots Across or Along the Border

While the history of French-speaking Canada lies beyond the scope of this study, it is important to recognize certain cultural patterns shared by a majority of French Canadians who came to Lewiston-Auburn in the nineteenth century, for the cultural heritage of these immigrants shaped their values and their lives in their new surroundings.

Most of the first migrants to Lewiston-Auburn came from parts of Quebec south and east of the St. Lawrence River, with a very large group originating in the region of the Beauce. They were often rural farmers whose lives had been profoundly affected by the rise of capitalism on both sides of the border. As farming became more mechanized and as competition developed to the west, farmers in these regions were forced to diversify their crops. Farmers who had previously produced wheat began to import it. Farming in these regions became a subsistence activity, especially after a series of bad harvests in the 1830s. Families who depended on farming to live often supplemented their incomes in seasonal occupations such as the lumber industry. Men would leave their families in the winter to work in lumber camps, including those in northern Maine, in a seasonal pattern of migration. Others found work as day laborers in rural areas or on construction sites or in new industrial factories in cities either in Canada or the United States. While the romantic idea of the colonial-era French Canadian *voyageurs* (riverine explorers) and *coureurs de bois* (fur trappers and woodsmen) lived on in this period, French Canadians in the nineteenth century possessed a characteristic geographic mobility based more on economic survival than freedom-seeking or the lure of the wild. This mobility primed them to seek out wage-paying employment beyond their family farms. With their wages, they could mechanize, buy land or buy consumer goods. The economic crises in French-speaking Canada in the early nineteenth century also drove rural farmers to mortgage their land and take on debts. New sources of wages were a means to pay such debt.

New Arrivals from the North

Historian Yves Frenette makes the case that French Canadians, already a geographically mobile population, had almost always traveled to other parts of Canada or to industrial cities in the United States before any sojourn in Lewiston.[11] In the early years of the French Canadian presence in the Twin Cities, from 1860 to the late 1870s, these were migrants rather than true immigrants. In periods of economic downturn, these migrants would simply return home or move on. Frenette demonstrates that the first French Canadians came to Lewiston-Auburn as family units, a pattern that distinguishes the Twin Cities immigrants both from Franco-Americans in southern New England and from other immigrants to Lewiston-Auburn.

Although there had long existed routes for laborers to travel by foot or wagon in the St. John and Kennebec River Valleys, it was the establishment of a rail line connecting Lewiston to the Canadian Grand Trunk Railway in 1874, bridging the five miles from Lincoln Street to Danville Junction in Auburn (which had been connected to the Grand Trunk since 1848), that brought an even greater influx of French Canadians to the region. In times of economic boom, scores of new arrivals disembarked from the train and were often met by relatives and neighbors from their home parishes in Canada who were already established in the area. The Lewiston Grand Trunk station became the Ellis Island of the Twin Cities.

It was only over time that French Canadians settled permanently, at first in a part of Lewiston known as the Island because it was sandwiched between the river and the canals. It would eventually come to be known as Petit Canada because of the preponderance of Franco-Americans in the district. The area was reportedly a pasture until as late as 1883.[12] Although the area had been the site of Lewiston's first homesteads—including that of Paul Hildreth, held to be the first white settler of the town—the economic heart of the city had long since moved inland to the major thoroughfares of Lisbon Street and Main Street and the business district laid out between the two routes by members of the Franklin Company, the city's major landowner. This uptown neighborhood was intended to be an example of enlightened city planning and included straight roads laid out in a grid, a grand city hall that overlooked City Park (complete with a wrought-iron Victorian gazebo for hosting culturally enriching activities) and the DeWitt Hotel, constructed to host visiting company officials and Massachusetts investors.

Little Canada, by contrast, was composed of hastily built tenements and "sidewalks as narrow as any seaport sidewalks,"[13] with numerous alleys

New Arrivals from the North (1860–1890)

Mill blocks on Canal Street in Lewiston, circa 1880. *Courtesy University of Southern Maine, Franco-American Collection.*

and dirt yards in between. The various mills had previously constructed housing for their workers, the mill blocks—rows of three-story brick Italianate structures—facing the factory buildings themselves on the other side of the canals. These accommodations were intended for young men and women, however, and the influx of whole French Canadian families created a demand for new types of housing, built at great speed with little oversight. This neighborhood was also built on Franklin Company land, but the company sold much of the land to the property owners. There were few attempts at imposing order on the rapidly expanding residential area. Its location made it ideal for French Canadian immigrants—just a short walk from the textile mills in which the vast majority of them worked and only a few steps away from the Grand Trunk depot.

Housing in the Twin Cities was scarce and had been from the time the Irish had come. The only available accommodations were often in one-story shanties where overcrowding was common. This was the case in the so-called patches of town where the Irish lived, like the Gas Patch at the very end

of Lincoln Street near the gasworks. Physicians of the period describe the Island as insalubrious, filled with rotting vegetable and animal matter and inadequate running water or toilet facilities. Some families lived in apartments below ground, which further damaged their health and well-being.[14] The census records show that in this period, there was extreme poverty among French Canadians, with only three households having property valued as high as $300.[15] Célestine Lavigne, who came to the United States in the 1890s, around the age of seven, recalled living conditions in her three-story apartment block. The first floor was retail space, and the second housed four families, each of whom rented two rooms as living quarters. The four families all shared a common sleeping space on the top floor, which was accessible only via a hallway; individuals "slept wherever they could." The apartments contained no stoves, and during the winter, residents "almost froze."[16] Half a century later, in the 1930s, many of those same buildings remained unheated and uninsulated.[17]

Family Life

Frenette's studies of the 1870 census records in Lewiston reveal that 80 percent of French Canadians worked in the textile industry, and in nine of ten households, there was at least one member so employed. However, married women over the age of thirty tended to work in the home. Traditional French Canadian society was patriarchal in structure, and the man was seen as the head of the family and therefore the chief wage earner. Older women who worked in the mills were often themselves heads of households. There were, however, fewer older men who were millworkers, perhaps because they preferred to work outdoors or they were not considered as productive as other workers.[18] Women and children were, on the other hand, sources of cheaper labor. It was common for children as young as six to work, and 99 percent of the children who worked were millworkers. By 1880, there were more children enrolled in school and more girls than boys. Nonetheless, French Canadian families tended to send their children to work more frequently and at younger ages than the Irish. Child labor was not made illegal until the twentieth century, but concerns about school attendance and child welfare were raised in the nineteenth.

On the family farms, each member of the family contributed to the family's collective welfare. These traditional values carried over to urban life,

where children were expected to give the bulk of their wages to their parents to support the family. The size of Lewiston's early French Canadian families is a contentious issue. Prejudice against Franco-Americans has often focused on large family sizes. While rural French Canadian families were large and there were certainly examples of families with more than ten children, the average family size in Lewiston in 1880 was about six, according to U.S. census records.[19] The 1893 parish census corroborates this finding—of those families with children under the age of first communion, the average number was about three.[20] These figures do not include children no longer at home or children boarded in other households, but older children stayed in the home while they were single and remained single for a longer period. Children, especially girls, were expected to care for their aging parents. French Canadians were generally observant Catholics, which probably contributed to a high fertility rate. In 1910, a Franco-American woman could expect to birth an average of nine children over her lifetime. However, actual family sizes were reduced by high infant mortality rates. Moreover, there was a great degree of variation among families. Some married couples had no children while others are recorded as having nineteen or even more.[21]

Most families were nuclear families, although married adult children might reside with one of the couple's parents for a brief time just after marriage. In 1880, 53 percent of the French Canadian population consisted of unmarried women,[22] the majority of whom worked outside the home. Some were boarders who lived with relatives, with friends from the same locality in Canada or in boardinghouses maintained by older women of impeccable reputation. It is possible that many sent their wages home. Still, young women who worked had far more autonomy in the United States than in Canada. In the novel *Canuck*, first published in Lewiston in 1936, Camille Lessard-Bissonnette (1883–1970) illustrates the kind of independence her heroine, Vic, has come to enjoy. As a result of her wage-earning capacity, she is able to denounce the abusive power of the family patriarch, send her brother to school and find her own lodging in the home of a widow. The novel's author began her career as a writer for the local French newspaper, *Le Messager*, under the pseudonym Liane while working as a *passeuse en lames* (in the filature) at the Continental Mill in Little Canada. She originally taught school in her native Quebec but immigrated to Lewiston from Ste-Julie-de-Mégantic with her family in 1904. As a newspaper journalist, she contributed columns to the women's pages as early as 1906. She was a proponent of women's suffrage on both sides of the U.S.-Canadian border, and throughout her career as a journalist, librarian, store manager and railroad agent, she

traveled back and forth across the border between Canada and the United States, much like the early migrants.[23]

Like the fictional landlady in Lessard's novel, many unmarried heads of household took in boarders.[24] In 1880, women headed 11 percent of French Canadian households. Since divorce was virtually unheard of in this population, some may have been women whose husbands were working elsewhere in traditional seasonal labor, such as the lumber camps, while others found themselves otherwise alone.

Battles with the Irish

As the French-speaking population grew, so did ethnic rivalries, especially between the Irish and the French. Although most Irish immigrants had come to Lewiston-Auburn as manual laborers, by the time of the influx of French Canadian labor a generation or more later, some had risen to hold positions as supervisors in the mills, facilitated by their fluency in English. As French-speaking neighborhoods expanded, there were physical clashes. Amédée Fournier, who immigrated in about 1894, recalled three public schools on Lincoln Street that the Irish attended, even though they were in the heart of Little Canada, near the fire station. When the Irish children would get out of school to return to their own neighborhood on the other side of Cedar Street, the Franco-American children would attack with their fists. The same would happen to Franco-American children when they crossed into Irish territory.[25] Bleachery Hill, the boundary between the Gas Patch and Little Canada, and the terrain under the bridges that spanned the Androscoggin were also sites of ethnic violence between the Irish and the French.

St. Peter's Parish

One characteristic French Canadian and Irish immigrants shared was their Roman Catholic faith. However, while they initially worshipped together, a need for a separate parish for the new arrivals soon emerged. In French Canada, the parish and its priest had been at the heart of each community. It is not surprising, then, that the earliest history of this ethnic group in Lewiston-Auburn involves worship and eventually the establishment of what

was termed a French parish. The first Roman Catholic parish in Lewiston, St. Joseph's, was founded by the Irish. Before a church was constructed, the Roman Catholic Mass was celebrated in a private home, the Bates Mill and Auburn Hall, and then the service was given in the former First Baptist Church that was moved to Lincoln Street and renamed St. John's. It was burned by anti-Catholic Know-Nothings in 1855 but then rebuilt. The Roman Catholic diocese acquired the land to build St. Joseph's Church, consecrated in 1867. French Canadians attended Masses said in Latin at this church. The homily, however, was in English. By 1869, the number of parishioners had grown so large that there was no room for all the worshippers, so the French-speaking parishioners attended Mass in the basement of the church, where the homily could be delivered in French by a Flemish priest who spoke their language, Reverend Louis Mutsaers. The first Roman Catholic bishop of Portland, David Weller Bacon, saw the increasing need for French-speaking priests and requested them from Canada. The local Franco-American community purchased the former St. John's Church on Lincoln Street. The congregation gathered on the second floor while the first floor housed business establishments. The first priest to come from Canada, Reverend Edouard Letourneau, celebrated the first Mass on July 2, 1870, performing the first marriage the same day. However, Father Letourneau was replaced in October 1871 by Father Pierre Hévey, a diocesan priest from St. Hyacinthe, Quebec. Legend has it that when Father Hévey was stricken with a critical illness, he prayed to God to allow him to live so that he might serve the Franco-Americans of New England.[26] He was to play a critical role in the burgeoning French-speaking community.

Soon after his arrival, Father Hévey was encouraging his parishioners to build a new church. He formulated a plan to secure a loan from a savings bank to raise the necessary funds, using his own personal property and life insurance as collateral for the loan, of which all but 10 percent was used for the church. The very first donation was a $10 gift from one Eleusippe Garneau made in February 1872. It represented a large contribution for a single individual but also reveals how many such contributions were needed for the construction. The parish acquired land at the corner of Ash and Bates Streets but eventually settled on a lot on a height on Bartlett Street. The cornerstone for the new building, which cost $75,000, was laid on July 7, 1872, and was consecrated the next year, on May 4, 1873, by Bishop Bacon. At that time, the parish numbered 2,054 souls who had donated their savings to help make the construction possible, many putting their house of worship before the construction of homes for their families, a fact duly

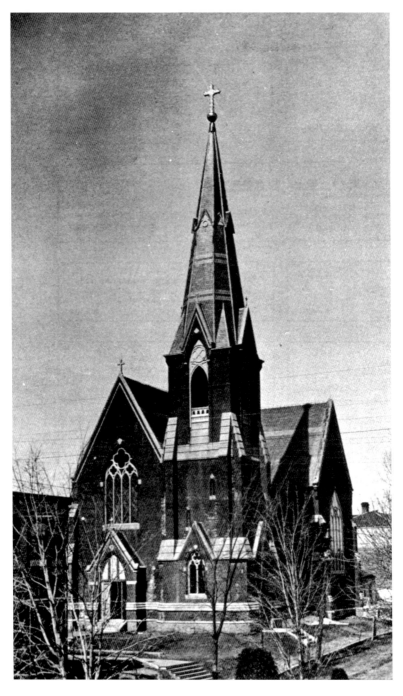

Sts. Peter & Paul Church on Ash and Bartlett Streets in Lewiston, circa 1900. *Courtesy University of Southern Maine, Franco-American Collection.*

noted by the bishop himself and in the *Lewiston Evening Journal* the day after the dedication. After consecrating the church, the bishop confirmed 215 children in the Roman Catholic faith.[27]

The life of the parish was sustained by a number of social and mutual aid societies founded in the period that coincided with the construction of the church and whose existence was encouraged by Father Hévey. The two most important were the Société St. Jean-Baptiste and the Institut Jacques Cartier, which merged in 1875. These and other organizations for mutual assistance provided a safety net for families whose survival depended on their ability to work. In the event of sickness or death, the societies ensured that members and their beneficiaries would have support. They would remain important to Franco-American cohesion in the years to come, forging strong links between spiritual, social and cultural life.

Louis Martel

While most of the French Canadians who arrived in the Twin Cities came to join the workforce as laborers, the new arrivals also included urban, middle-class French Canadian professionals. Their background placed them in positions of leadership within the new community. The most salient example is Dr. Louis J. Martel, a native of St. Hyacinthe like Father Hévey. In 1873, at the age of twenty-three, he immigrated to Lewiston immediately after finishing medical school at Victoria College.[28] In addition to his professional work as a doctor and pharmacist, Martel threw himself into the life of the Franco-American community, playing a pivotal role in the establishment of several institutions—not only

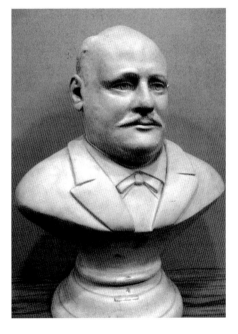

This bust of Louis Martel by Robert Wiseman, circa 1900, was presented to the Institut Jacques Cartier, which Martel founded. *Courtesy University of Southern Maine, Franco-American Collection.*

Le Messager and St. Mary's Hospital but also St. Peter's Parish and the Institut Jacques Cartier. Martel was also politically active, first in the Maine legislature in 1884. He later served as a city alderman from 1890 to 1892. He made an unsuccessful bid to be elected the first Franco-American mayor in 1893 but lost by a narrow margin. He used his position in the community to advance what would become the dominant ideology of the cities' Franco-Americans in this period, encouraging other French Canadians to become naturalized American citizens as he himself had done in 1879. Yet despite his many accomplishments, as a doctor serving the working poor, he often was paid in kind or gave credit for his services. It is said that when he died prematurely at the age of forty-three in 1899, he died in penury. His death has been anecdotally attributed to an infection contracted while operating on a patient at the hospital.[29]

Parish Schools

Father Hévey's attention to parochial education marked still another major milestone in the life of the French-speaking community. After a yearlong absence in 1873 due to ill health, Father Hévey returned to Lewiston-Auburn determined to establish a school for the children of his parish. Some instruction in French had been provided to girls by a Mademoiselle Lacourse in the early 1870s and to both boys and girls by Mesdemoiselles Vidal and Boubeau in a school simply known as the École du Petit Canada (Little Canada School). However, the need to educate Roman Catholic children in both French and English was critical in the eyes of many. The French saying *"Qui perd sa langue, perd sa foi"* ("Whoever loses his language loses his faith") had long been the watch phrase of French Canadians living under an English-speaking Protestant minority. It seemed equally pertinent in Lewiston-Auburn, where the English-only public schools posed a threat to the cultural integrity of the people of Little Canada and beyond. In establishing a parochial school system, the French Canadians of the Twin Cities were emulating the educational system of Quebec, where the majority of teaching was conducted under church auspices.

In 1878, Father Hévey contacted an order of nuns from his hometown, the Sisters of Charity of St. Hyacinthe, known more commonly as the Grey Nuns. Founded by Marguérite d'Youville in the seventeenth century in Montreal, the Grey Nuns took as their calling service to the sick and

New Arrivals from the North (1860–1890)

École du Petit Canada on Lincoln Street in Lewiston, circa 1900. *Courtesy University of Southern Maine, Franco-American Collection.*

elderly, children and the urban poor. (They were called the Soeurs Grises not because of the color of their habits but because they chose to work with the marginalized and, for that reason, were considered *grises*, meaning "tipsy" or "drunk.") Although they were not a teaching order, Father Hévey readily convinced them that the needs of the working poor in the Twin Cities were great and they would certainly find ways to carry out their mission. In 1878, the first three nuns from this order, like so many French Canadians before them, stepped off the train at the Grand Trunk station. Sisters Côté, Leblanc and Galipeau took up residence in a house once owned by Dr. Louis Martel situated at the corner of Pierce and Walnut Streets. Called the Asyle (Asylum) de Notre Dame de Lourdes, it became at once a convent and an orphanage, as the sisters immediately took in orphaned girls. It also became the site of the first bilingual school in Maine. The sisters taught two hundred boys and girls by day and offered evening classes to young adults, teaching English-language courses and classes about the U.S. government. They also visited the sick and elderly in the evenings.[30]

Despite his success as a religious leader of a growing flock, Father Hévey became caught in a global chain of events that, along with ill health, would ultimately lead him to depart from the Twin Cities. After the advent of the Third Republic, France witnessed a rise of anti-clericalism that led in 1880 to the expulsion of priests, brothers and nuns from the public schools. These displaced educators began to emigrate from France to other countries. Religious authorities in Maine, Canada and elsewhere took the position that it would be best for French Canadian priests to minister to French Canadians in Canada and for priests from France to minister to French-speakers in the United States. In September 1881, Maine's first African American bishop, James Augustine Healy, who had studied in both Montreal and Paris, gave the parish located in Lewiston to the Dominican Order "in perpetuity."[31] The flourishing parish represented more work than a single priest could handle, and Hévey was not in the best of health. The Dominicans would be able to supply enough priests to minister to the expanding flock. They also were able to offer a stipend for Hévey in the future.[32] However, the decision seemed abrupt, to say the least. The beloved pastor himself announced his sudden departure to the stunned congregation at Sunday Mass just prior to leaving. The arrival of these Dominican clergymen marked the beginning of ongoing tension between the priests and nuns from France and the priests and nuns from French Canada.

In October 1881, the Dominican Fathers came to Lewiston-Auburn to assume the administration of the local parish and its school, eventually called Sts. Peter & Paul after the two saints who had appeared to the order's founder, Saint Dominic, in a vision. Reverend Alexandre-Louis Mothon became the pastor. He would serve at intervals as pastor until 1906. At the time of the arrival of the Dominicans, the parish numbered four thousand members, around one-quarter of the city's population.

When Father Mothon described the site of the new Dominican mission in an 1893 report to his superiors, he noted that it was the most important industrial center in the state of Maine, powered as it was by the Great Falls. He found stark contrasts: majestic buildings of brick and granite next to wooden cabins; a commercial center featuring "a profusion of dazzling signs and advertisements that catch the eye of even the most inattentive person, reminding him, despite himself, that he is in the country of industry and especially of marketing"; and other districts full of elegant homes. He remarked on the broad and well-planned streets, full of air and light, and the limpid waters of the river.[33]

NEW ARRIVALS FROM THE NORTH (1860–1890)

A CITY WITHIN A CITY

Given the pressing needs of their parishioners, the Dominican priests delayed construction of a monastery until a new school could be built. At the time, there were 300 children being taught by the Grey Nuns. The Dominicans acquired land on Lincoln Street where it met Chestnut Street and started

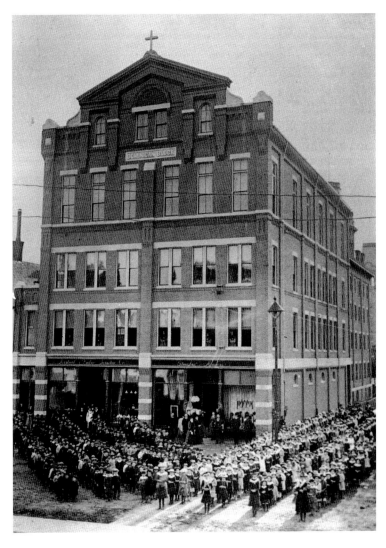

The grand opening of the Dominican Block on Lincoln and Chestnut Streets in Lewiston, 1883. *Courtesy University of Southern Maine, Franco-American Collection.*

construction of a five-story building there in 1882. The Dominican Block was designed as a community center, including commercial space on the street level whose first occupants were the Montreal and Quebec Clothing Company and a store owned by Stanislas Marcoux. There was a hall for theatrical productions and also for Sunday Mass for the residents of Little Canada and New Auburn and classrooms on the upper floors destined for the education of the parish's girls. The Notre Dame Asylum remained the site of the school for boys. A Dominican priest taught evening classes for adult learners, both men and women. According to contemporary accounts, in January 1883, 650 children aged six to thirteen left the parish church after Mass to walk to the opening ceremony of the new school. The Dominican Block, referred to as the "French-Canadian City Hall,"[34] was but one of many projects that consolidated the presence of a city within a city, one the English-speaking community and the other a self-enclosed French-speaking community that was quickly becoming self-sufficient.

THE FRENCH PRESS

Another key development for the early emergence of the French-speaking city was *Le Messager* (the *Messenger*), a French-language newspaper founded in March 1880 and first housed in a wooden building on Chestnut Street. The building also housed a library run by Joseph L'Heureux, the building's owner. The first press, operated manually with handset type by Noé Carignan, son of Lewiston's first French Canadian, was in the basement. The paper was financed by Dr. Martel, edited by J.D. Monmarquet and had a circulation of between five and six hundred, appearing daily in two pages with two columns each. After a falling out between the editor and his backer over political affiliation, the paper changed hands and locations several times. *Le Messager* moved to a brick building on Main Street in 1882 and achieved statewide distribution in 1883 under editor Eugène Provost, moving briefly to the Provost Block on Chestnut Street. Around this time, Jean-Baptiste Couture (1866–1943), a seventeen-year-old typesetter who had worked for *L'Événement*, a Quebec City daily, joined the staff. A native of Lévis, Quebec, Couture was one of eighteen children born to Olivier and Marie Herbert Couture. His father, Olivier, was a schoolmaster. Jean-Baptiste was educated at school until age thirteen and then attended a normal school (teacher training college), which was housed at the Chateau

New Arrivals from the North (1860–1890)

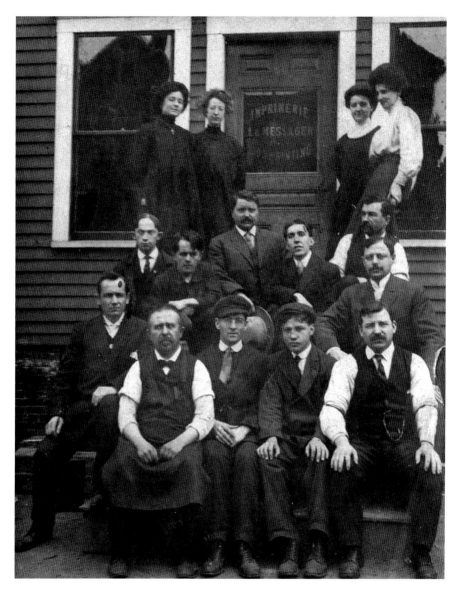

Le Messager staff at their Lincoln Street office in Lewiston, circa 1910. *Front left*: J.B. Couture; *back, far right*: Camille Lessard. *Courtesy University of Southern Maine, Franco-American Collection.*

Frontenac in Quebec City. To cover his tuition, he allegedly swept and built fires in the grand building.[35]

Le Messager continued to change hands until it fell into insolvency in 1887. Couture, enlisting the aid of his brother-in-law, P.S. Ghuilbault, took

over as editor but left for Lowell, Massachusetts, after a disagreement with Ghuilbault. The newspaper achieved stability only when Dr. Vanier, another prominent community leader, invited Couture to return and edit the paper with his backing. Couture was soon able to repay the doctor and continued as owner/publisher for another fifty years. Despite early turnover and several more moves, *Le Messager* eventually relocated to 223–25 Lisbon Street, where it became a fixture of Lewiston-Auburn until 1966.

A Tale of Two Hospitals

Perhaps no one event illustrates the doubling of Yankee and French institutions and lives better than the founding of Maine's first Catholic hospital, simply known as the French hospital at its founding and later named St. Mary's General Hospital. Work in the textile mills was dangerous. The crowded conditions in Little Canada also led to the spread of disease. The Grey Nuns recognized the crying need for a hospital facility, a need that was closely aligned to the mission of their order. They had been involved in healthcare since their early days in Lewiston-Auburn. In June 1888, they had raised enough funds to purchase the Golder farm at the junction of Pine and Sabattus Streets on what was then the outskirts of the city for $22,000.[36] The farmhouse would come to serve as the first Catholic hospital in the state. The expanded building included the sisters' residence, an orphanage and two wards of about thirty beds, with an additional five or six private rooms. The sisters' hospital was the first hospital in the Twin Cities, where the majority of doctors were Yankee Protestants. Rather than support the new facility, they denigrated it, refusing to practice there. With the support of the Yankee community, they created instead their own Central Maine General Hospital, receiving a substantial subsidy from the state.[37] The Catholic hospital was staffed by a handful of local doctors like Louis J. Martel. It also relied on doctors who came temporarily from Quebec.[38]

Since the Grey Nuns served people of all ethnicities and creeds without distinction, some of the same doctors who had vehemently refused to set foot in the sisters' hospital eventually came there to treat their own patients and discovered, to their surprise, a medical facility of superior quality. In 1894, the state delegation from Lewiston requested a subsidy for the sisters' hospital. Former governor Alonzo Garcelon attended the public hearing at the statehouse along with many other leaders of the English-speaking

New Arrivals from the North (1860–1890)

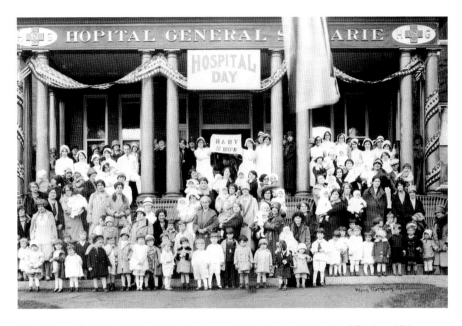

Baby Day at St. Mary's Hospital in Lewiston, 1926. *Courtesy University of Southern Maine, Franco-American Collection.*

community. The Sisters of Charity received $2,500 in state monies over the next two years. It is not surprising to find Garcelon's son, Dr. Alonzo M. Garcelon, on the hospital's staff a few years later at the end of the century.

Life in Little Canada

As French Canadians saved their wages, some were able to lease land and build three- to six-story wooden tenement buildings that housed two families on each floor. Landlords were in fact among the first French Canadian entrepreneurs in Little Canada

Ozios Tancrel came to Lewiston with his wife, Zénaïde, from Ste-Croix-de-Lotbinière, Quebec. The husband found work in the opening and picking room in the Hill Mill, while his wife took in boarders. She provided lodging and meals for four full boarders and provided noonday meals for quarter boarders. On the strength of their combined earnings, they were able to borrow money from the Provost Brothers, merchants on Lincoln Street, in order to purchase an eight-tenement block on River

The wedding of Marie Philippon and Alfred Tancrel at 24 River Street in Lewiston, April 1897. The property was owned by the Tancrels. *Courtesy University of Southern Maine, Franco-American Collection.*

Street "then standing on posts. They dug a cellar, built a foundation and moved the house back two feet." There they raised their son, Alfred, and he raised his own family.[39]

In Little Canada, French was the lingua franca and could be heard everywhere. The streets in Little Canada were narrow and sunny since they were not tree-lined like Canal Street and the streets in neighborhoods to the north. The tenements featured outdoor porches on each floor that gave families even greater living space. Music and song could often be heard lilting from a porch or open window. Visitors compared the atmosphere to that of cities in Canada or Europe. Although the district was urban in character, many families had garden plots and raised animals near the river. Recreation also included activities centered on the river, such as boating and swimming.

Although many French Canadians had lived in urban settings before, the first few days and weeks in the Twin Cities marked the transition in the lives of those who had lived as subsistence farmers in the lands to the north to that of an urban population of wage earners who swiftly became consumers. *Canuck* gives a particularly compelling portrait of this transition in the early

years of the twentieth century. In addition to furniture and household basics, there were new expenses like city clothing rather than the homespun garments worn and made on the farm. Urban dwellers had a wide array of new choices on which to spend their hard-earned pay.

While their new urban environment offered many opportunities, traditional cultural values endured. Franco-American social life in the city revolved around family and friends, as it did in their prior homes and as it still does today. The quintessential social gathering was the house party. Music was a central component of Franco-American life; many people played fiddle, accordion, piano or percussive instruments like spoons and bones. Even feet became percussive instruments for traditional musicians. Friends and family might gather in a kitchen or living room with musicians in the center and space made to dance. Sometimes the musicians would take their place above the group on a table or stove to make even more room for dancing, both traditional and contemporary. Many traditional French Canadian songs that survive today originated as work songs.

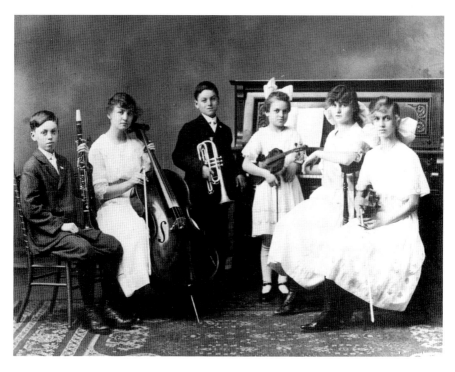

The Jalbert Family Orchestra from Lewiston, 1920s. Family groups like this one primarily played at home for friends and family. *Courtesy University of Southern Maine, Franco-American Collection.*

Likewise, Franco-American cuisine owed more to the need for hearty fare on a working farm than to style. It was shaped by the seasons so important to farm life, for example the slaughter of pigs (*cochons*) in late fall. The meat pies, sausages and hams that result are important elements in Franco food culture. It is no surprise that the slaughter of pigs is a recurrent motif in the novels of Franco-American women across generations, from Camille Lessard to Grace Metalious and Rhea Côté Robbins. Pork products are a key ingredient in Franco-American dishes. Pea soup, for example, is flavored with a ham bone and bits of ham after the ham has been served, often at a special occasion such as Easter. The dried peas that form the base of the soup, as well as the onions and potatoes often used in it, are all crops that can easily be grown in a cold climate. The maples that forest Quebec are the main ingredient in *tarte au sucre* (sugar pie), made of crust and maple sugar. Boiled-down maple syrup on snow is another traditional treat. Franco-American cuisine is also influenced by the size of traditional families on French Canadian farms and the economic hardship they faced. They made use of as much of

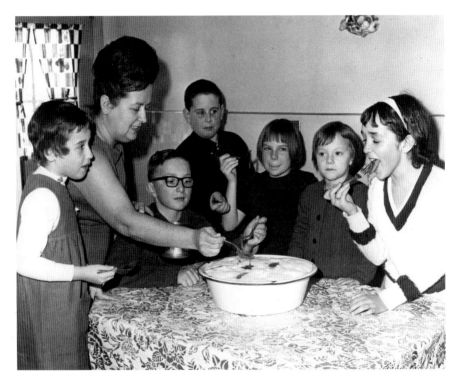

Pauline Allard makes maple snow taffy in Lewiston, circa 1960. *Courtesy University of Southern Maine, Franco-American Collection.*

the pig as possible, grinding the meat to make *tourtières* (meat pies), *cretons* (a kind of spread made of ground pork butt, onions and spices like cloves and allspice) and sausages and using the ears, knuckles and bones for soup. These recipes—soups, pies, ragouts and spreads—could all be prepared to feed large groups. The twentieth-century *pâté chinois*, or Chinese pie, a variant of shepherd's pie, owes much to this culinary tradition.

Marthe Grenier Rivard emigrated with her family from a farm in St. Léon, Quebec (now Val-de-Racine), in 1923. The life she remembered, however, bears out the strong traditional nature of French Canadian life on the family farm. She came from a large family: her parents had fourteen children. All of them worked the land from as early as possible in childhood. She herself remembered collecting rocks from the fields as a small child and helping her sisters milk cows by holding their tails. She then "graduated from the tail" to actual milking when she was of school age. Work was an all-day affair. The seasonal nature of life included housekeeping details. The children slept on straw mattresses that they stuffed each fall, but by springtime the mattresses were flat. In good weather, they slept in the barn. The family fetched water from a nearby stream, but winter temperatures made it difficult. They used a wood stove for heat; the walls and ceilings, blackened by soot, had to be scrubbed clean by the older children after winter ended. Although they were very poor, they were never hungry. There were always beans and pea soup, foods she always enjoyed.

Marthe thought she might have been a good *habitant*, or French Canadian farmer, but she never found out. Her older siblings immigrated to Lewiston because, as was typical, they had relatives living in the city. As they got older, there was less work for them on the farm because the younger siblings had taken over their tasks. Marthe, her parents and the other young children soon followed the other family members to the Twin Cities. They came by train, like so many before them. As they made their way to the station by horse and buggy, family and friends came out to say goodbye. There were tears all around. Marthe went back to visit her former home, but she was ever after a resident of the Twin Cities.

She attended public school briefly but found she was placed in a lower class grade solely because she spoke little English. She found the schoolwork too easy because she had already studied the material in Canada and was bored. She left school to take care of her ailing mother and infant brother, but life at home was confining. She went back to school briefly but soon found work in a shoe shop in Auburn. She was sixteen. Like so many Franco-American children before her, she gave the bulk of her pay to her parents

and did so up until the week of her marriage. She and her new husband then set up a household of their own. The traditions evident in her life experience—family, friends, faith, community, hard work and love of life—are all hallmarks of the Franco-American story.[40]

Religious holidays, which follow the same seasonal calendar as farm life, were especially important to French Canadians, with the Christmas Réveillon one of the most important events of the year. Families would attend Christmas Mass at midnight and then return home to feast, celebrate and exchange gifts. Among the traditional foods, one of the most important was *tourtière*, the traditional meat pie mentioned before, made of ground pork, beef, veal or a combination; diced cooked potatoes; and spices. Some cooks insist that slow cooking was and is the essential element of a good *tourtière* while others maintain the slow cooking must be done with wine. The Christmas holidays included New Year's Day, when it was traditional in this patriarchal culture for the *pater familias*, often a grandfather, to bless family members for the coming year. The Feast of the Epiphany, in some families marked by serving a *galette de rois* (king cake), concluded the Christmas season. Lent and the Easter season until Pentecost was another important period in the seasonal and religious calendars. The months of May and October were dedicated to the Virgin Mary; devout families prayed the rosary together in the evenings. The feast of St. John the Baptist on June 24 had been celebrated in some parts of France for centuries; it coincided with traditional bonfires that marked the summer solstice since ancient times, well before the arrival of Christianity. In Canada and in Lewiston-Auburn, this holiday took on locally specific forms described in the next chapter. Nonetheless, the holiday forms a part of the seasonal character of Franco-American cultural practices that are profoundly grounded in the North American French experience as well as traditions that came across the Atlantic from France.

By the 1890s, the Franco-American community had developed its own identity. It held on to cherished traditions but was firmly grounded in its new home in the Twin Cities. The community, encouraged and aided in particular by French-speaking religious missionaries from both Canada and Europe, had established a number of institutions separate from those of local English-speakers, except in the workplace. It formed a city within the Twin Cities and would continue in this vein, establishing new parishes, parochial schools, orphanages, a home for the elderly and an enormous number of social and fraternal organizations for religious purposes, mutual aid and cultural and sports activities. Despite poverty and hardship, the decades between 1890 and the end of the First World War witnessed what could truly be called a Franco-American Belle Époque.

2

A Franco-American Belle Époque (1890–1914)

In the period of the 1890s until after the First World War, the Franco-American presence in the Twin Cities grew both in size and visibility. Continued immigration to the Twin Cities meant that by 1910, Franco-Americans formed a majority within Lewiston (the population of Franco-Americans in Auburn would continue to increase during this period but never surpassed 50 percent).[41] French Canadian migrants had increasingly put down roots, moving beyond the confines of Little Canada and gaining upward social mobility. They were also beginning to craft a new identity for themselves as Franco-Americans rather than French Canadian immigrants. The vast majority remained skilled and unskilled laborers who worked in the textile industry or the more recently developed shoe industry centered in Auburn. Most were poor, but they had found space for the expression of rich spirituality and a distinctive set of cultural values. The result was a flourishing of artistic and cultural enterprises, an expansion of the Franco-American business community and a slow but steady march toward political power in the Twin Cities. At the same time, however, the success of the Franco-American community highlighted divisions and tensions within that population.

Social Mobility

French Canadian immigrants represented a range of educational backgrounds and experiences. While Roman Catholic missionaries ministered to Franco-Americans' spiritual needs, French Canadian professionals and entrepreneurs saw to the more corporeal needs of their own community. A few, notably doctors and dentists, were able to practice the professions for which they were trained in their new home.

Some millworkers were able to advance up the social ladder by amassing capital in their industrial jobs that they used to invest in property, as the Tancrel family did (see Chapter 1), or to found their own businesses. François-Xavier Marcotte's story is typical of such an immigrant. He was born in Wotton, Quebec, in 1859 and immigrated to Lewiston twenty years later, returning briefly to Canada to wed Marie Gosselin of Ste. Sophie, Quebec, in 1881. While an "Exavier Marcotte" is listed as a millworker in the 1880 census, by 1890, Xavier Marcotte owned a mortuary as well as a furniture store at the corner of Lincoln and Cedar Streets, opposite the Dominican Block and in proximity of the Grand Trunk station. Newly arrived French Canadian immigrants easily found their way to the store, where Marcotte would help them find an apartment and sell them the household goods to

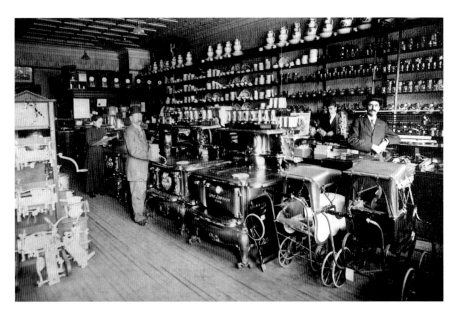

The interior of the F.X. Marcotte Store on Lincoln Street in Lewiston, circa 1900. *Courtesy University of Southern Maine, Franco-American Collection.*

furnish it. They would then shop for food staples at the Provosts' market,[42] for the Provost Brothers, like Marcotte, were entrepreneurs who branched out in a number of businesses ventures, including real estate and insurance.

Marcotte was able to construct his own block at the corner of Chestnut and Lincoln Streets in about 1904, a building that still houses F.X. Marcotte Furniture, a Lewiston landmark still co-owned and managed by family members. He later served on the board of the Manufacturers' National Bank and became its vice-president. F.X., although childless, was the head of a large extended family and was renowned for his generosity to other Franco-Americans. One of his most enduring legacies is the building that housed the St. Joseph Orphanage and still houses Maison Marcotte. His donation to the Sisters of Charity came with the single stipulation that twenty elders would always receive free care from the sisters. As a widowed octogenarian, he himself spent his last days in the hospice, which today continues as an assisted living center.[43]

Basic Services

Many entrepreneurs, like the Provosts, made a fine living selling the staples of daily life to their fellow French-speakers. A single September 1887 issue of *Le Messager*[44] contains advertisements for Franco-American businesses from cities all over the state, including Waterville, Augusta, Brunswick, Biddeford and Saccarappa (now Westbrook). Among local businesses, some Yankee establishments, especially clothing stores that marketed to a wealthier clientele, listed the names of French-speaking clerks who assisted Canadiens who would come to shop. Likewise A.J. Wright, a jeweler on Lisbon Street, offered the services of Charles Gaudet, the only French Canadian jeweler and watchmaker in the city, on the premises.

Businesses whose proprietors were distinctive for their French names often sold basic necessities and included Alphonse Auger's shoe store, the Leclerc & Chaput bakery and pastry shop and Mailhotte & Co., a furniture store that also sold tinware. Louis Roberge sold charcoal at the corner of Ash and Bates Streets, but orders could also be placed with Stanislas Lévesque, who sold shoes on Chestnut Street, as did Frank Pinette on Lincoln Street. Grocery stores proliferated in Little Canada and its vicinity and included Auger & Nadeau, J. Belliveau & Co., F.X. Girard and Guay & Labranche. Provost & Co. was both a grocery and

Arzélie, MarieAnne and Victoria Janelle at their home in Lewiston, circa 1910. The sisters ran Janelle's clothing store on Lisbon Street. *Courtesy University of Southern Maine, Franco-American Collection.*

bakeshop, and A.M. Belanger & Co. and Phaneuf & Co. sold not only groceries and meats but also dishware and paints.

Services advertised in *Le Messager* included carriage excursions (Jos. Marchand and Guay & Legendre), painting and decorating (B.H. Couturier) and music and singing lessons (H. Roy.). Dr. S. Dumont advertised medical services. Joseph Leblanc's Lewiston Steam Dye House (see Chapter 1) cleaned clothing as well as feather beds, mattresses, pillows and kid gloves. Cleophas Thibault's billiard room served lunch and refreshments at any hour. Another important service was the delivery of ice in the days before refrigeration when food was preserved in iceboxes. Several Franco-American families like the Goulets and the Carons harvested the ice that was plentiful in late spring in Maine and sold it. By the turn of the century, Franco-American businesses had expanded to include more luxuries. The Janelle sisters, a family of single women, founded a fashionable clothing store on Lisbon Street, one of Lewiston's main thoroughfares, in 1905.

Philippe Dupont's bakery, founded in 1893, was located in New Auburn, an Auburn neighborhood that housed many Franco-Americans. Among some of

A Franco-American Belle Époque (1890–1914)

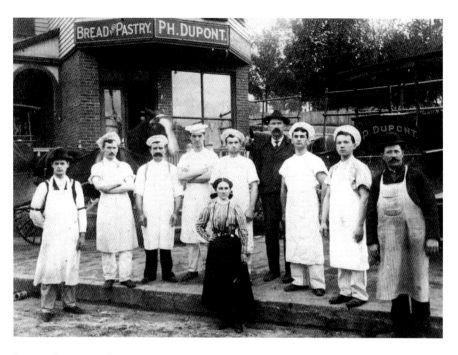

Dupont Bakery staff pose on 49 Second Street in Auburn, 1900. *Second from left*: Armand Dufresne; *center, suited*: Philippe Dupont. *Courtesy University of Southern Maine, Franco-American Collection.*

Dupont's early employees, a number went on to found their own businesses or partner with other entrepreneurs. In 1922, Armand Dufresne became a partner in the Maine Baking Company in Auburn with Philippe Couture. François-Régis Lepage, the former foreman at Dupont, became the proprietor of LePage bakeries (1903) and eventually purchased Dupont's operation in 1965, and LePage's friend and former partner William Mailhot went to work for D.W. Penley, a meat processor in Auburn. He then bought out a Lewiston sausage company in 1910. The family concern still produces sausages—including blood sausage, or *boudin*—as well as *cretons* and *tourtières* (see Chapter 1).[45]

Mortuary Services

It is no wonder that F.X. Marcotte got his start as an undertaker. In the days of poor living and working conditions, high maternal and infant mortality and major epidemics of diseases like measles or influenza, death

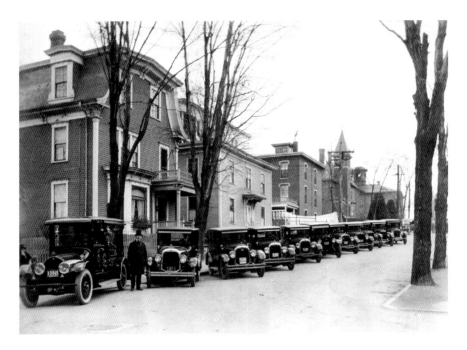

These hacks, or hired cars, were used by Poisson & Fortin, undertakers, located at 56 Park Street in Lewiston, 1924. *Courtesy Fortin Group.*

was ever present, and the undertaker's role was essential; he not only furnished caskets but also saw to the proper embalming and burial of the dead and the comfort of the bereaved. In 1910, two founding fathers of long-standing Lewiston-Auburn funeral homes, Régent Fortin and Napoléon Pinette, became partners. They took over Marcotte's mortuary business, still housed in the Marcotte Block on Lincoln Street in Little Canada. They remained partners until Pinette established his own funeral home, and Fortin went into business with Louis Poisson in 1922. Each of the two original partners expanded beyond Little Canada to newer Franco-American neighborhoods (see below).

Pinette is an example of a Franco-American immigrant to the Twin Cities not from Canada but from the Maine borderlands. Born an American in Wallagrass, Maine (around ten miles from the Canadian border), in 1891, Pinette grew up on the family farm and worked as a woodsman from age thirteen. Coming to Lewiston in 1911, he sought out a job that allowed him to work outdoors. This led him to become a furniture mover with F.X. Marcotte and, despite his squeamishness at the sight of blood, an undertaker. Fortin was also a former Marcotte employee.[46]

Funeral arrangements were handled within the French-speaking community following French Canadian Roman Catholic ritual. In those days, the deceased were waked in their own homes. A crepe on the door would mark a Franco-American home in mourning, and the blinds and shades would be drawn. The wake would be an all-day affair from ten o'clock in the morning until ten o'clock at night. Some families also held an all-night vigil for the deceased. Food was served throughout the day; the rosary was recited on the hour, if not more often. There were few flowers, and no eulogy was given at the Mass, said in Latin. Well into the first part of the twentieth century, few Franco-Americans owned vehicles appropriate to such a solemn occasion as a funeral, unlike their Yankee neighbors. After the funeral, a procession of the hearse, followed by hired "hacks," first carriages and later automobiles would bring the remains for burial, usually at the Roman Catholic cemetery, St. Peter's. The order of the procession was hierarchical, with those demanding high respect, such as family elders, following closely behind the casket, and children were frequently placed in their birth order within the parade of vehicles.[47]

Construction

As the Twin Cities grew, firms that provided materials for new construction also prospered. The Franklin Company initially operated its own brickyard on the Island, which, as early as 1872, was largely staffed by French Canadian immigrants.[48] Later, however, Franco-Americans not only worked in the yards but also owned many of the businesses, including Morin Brick. An advantage of brickmaking was that it was an enterprise that could be begun with relatively little capital. Jean-Baptiste Morin (born in 1867 in St. André, Quebec), known as Honest John to the English-speakers of the Twin Cities, started a business that endures to this day on his brother-in-law Jean-Marie Olivier's Auburn horse farm in 1908. Morin quickly expanded by leasing the established P.M. Austin yard the same year.[49] In addition, construction and contracting businesses have remained important Franco-American enterprises.

Demographic Increases

As more immigrants arrived, as many as sixty-five a day,[50] the French-speaking population found its way into neighborhoods beyond Little Canada, first across the river to New Auburn in a neighborhood once known as Barkerville because of the Barker Mill. The French-speaking population also made incursions into neighborhoods to the east that had once been the home of the Irish, such as Bleachery Hill. They then moved to parts of the city above Lisbon Street, including the streets to the east of the City Park—an area that had once been known as the Franklin Company Pasture, whose vestiges still bear the name. By 1910, Franco-Americans predominated not only in Little Canada but made up roughly three-quarters of the inhabitants of this quarter of Lewiston as well.[51] At the time of its construction, St. Peter's Church had been built on a promontory known as English Hill. Before long, it came to be known as French Hill.[52]

The Expansion of French-speaking Schools

The cities' changing demographics created the demand for expanded ministry on the part of Catholic clergy and an ever-greater need for social services. In August 1886, four Marist Brothers arrived in Lewiston to further serve the educational needs of Catholics. They first taught in two unused public school buildings on Lincoln Street that proved unworkable, as well as in the basement of the church. In 1887, St. Paul's Collège (a secondary school) opened on Bates and Blake Streets in order to accommodate 454 boys while the Grey Nuns continued to teach the 810 girls enrolled in parochial schools. The facility for boys also housed the Association St. Dominique, a society for young men, first housed on Lisbon Street. It featured a reading room, smoking lounge, gym and game room, which included several billiard tables. The salon had a piano. Meetings began with the full rosary. By 1890, the total enrollment in Catholic schools was 1,538.[53]

It was clear that a new school was needed to serve Auburn's Catholic children. Thirty-five Catholic children were already being educated in a school by a lay teacher, Miss Vidal, but the demand necessitated a larger undertaking.[54] Land was purchased in New Auburn, and a foundation was laid. In late 1891, Mothon requested a new order of religious women to teach. The Dames de Sion (Ladies of Zion) were a congregation of women

religious founded in Paris in 1847 by the Ratisbonne brothers. The brothers were Jesuit priests who themselves converted to Roman Catholicism from Judaism and created congregations of priests and nuns to effect further conversions, especially in the Holy Land. The order was international, with houses in England, Ireland, Scandinavia and Jerusalem, as well as in Paris.

The new school in Auburn was called St. Louis School, perhaps in honor of the canonized crusader King Louis IX of France, who, like the Dames, had gone to the Holy Land. It had a chapel on its top floor in which Mass was held for the 415 Franco-American families living in Auburn.[55] Classes were conducted on the first floor. There was soon a new convent, a boarding school for girls and, by 1899, a novitiate. By 1893, the Sisters of Charity, who had not traditionally been a teaching order, had ceded teaching responsibilities in the Dominican Block to this other order of sisters.

Distinctions drawn between the Sisters of Charity and this new order of teachers indicate a growing tension within the Catholic clergy of the Twin Cities. The Dames de Sion were lauded by the French Dominican priests for teaching "so pure" a variety of French, "the good, the beautiful, the dearest tongue from France."[56] In contrast, Mothon denigrated the French Canadian Grey Nuns as having been able to offer students only a rudimentary education. This myth of a "purer" version of French from Paris—taught, ironically enough, by women recruited for their skills in English and known for the international composition of their congregation—has persisted in the Twin Cities with no attention to regional and social class variations among French-speakers in France. The tension between clergy from France and from French Canada continued to mount even as they continued to serve.

Residential Schooling

The Grey Nuns had been invited to the Twin Cities to serve the educational needs of French-speaking Catholics, but they were not primarily a teaching order. Their mission and expertise lay in the care of the sick, the elderly and foundlings. They had steadily worked in these capacities since their arrival, reaching a milestone with the creation of what came to be called St. Mary's General Hospital. The next decades would see their services continue to grow.

In 1893, with a generous grant from Bishop Healy of Portland, the Grey Nuns established the Healy Asylum, a home for orphans, children whose parents were unable to care for them and delinquent boys from all over the

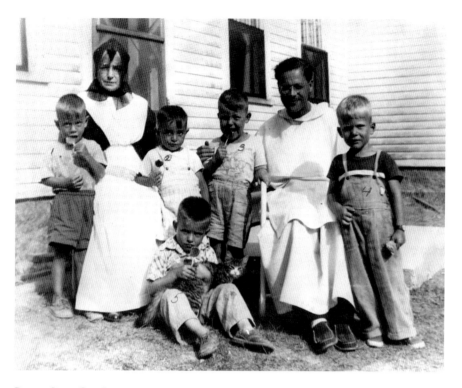

Boys at Camp Don Bosco, Maine, Fayette, 1952. Camp Don Bosco was a summer camp for the residents of the Healy Asylum. *Courtesy University of Southern Maine, Franco-American Collection.*

state of Maine. The asylum had classrooms on the first floor; a kitchen, a cafeteria and a laundry in the basement; visiting parlors and the nuns' quarters on a second floor; and a dormitory on its top floor. There was also space for recreation in the yard. The Grey Nuns had not entirely relinquished their teaching responsibilities, as the asylum and St. Joseph Orphanage on the hospital campus offered schooling to their residents, a situation duly noted in reports of the Lewiston School Department. Because most Franco-American children attended parish schools, the costs to the public school system were much lower than they would have been had these institutions not existed. Nevertheless, it was estimated that about one-fifth of the "French" children, as they are listed, attended public schools.[57]

The sisters cared for children in a variety of circumstances, not only those who had lost their parents. Some children had a parent so ill that he or she could no longer be there for a young family. The Grey Nuns seemed particularly attuned to the needs of women in their child-bearing years, perhaps because the sisters saw to maternal healthcare as well. The nuns

offered short-term residential settings to children whose mothers needed respite before resuming their family responsibilities.

The nuns housed these children until the situation was resolved or the children grew old enough to leave the home where they were placed. This was also true for children of families in crisis due to separation, remarriage or dire financial straits. Boys were expected to leave the Healy Asylum at the age of fifteen. The sisters helped them find a place in a private home or an apprenticeship. There was no set age limit at the St. Joseph Orphanage. Some girls entered the convent as novices from the orphanage. In addition to providing food and shelter, the sisters held a full day of regular classes for their charges, although the boys and girls in the two orphanages are strangely not listed in the Lewiston School Census records as students even though they attended classes. They are simply listed by name and include children of multiple races and ethnicities, although those marked as French predominate. As one former resident of the Healy Asylum put it, "The Sisters spoke French. There were some who didn't speak French…but they learned it."[58] The sisters themselves set the schedule for academics. They allowed boys to serve as altar boys at Masses (for funerals, for example) held during regular school hours when other altar boys could not.

Because the Grey Nuns chose to serve the working poor, many of the children in their care resided with them only during the workweek. On Saturday afternoons and Sundays, their parents would retrieve them for a family weekend before returning them on Sunday nights. The Grey Nuns thus invented a paradigm for childcare for working parents, mothers in particular. For a population who lived in precarious times, these homes provided an essential service, an early form of daycare, otherwise unavailable.

Discipline could be harsh, as it was in many schools and families in those days; some children never understood the reason behind their placements. The sisters were feeding large numbers on tight budgets, and no one remembers the food with enthusiasm. The sisters themselves led disciplined, highly structured lives in the service of God. Children, in turn, were expected to follow this model and to quietly obey. Additionally, the sisters had to care for many children—two sisters might be assigned to supervise 150 children. A child who talked too much might have to stand in the middle of the class. One who chewed gum might wear it on his or her nose. Corporal punishment was also used to discipline the children, as it was in many settings in those days.[59]

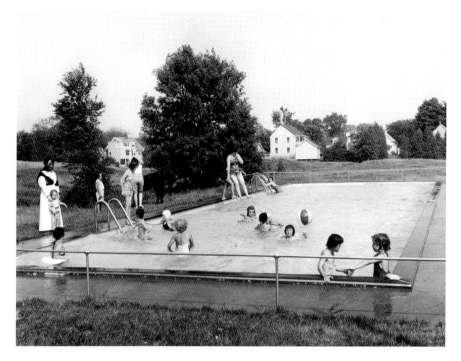

The swimming pool at St. Joseph's Orphanage in Lewiston, circa 1950. *Courtesy University of Southern Maine, Franco-American Collection.*

Activities for children in the orphanages included music and theater. Both residences had a swimming pool in the '30s, '40s and '50s. A parish women's group, les Marchandes de Bonheur (Merchants of Happiness) ensured that the children had gifts at Christmas, and Père Noël arrived at the party as well. There were social activities for both boys and girls, such as dances and outings. One woman recalled that during one outing to a local beach, the boys were allowed to go swimming, but the girls were not. The sisters had an extreme concern about modesty, for girls in particular. When children dressed, they wore tent-like nightgowns to cover themselves and put on their clothing inside them. They also bathed in these same garments and found it chilly to get out of the tub, especially in the Maine winter.

Former residents of these institutions do not recall the overall experience in positive terms but do remember individual friends or sisters with fondness. They also express appreciation for the cultural values transmitted to them in these settings.[60]

A Franco-American Belle Époque (1890–1914)

The Dominican Sisters

In 1893, when the parish could not meet their requested salaries, the Marist Brothers left, and by 1894, the Dames de Sion had taken responsibility for St. Paul's school for boys, St. Peter's for girls (as the school in the Dominican Block was called) and St. Louis. However, as time went on, the Dames realized that the situation was not a temporary one, and because providing education for boys violated the rules of their order (except in urgent circumstances), they left in 1904. Henceforth, the Little Franciscan Sisters of Mary took responsibility for Auburn's parochial school students while Lewiston's students had the Dominican sisters of Nancy, France, as teachers.

The Dominican sisters approached the task with trepidation. First, they had to learn English in order to teach in the bilingual school. They took lessons from the Dominicans in Fall River, Massachusetts, in preparation. A handful of sisters from a chapter in Ohio were also assigned to Lewiston to offer assistance. The school had enormous classes, even by the standards of the time, with sometimes fifty, sixty or even eighty children in a single class. The sisters had reservations that the workload would leave them little time for spiritual life. Still, twenty-eight sisters from eight different countries arrived from Europe. After a pleasant summer, including a picnic at Casco Castle with the children organized by the Dominican priests, the challenge of the academic year began.

There were eight hundred students in sixteen classes in the Lewiston schools. The sisters found them ignorant and rude and even openly hostile. They reported that one child spat on a teacher while an older boy stood on a table and defied the nuns, taunting them to hit him. A priest supplied straps to keep the "scoundrels" under control, but the sisters were reluctant to use corporal punishment.[61]

La Cause Nationale

The preference of Alexandre Mothon and the Dominican Brothers for French nuns over French Canadian orders like the Sisters of Charity was part of a complex tapestry of church politics in the Twin Cities. Rivalries developed between the French missionaries and their Franco-American flock.

Two concurrent events would expose these tensions. The first of these was the 1881 "Lewiston Agreement" that gave the parish of St. Peter's to the

Dominican Order.[62] Even early generations of immigrants had recognized the need to participate in American civil society and learn English. French Canadians had established the first bilingual schools with that in mind. However, they also held fast to the French language in matters of faith, family and community. St. Peter's Church and the Dominicans were at the center of this effort.

Over 75 percent of the state's Roman Catholics had roots in the borderlands of French Canada and Maine, yet the church hierarchy was Irish. Franco-Americans feared that Irish prelates like Bishop Healy's successor, William O'Connell (who served as bishop of Portland from 1901 to 1906 and continued to exercise authority over Maine as archbishop of Boston from 1907 to 1944), hoped to unify Maine's Catholics by suppressing the French language in favor of English. In the face of this threat, a statewide movement known as La Cause Nationale (The National Cause) was born in 1905 in Lewiston as a standing committee of the Institut Jacques Cartier. Proponents held a convention in Lewiston in 1906 and then sent representatives to Rome to demand a French Canadian bishop when the see became vacant the same year. Their bid was unsuccessful, and the lack of a French Canadian or Franco-American head for the diocese (Amédée Proulx served as auxiliary bishop from 1975 to 1993) continues to rankle some in the Franco-American community today.

Meanwhile, as the Franco-American parishioners protested the Irish American church hierarchy, the French Dominicans found themselves caught in the controversy raging between the bishop and the Franco-American population. The Lewiston Dominicans, like other Dominican houses in North America, fell under the authority of the French Canadian provincial, Albert Mathieu. However, for many years, Alexandre Mothon and the Dominicans had held ambitions of asserting their independence and perhaps establishing their own province in the United States. In 1887, several Dominicans from Lewiston had established a new priory in Fall River, Massachusetts, to tend to the Franco-American population there.

The growth of the Franco-American population in Lewiston and Auburn strained the capacity of the Church of Sts. Peter & Paul despite the addition of several side chapels to the original structure and the creation of St. Louis Parish in Auburn. In 1905, the decision was made to demolish the old church and erect a grand structure in its place. The new church was an enormously ambitious project, and while it is difficult to determine the exact thoughts and motives of individuals in this controversy, the Dominicans' plans to construct a cathedral-like structure in Lewiston can only have antagonized

A Franco-American Belle Époque (1890–1914)

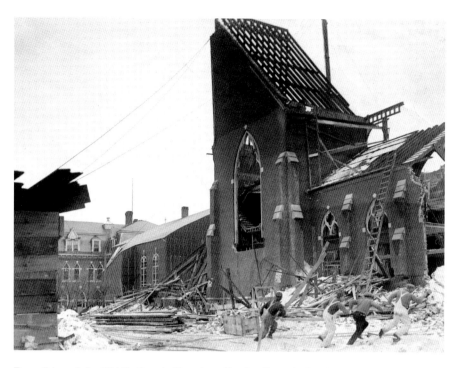

Demolition of the Old St. Peter's Church on Bartlett Street in Lewiston, 1905. *Courtesy University of Southern Maine, Franco-American Collection.*

Bishop O'Connell and his successors. Even today, the Church of Sts. Peter & Paul is larger than the Cathedral of the Immaculate Conception in Portland and the second-largest church in all of New England.

Opposition to the new church came not just from the diocese but also from *Le Messager* and its editor, J.B. Couture. The newspaper challenged the local Dominicans on two counts: the decision to demolish the old church, which *Le Messager* claimed was taken without due consultation with the parishioners, and the silence of the French priests on the question of national parishes in other cities that seemed to indicate an alignment with the bishop. However, the bishop's appointments of parish priests elsewhere were of less concern than the dynamic within their own Dominican order.

In response to *Le Messager*'s editorials, the Dominicans withdrew their support for the newspaper and backed a new one, *Le Courrier du Maine*. Henri Roy, the parish organist and choirmaster, was its publisher. *Le Courrier* was also given the contract to publish the biweekly parish bulletin instead of *Le Messager*. However, that same month, an ailing Father Mothon resigned. A delegation from the Institut Jacques Cartier lobbied the provincial of the

Dominican order in France to replace Mothon with a French Canadian. He did so but compromised by splitting Mothon's duties between two individuals: a French priest as prior of the monastery and a French Canadian as pastor to the flock of St. Peter's. Historian Mark Paul Richard attributes the steady appointment of French Canadian and Franco-American priests over the next eight decades as key to the community's distinctive ethnic identity, strengthened by the bonds of language, faith and tradition.[63] The newly appointed pastor, Father Antonin Dallaire, announced to his flock that he was indeed "de pure laine,"[64] an expression for a dyed-in-the-wool French Canadian that can also have connotations of ethnic purity. The provincial also used his authority to end the newspaper war, instructing the Dominicans to end their support for *Le Courrier*, which soon folded. Roy's Echo Publishing, however, continued operating for many decades.

Corporation Sole

Within Maine as a whole, the conflict between French-speaking Roman Catholics and the diocese was further exacerbated when yet another ethnic Irish bishop, Louis S. Walsh, was appointed to replace O'Connell. The whole story of the controversy that ensued played out at the state level, but Lewiston-Auburn and one of the Twin Cities' most prominent leaders, J.B. Couture, were at the eye of the storm.

Under an 1887 Maine law, the diocese, with the bishop at its head, formed what was called the Corporation Sole. In short, all parish properties belonged to this body, largely as a measure to preserve the good financial credit of its institutions. This model of governance in Maine was antithetical to the model that existed in Quebec, where each parish formed a separate corporation with oversight for its own institutions. Bishop Walsh, in his effort to unify Catholics, supported the division of ethnic parishes in order to create new parishes whose membership was grounded in geographical space, with parishes constituted from adjoining neighborhoods rather than ethnic identity. Despite the fact that Sts. Peter & Paul parish was an exception because Bishop Healy had given it to the Dominicans "in perpetuity," La Cause Nationale took issue with what it saw as an effort to undermine the ethnic identity of Franco-Americans.

In 1909, the standing committee mounted a campaign to repeal the Corporation Sole law in the state legislature and to replace it with a model of

local governance. Bishop Walsh opposed the bill and became the object of fierce attacks statewide in the French-speaking press, *Le Messager* included. In 1911, after the bill's defeat in the state legislature, Walsh issued interdictions against six leaders of the movement, including J.B. Couture. Interdiction was one step shy of excommunication; faithful Roman Catholics were not to associate with the men and the societies to which they belonged. According to one account, the interdiction was announced on the day Couture's daughter received her first communion.[65] However, the bishop's attempt to assert his authority only provoked further derision and resentment and even greater solidarity among Franco-Americans in the face of this attack on their community. The ever-popular editor of *Le Messager* appeared unscathed. He had the support of parish leaders and a general public that did not want to be told what it could or could not read.[66] Couture never reconciled with the bishop, who predeceased him. The interdiction was lifted on Walsh's death.

During this period, the Franco-Americans of Lewiston-Auburn had successfully defended their right to worship in their own French parishes, yet the persistence of the Corporation Sole gave the bishop control of the parish finances and, crucially, the building fund. While the Dominicans raised money for the new Church of Sts. Peter & Paul, the bishop undermined their efforts by splitting the parish into new components and directing funds to the construction of new churches. Each time a new parish was created, the diocese gained ground, extending its control over more of the faithful, and the ambition of establishing the new cathedral-like Sts. Peter & Paul became more distant. The Dominicans had founded St. Louis as a part of their mission, but Bishop O'Connell permitted 400 families to break away from Sts. Peter & Paul in 1902, appointing his own diocesan priest to minister to them.[67] When families in Little Canada wanted their own parish, St. Mary's was established in 1907.[68] Holy Family, founded in 1923, consisted of former St. Peter's parishioners who settled in what was called the Rideout Canton, far from downtown Lewiston. Holy Cross, in the neighborhood of West Rose Hill, was meant to be a multiethnic parish like Sacred Heart in Auburn (founded 1923), but when the 140 Franco-Americans families in it requested a French-speaking priest, it became an ethnic parish. The persistence of ethnic parishes helped reinforce the population's Franco-American identity, but most importantly, each new parish administered its own school, continuing the system of parochial education.

Before construction of the churches, worshippers often used neighboring buildings or, later, roofed-over basements for services. This was even the case for Sts. Peter & Paul, where Masses were held in a building known as the shed

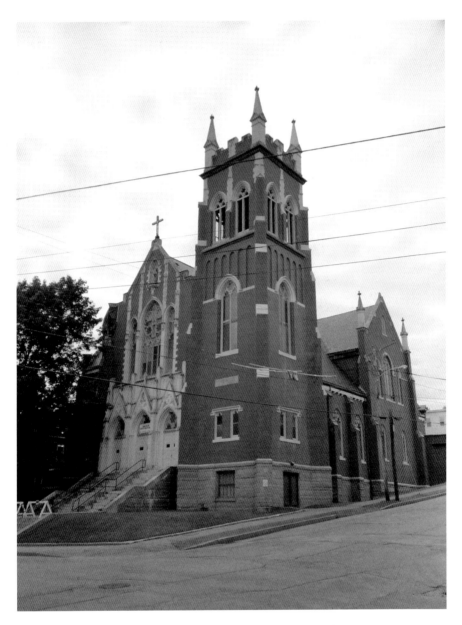

St. Louis Church on Third Street in Auburn. *Courtesy Mary Rice-DeFosse.*

for many years. The new church buildings were consciously constructed in ways that highlighted their French and North American identities. St. Louis Church (1915), and especially St. Mary's (completed 1927), was designed

A Franco-American Belle Époque (1890–1914)

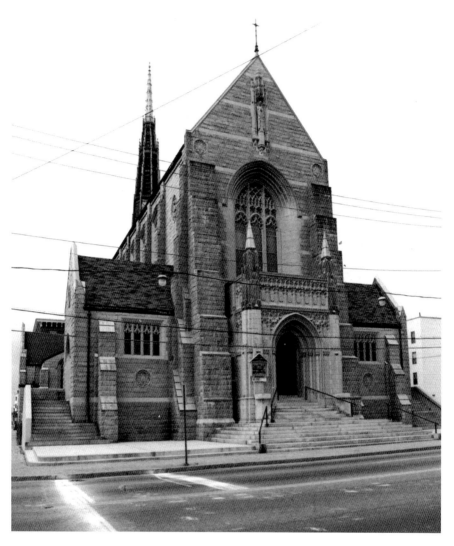

St. Mary's Church on Cedar and Lincoln Streets in Lewiston, circa 1960. *Courtesy University of Southern Maine, Franco-American Collection.*

to resemble the churches of medieval France in Gothic style, with narrow, arched stained-glass windows and tall spires. St. Louis was built of brick, but St. Mary's, constructed of granite, was particularly emblematic of this style. Both were designed by Timothy O'Connell of Boston, who would also design the new Sts. Peter & Paul, but St. Mary's was constructed by a local

Franco-American firm, Lemieux and Chevalier of Lewiston. Among the images in its spectacular stained-glass windows were depictions of the North American martyrs. For St. Louis Church, the unusual decision was made to commission a set of bells from the Paccard Bell Foundry in Annecy, France, funded by donations from the Provost and Dupont families.

French Canadians to Franco-Americans

The immigrant community group was beginning to identify as Franco-American for the first time as members began seeing themselves as both French Canadian and American simultaneously. *Le Messager* was at the forefront of this shift, writing, "We will never be French-speaking Anglos, whatever one of the great men of our country may say, [but] you must stop thinking of us as if we are only passing through…we are starting to want to become American citizens, as is our right." The inducements of Louis Martel and others to their compatriots to naturalize as American citizens was part of this message—"It is possible to become a citizen of the American Republic and remain French-Canadian"[69]—but so was the maintenance of French Canadian and European French customs and culture. This combination of naturalization and cultural survival was labeled *la Survivance* and became the defining philosophy for Franco-Americans in New England through the first half of the twentieth century. They would be both French Canadians and Americans but not ex-patriots. In many ways, la Survivance was simply a continuation of the romantic ideal of a grand French-speaking community across North America. The New England émigrés were the latest branch in a continent-wide family.

Social and Cultural Life

To promote these ideals, Lewiston-Auburn's Franco-Americans created dozens of clubs, societies and fraternal groups to bind the community together and help preserve French language and culture. The foundation of the effort was doubtless the parochial school system, which educated the community's youth in the mother tongue. But adult societies were just as important to la Survivance. Most of the Franco-American societies of

A Franco-American Belle Époque (1890–1914)

Lewiston-Auburn were strictly Francophone, meaning that all club business was conducted in French. There were too many groups for each to be enumerated in detail, but a few examples will serve to demonstrate the breadth of Franco-American culture during this golden age.

The Institut Jacques Cartier, founded in 1872 to rally the community to build the first St. Peter's Church, was the first Franco-American group in Lewiston. The group was a mutual society and therefore used membership dues to offer payments to members' families in the event of sickness or death. As a "national" society, however, it drew its inspiration from other such Franco-American groups. The founding of the institute was prompted by the visit to Lewiston by Charles Lalime, the brother-in-law of Ferdinand Gagnon, who had emerged as the leader of the Franco-American community in Worcester, Massachusetts. As a fundraising mechanism, the institute was hugely successful, and the church was completed by May of the following year.

The group had been founded as the Société St. Jean-Baptiste (St. John the Baptist Society) after the patron saint of French Canadians, but a disagreement between older and younger members led to a split in the group in 1874. Dr. Louis Martel and others formed their own group, which they named the Institut Jacques Cartier, after the founding father of New France. When the rift was healed and the two groups reconciled in 1875, the latter name was kept, allegedly because the institute was equipped with a flag and other insignia bearing its name while the society was not.[70]

St. Jean-Baptiste Day

Following the construction of the church, the newly healed organization turned its attention to promoting patriotism among Franco-Americans. In 1875, it put on the first St. Jean-Baptiste Day (June 24) celebrations in Lewiston, establishing a tradition that would continue for another century. St. Jean-Baptiste Day had been a day of patriotic displays for French Canadians at least since 1834, when the St. Jean-Baptiste Society was established in Montreal. The association of French Canadians with St. John probably goes back to the saint's popularity in medieval France, especially in the west of France, the original home of many early French colonists. Celebrations of St. Jean-Baptiste are recorded among French Canadians as early as the seventeenth century.

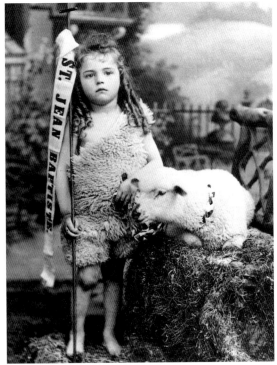

Above: St. Jean-Baptiste Day Parade, 1897. The float is a replica of Jacques Cartier's flagship, the *Grand Hermine*. *Courtesy University of Southern Maine, Franco-American Collection.*

Left: Alfred Auger of nearby East Poland is dressed as Lewiston-Auburn's St. Jean-Baptiste, 1890. *Courtesy University of Southern Maine, Franco-American Collection.*

A Franco-American Belle Époque (1890–1914)

In much the same way as St. Patrick's Day became a rallying point for Irish Americans, June 24 became the focal point of the Franco-American calendar in Lewiston-Auburn in a display that would bring together all the Franco-American groups in the Twin Cities. After Mass at St. Peter's Church, members of the group, accompanied by schoolchildren, would parade through Lewiston and finish the day with a picnic in Auburn. As part of the festivities, one boy from the community was chosen to represent St. John the Baptist, dressed in sheepskin and accompanied by a lamb. Parade floats often depicted scenes from French or French Canadian history—tableaux of the arrival of Jacques Cartier, the evangelization of American Indians and depictions of *voyageurs* and *coureurs de bois* were popular.

The parades were often headed by marching bands. Franco-Americans inherited a rich musical tradition from their French and North American forebears, and in this period, they adapted this affinity to contemporary tastes and for public display. The Association St. Dominique included the

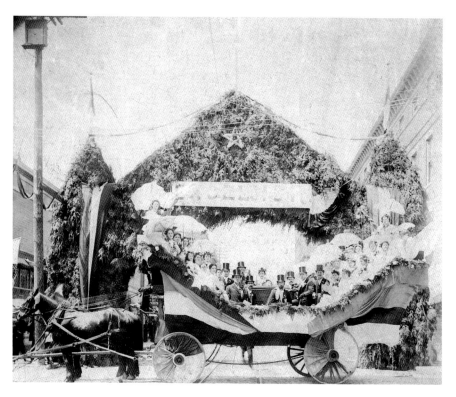

St. Jean-Baptiste Day float, Sts. Peter & Paul's parish choir in Lewiston, 1896. *Center-right*: choir director Henri Roy. *Courtesy University of Southern Maine, Franco-American Collection.*

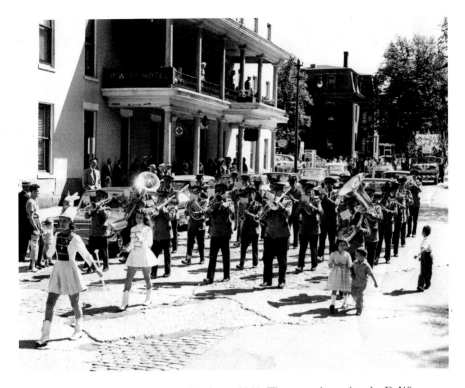

Montagnard Band on Pine Street in Lewiston, 1960. The group is passing the DeWitt Hotel. *Courtesy University of Southern Maine, Franco-American Collection.*

Fanfare St. Dominique, often simply referred to locally as the French Band. The fanfare joined other marching bands in town but was distinguished by its Franco-American makeup. The Association St. Dominique also sponsored a boys' band, the Fanfare Ste. Cécile, from 1897. Both groups marched in parades. They were joined by drum and bugle corps attached to the local snowshoeing clubs (see "Les Raquetteurs" section).

"The Athens of French America"

Music of another kind formed the heart of other groups as well. Le Club Musical-Littéraire was founded on April 22, 1888, in the Dominican Block by a group of young men at the invitation of Henri Roy. Initially known as the Chorale Ste. Cécile, its aim was the study of music. By 1895, it had merged with another group meeting in the same location—the Cercle Crémazie,

whose focus was literature (the club counted among its members both Louis Martel and F. Phileas Vanier, publisher of *Le Messager*). The stated aim of the combined group was "to preserve among us a love of the French language, to maintain the traditions and the distinctive character of our race, and to develop a taste for beauty in our community."[71]

The club functioned not just as a bastion of French language and culture but also as a social group for members, especially young men and women, some of whom began successful stints as authors and actors at the club. The club's biggest achievement was probably its introduction of French-language theater to Lewiston-Auburn. Most of the works they offered to the area's Franco-Americans were local (if not statewide) premieres but became nonetheless popular in the Twin Cities. The club was best known for its comic musical theater.

The club was sometimes seen as an elite institution, the "aristocratic circle of the Franco-American society of Lewiston," as it was described in 1915.[72] However, of its initial members, most held middle-class, white-collar jobs as store clerks, although some were doctors and lawyers. A few were even millworkers or laborers. Thus, the membership was certainly more affluent than the majority of the Franco-American population in 1884, but it was by no means exclusively an elite institution.[73] Nonetheless, a group with an indisputably modest beginning was the Cercle Canadien, formed in 1902 by twelve mill employees in the garret of the third floor of a house at 25 Lincoln Street in Little Canada. Each member was required to bring his own chair.[74]

Both groups owed their success in large part to the talents of Jean-Baptiste Couture, who, in addition to his career as a journalist (see Chapter 1), had a passion for musical theater. He directed most of the productions in the Twin Cities in the early twentieth century, for several different organizations, including the Cercle des Amateurs. He would also found a French radio station in Lewiston, WCOU, above the headquarters of *Le Messager* and go on to serve two terms in the Maine House of Representatives. In 1933, Couture was awarded the French government's highest honor, the Légion d'Honneur, for services to the French language.

The flourishing of theater in Lewiston-Auburn was so successful under Couture's guidance that Québécois historian Robert Rumilly dubbed the city "the Athens of French America" in 1958.[75] In addition to the Cercle Canadien and Club Musical-Littéraire, there were other theatrical groups—the Institut Jacques Cartier had produced a piece called *La Malédiction* in 1874, and the Association St. Dominique also performed plays. The parish sponsored

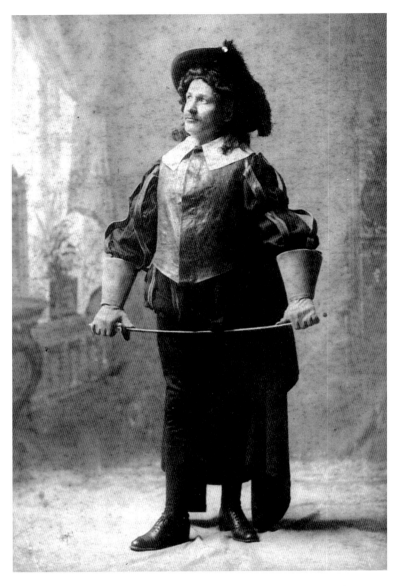

Jean-Baptiste Couture plays the title role in *Fra Diavlo*, Lewiston, 1926. *Courtesy University of Southern Maine, Franco-American Collection.*

another theatrical group, Les Défenseurs, and theater was a component of the curriculum at the parochial schools. Much of the music for musical theater was provided by L'Orphéon, a male vocal ensemble.

J.B. Couture was particularly fond of Goethe's *Faust* (his sons were named Faust and Valdor) and the comedies of Molière. Sentimental melodramas

A Franco-American Belle Époque (1890–1914)

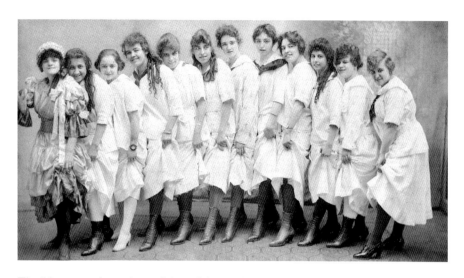

The "sisters, cousins and aunts" from *L'Amour à Bord (HMS* Pinafore*)*, Lewiston, circa 1930. *Courtesy University of Southern Maine, Franco-American Collection.*

were especially popular. *Les Cloches de Corneville* (*The Bells of Corneville*, Robert Planquette, 1878) was a perennial favorite and *La Veuve Joyeuse* (*The Merry Widow*, originally *Die Lustige Witwe*, Franz Lehar, 1905) another. Couture even undertook a translation of Gilbert and Sullivan's *HMS* Pinafore into French (as *L'Amour à Bord*, or *Love On-Board*) in the 1930s. The range of local productions shows that the overriding criterion was not a work's national origin but the French language.

Lewiston had an abundance of musical talent: Sts. Peter & Paul featured a renowned choir of men and women under choir director and church organist Henri Roy. Their repertoire included "works of the Masters" like Masses by Mozart, Cherubini, Beethoven, Gounod and Haydn, as well as works by composers known almost exclusively for religious music such as Lambillotte, Perrault and La Hache. The members of church choirs and their organists also lent their skills to the theatricals. However, the relationship between secular and sacred music was not always straightforward. Couture's productions were purportedly criticized by the Dominicans for their racy subject matter, and he was briefly replaced as musical director for the Club Musical by Roy. Ironically, the production Roy directed, the musical comedy *La Fille du Tambour Major* (*The Drum Major's Daughter*) by Jacques Offenbach, was hardly an exemplar of Catholic morals. The plot revolves around divorce and mistaken paternity while the composer-playwright is best known today for his play *Orphée aux Enfers* (*Orpheus in the Underworld*) and its score,

including a musical number associated with the cancan and its provocative dancers. Roy later admitted to censoring the production for the approval of the Dominicans, an act that allowed him to recruit the women's group Les Enfants de Marie (the Children of Mary) to perform in the production.[76]

Les Raquetteurs

Of all the social and fraternal organizations formed by the Franco-Americans of the Twin Cities, none was as popular, as enduring or as uniquely French Canadian in origin as the *clubs de raquetteurs*, or snowshoe clubs.

Snowshoes had been developed by Native American societies thousands of years before they were observed by the first French settlers in Canada, who labeled them *raquettes* for their resemblance to tennis rackets (a sport very much en vogue in France in the sixteenth century). The utility of the snowshoe in Canada's harsh climate was soon appreciated by the French colonists, especially the *coureurs de bois*.

Snowshoeing became an organized sport in 1840 with the foundation of the Montreal Snowshoe Club; by 1907, the practice had spread throughout Quebec, and in that year some twenty-five clubs united to form the Union Canadienne des Raquetteurs (Canadian Snowshoeing Union).

Snowshoeing found its home in the United States in Lewiston in 1924. Le Montagnard (the Mountaineers), the first permanent American snowshoe club, was organized by a recent émigré from Quebec, Louis-Philippe Gagné. (An earlier attempt to form a Lewiston snowshoe club, Le Trappeur (the Trappers) is recorded in 1884 but was apparently unsuccessful). Gagné (born in 1900) arrived in Lewiston in 1922 from Quebec City, where he had been a sports editor for the newspaper *Le Soleil*. He came to Lewiston to work for *Le Messager* and would proceed to become its editor in due course. Indeed, Gagné would be one of the more prominent Franco-Americans of his generation in Lewiston-Auburn, serving as mayor of Lewiston from 1947 to 1948 and becoming well known for his weekly newspaper columns and radio show.

However, upon his arrival, Gagné's passion and energy were directed first at snowshoeing. Gagné had been an enthusiast in Quebec and set about organizing a club in Lewiston. Le Montagnard took its name from a noted club in Montreal and received its modest collection of first uniforms from its sister club. Even as the organization was in its infancy, however,

A Franco-American Belle Époque (1890–1914)

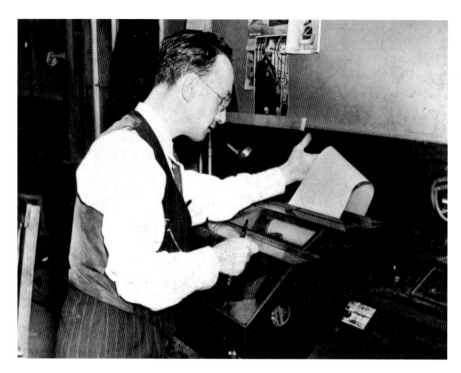

Louis-Philippe Gagné receives a news wire at the offices of *Le Messager*, Lewiston, circa 1940. *Courtesy University of Southern Maine, Franco-American Collection.*

Gagné's ambition reached further. He proposed that the Lewistonians invite the Canadian *raquetteurs* to a convention the following year, which became the first ever international snowshoe convention, held in Lewiston, on the weekend of February 7–8, 1925.

The decision to host the convention was controversial, and Gagné himself later admitted to manipulating the vote.[77] Despite any misgivings from his fellow snowshoers, and fears from some in the city that Lewiston was not equipped to host such a large gathering, the convention was hailed as a great success. Over eight hundred visitors from Quebec arrived via the Grand Trunk on specially chartered trains, vastly outnumbering the American contingent, which numbered, at most, a few dozen. The visitors were greeted by the mayor of Lewiston, Louis Brann, and the governor of Maine, Owen Brewster. The program included a mock attack on city hall by the Canadians, followed by the firing of "cannon" in its defense by the hosts. The "attack" forgiven, the snowshoers held races in 100-, 220-, 440- and 880-yard runs, as well as a three-mile run and three-mile walk, in City

Park in the afternoon. Later conventions would include more innovative contests, including hurdling. After a baked bean supper at the armory, there was another "attack" by the Canadians, this time against the ice palace that had been constructed in the park:

> *The evening was featured by a parade and a fireworks exhibition in the ice palace on city park, the like of which was never before seen in this city, if in any Maine or New England city. The spectators thronged the streets and stood about the city park, completely surrounding the ice palace, forming a mass at least of 100 deep. In fact, so many were on the streets that it almost seemed as if every person in the town able to get outdoors was on the scene.*[78]

The 1925 convention was held during the Prohibition era in the United States, but the *Lewiston Daily Sun* made clear that the snowshoers had little respect for the legislation. Describing the weekend as a "Mardi Gras," the *Sun* called the festivities "a revival of the pre-Volstead days" (the Volstead Act was the piece of congressional legislation that enforced the Eighteenth Amendment and outlawed the sale of alcohol) and gave examples of the

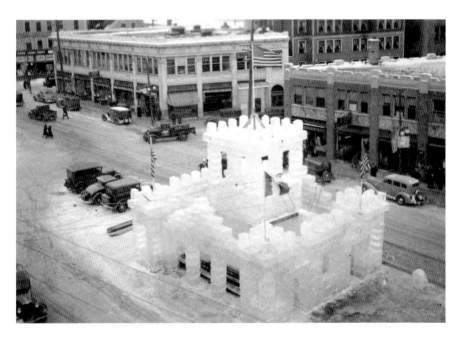

Ice palace on Main Street in Lewiston, 1926. The ice palace was typically located in City Park. *Courtesy University of Southern Maine, Franco-American Collection.*

A Franco-American Belle Époque (1890–1914)

Canadians, if not the Americans, finding something to fill their flasks. The effects were also clearly described. There were amorous scenes described as being reminiscent of a "mutual petting party" and pranks that included false fire alarms, streetcars lifted off their tracks, joy rides taken in hearses and women's lingerie worn as headgear. Despite such antics, the review of the paper was positive—"visitors found girls 'safe and sane and kind for gentlemen to handle,'" ran one headline, and "'fun for all and all for fun' is the snowshoers' motto," read another.[79]

The success of this 1925 convention led to the formation of more snowshoe clubs in Lewiston—among which was Le Diable Rouge (the Red Devil). The Institut Jacques Cartier and the Cercle Canadien also created snowshoe teams, forming the other founding members of the American Union in 1925. Lewiston remained the spiritual home of snowshoeing in the United States, even as the movement expanded to Franco-American communities throughout New England, and numerous other conventions

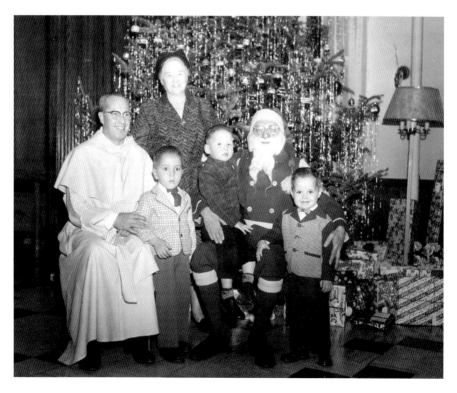

Christmas at the Healy Asylum in Lewiston, circa 1950. Santa Claus was played by Fernand Despins in his Diable Rouge snowshoe uniform. *Courtesy University of Southern Maine, Franco-American Collection.*

Snowshoers in Lewiston's City Park, circa 1930. *Left*: Arsène Cailler, Lewiston's first Franco-American police chief. *Courtesy University of Southern Maine, Franco-American Collection.*

were held in the city, both national and international. By 1979, there were thirty-four American clubs and more than two thousand members. At one point, Lewiston alone had more than a dozen clubs.

As the reports of the 1925 convention make clear, snowshoe clubs were more than simply athletic associations, and they acted more as social groups, meeting year-round. Many clubs had lakeside chalets outside the city from where they would embark on their hikes but also maintained downtown clubhouses on Lisbon Street. Like other organizations of the time, many of the clubs were initially open only to men. Some groups opened women's auxiliary branches, like Les Dames Montagnards, but women's clubs, such as la Gaîté and l'Oiseau de Neige (the Snowbird), were also formed. The continued tradition of the conventions helped cement the relationship between Franco-Americans and Canada, and the snowshoe clubs continued to conduct all their business in French into the late twentieth century.

The snowshoe clubs also embraced music. Snowshoe conventions included a parade of the participants in full uniform through Little Canada and along Lisbon Street, and the club members marched to the music of their bands.

Most clubs developed their own drum and bugle corps for this purpose. The Montagnard Band was featured in the 1957 movie adaptation of the novel *Peyton Place* (coincidentally written by Franco-American author Grace Metalious). In 1959, Bert Dutil and other members of the Passetemps (Pastime) drum and bugle corps founded an independent marching band, the Pine Tree Warriors, in order to perform year-round. The group became well known and performed across the country and in Canada. According to Dutil, the band's appearance at the 1967 Montreal World's Fair caused a stir as the audience was startled to see an American group taking orders in French.[80] The Pine Tree Warriors also performed at the U.S. bicentennial celebrations in Washington, D.C., in 1976.

"A *CANADIEN* VICTORY"

The final pillar in the Survivance movement that emerged in this period, alongside economic success, community spirit and cultural vibrancy, was political power. In order for Franco-Americans to resist assimilation into the Anglo-Yankee vision of New England, they had to be able to wield influence in city hall and at the statehouse. Both the push for naturalization and learning English helped achieve this goal.

It is no coincidence, therefore, that the first elected Franco-American official in the Twin Cities, Léon Lefebvre, became alderman for Lewiston's Ward 6 in 1880, the same year that *Le Messager* was founded. Ward 6, which contained part of Little Canada (from Cedar Street southward), was a natural constituency for a Franco-American politician. However, the continued immigration of French Canadians to the cities, and especially the coming of age of Franco-Americans born in the United States (and thus endowed with citizenship from birth), meant that politics of Lewiston soon came to be dominated by Franco-Americans. (Auburn's Franco-American population remained proportionally smaller than Lewiston's, and the community's political influence there was consequently less. Auburn did not possess a Franco-American mayor until Rosaire Hallé was elected in 1947). By October 10, 1921, *Le Messager* could proclaim the following (original capitalization):

> *Today, a mere forty years after our first success, we have reached, so to speak, the pinnacle of political life in our city and our county. We comprise almost 4,000 voters and more than three-quarters of the municipal offices*

are occupied by Franco-Americans, who are GOOD AMERICANS, but who speak French perfectly and who are not ashamed of their Canadien *or French origins…over the past ten years, more or less, our progress here has been nothing short of gigantic, and now, our nationality has been elevated to the highest political and social level yet reached by Franco-Americans in any city in New England.*[81]

Early Franco-Americans officeholders in Lewiston included Louis Martel, who was a state legislator in 1884. Franco-Americans were elected to the offices of first alderman (P.X. Anger in 1887), city clerk (François-Xavier Belleau in 1890) and even state senator (Albert Morneau, 1912), but the mayor's office proved elusive, even to Martel, who ran in 1894. Achieving the symbolic victory of leading the city of Lewiston would instead fall to a protégé of Martel, Dr. Robert Wiseman, in 1914.

Wiseman is often hailed as Lewiston's first Franco-American mayor;[82] however, his story is an unusual one of cultural adoption since he was born to Scottish and Irish parents. However, Wiseman was born in Stanfold (now Princeville), Quebec (in 1871), and his parents educated his older sister in the local French-language school.[83] Robert immigrated as an infant to Lewiston in 1873. Both his parents died within a few years, and he spent a short period living with a sister in New Hampshire. On returning to Lewiston, he married a Franco-American, Rose Cyr, and thereafter apparently became an active member of that community. He and his family initially lived on Cedar Street in Little Canada.[84] The Wiseman family attended Sts. Peter & Paul Church, and Robert was a member of many Franco-American organizations, including the Institut Jacques Cartier. After graduating from Bowdoin Medical College in 1903, he followed in Martel's footsteps in becoming a surgeon at St. Mary's Hospital. Only one Franco-American mayor had previously been elected in the state—Albert O. Marcille of Biddeford (1910–12). *Le Messager* announced Wiseman's victory with the headline "C'est une Victoire Canadienne" ("It's a *Canadien* Victory") and stated that it was the first time in the history of the city that Franco-Americans had elected one of their own as mayor. Despite predictions that "Americans" (i.e., Yankees) would either stay away from the polls or vote against him, Wiseman won not only the heavily Franco-American wards of the city but also some with Yankee majorities.[85] Wiseman's ancestry and name may have assisted him in capturing the votes of Yankees wary of endorsing a "French" candidate. However, it's easy to see why Wiseman was seen as the Franco-American candidate despite the Anglo façade. He gave campaign speeches

in French, as well as English, and was endorsed by *Le Messager*, in which he placed advertisements appealing directly to Franco-Americans. On the eve of the election, his supporters marched from the Dominican Block to city hall, led by the Fanfare St. Dominique.[86] *Le Messager* confidently predicted that the coming together of "Canadien" and "American" interests in Wiseman's campaign would signal a new era in Lewiston politics, a statement that would turn out to be prophetic.[87] After serving a single term (declining to run for reelection), Wiseman would be followed in office by Charles Philip Lemaire (1917–20), and Franco-Americans would come to dominate the office from then on. From 1932 until 1970, each of the twenty mayors of Lewiston was a Franco-American. Wiseman himself would serve a record nine one-year terms and remain a well-known and popular figure in the community. Wiseman was first elected on a fusionist Republican-Progressive Party ticket but later returned to the Democratic Party, which had first nominated him in 1911. By the 1920s, once the Democrats had embraced the progressive philosophy, Franco-Americans, like Catholics nationwide, would prove to be stalwart party supporters. Well into the twenty-first century, a French surname would be an electoral advantage in Lewiston.

3
Hard Times (1914–1941)

If decades around the turn of the twentieth century composed a golden age for the Franco-American community, the following interwar years might be described as a silver age. Although these decades saw a continued cultural flourishing and political ascendancy, this period was also one in which the Franco-Americans of the Twin Cities came under increased pressure from a number of outside forces. The local and national economies were struggling, and anti-immigrant feeling was on the rise, and on top of these were added natural disasters. The community endured, partly due to the strong foundations it had laid in the preceding decades, but it was not unchanged. This era saw a hardening of the Survivance movement while Franco-Americans of a new generation found pathways that allowed them to follow their dreams while retaining their core identities.

Fire and Flood

One illustration of the difficulties faced by the Franco-American Community in this period can be found in a description of Little Canada in 1917. A report in a Franco-American newspaper, the short-lived *Petit Journal*, led to an investigation of conditions in the neighborhood by the *Lewiston Evening Journal*. The *Evening Journal*, while refuting allegations made by the French paper that the district was "the filthiest and most dangerous district of Lewiston," noted

the great fire hazard presented by the close-packed wooden buildings of four and five stories, many of which had inadequate fire escapes or lacked them completely. The danger of fire was all the more acute because of the large number of people living in the neighborhood (2,200) and the narrowness of the streets, which would prevent a fire truck from reaching any blaze.

Most emblematic, however, of the cities' neglect of the Franco-American population was the proximity of Little Canada to the Lewiston City Dump and, on the opposite side of the river, the location of another dump near New Auburn. The *Evening Journal* article describes children playing among the trash, and the smell of the refuse permeated the entire district.[88]

Fears of a great fire in Little Canada were to prove unfounded, but a conflagration did erupt many years later in New Auburn. As predicted, the tightly arranged wooden buildings burned quickly. On the afternoon of May 15, a fire broke out at the rear of Arthur Pontbriand's garage at 12 Mill Street. With the help of a stiff breeze, the blaze spread across four blocks, eventually making 2,167 people in 442 families homeless and causing damage estimated at $2 million.[89] St. Louis School was gutted by the fire, although the convent and church survived. New Auburn was primarily inhabited by millworkers, and the majority of the

The Dupont Bakery in ruins after the New Auburn fire, 1933. In the background is St. Louis Church. *Courtesy University of Southern Maine, Franco-American Collection.*

Hard Times (1914–1941)

Lincoln Street (near the intersection with Cedar Street) in Lewiston during the Androscoggin flood of 1936. *Courtesy University of Southern Maine, Franco-American Collection.*

business owners and residents displaced by the fire were Franco-American, although Auburn's Jewish community also had a presence in New Auburn (the Beth Abraham Synagogue was another survivor of the blaze). Among those businesses destroyed was the Dupont Bakery, located at 49 Second Street.

New Auburn and Little Canada were both assailed less than three years later with the Androscoggin River flood of 1936. This flood, the worst in recorded history for the river, caused hundreds of millions of dollars' worth of damage along the river's course in New Hampshire and Maine. Locally, the floodwaters destroyed the South Bridge joining Little Canada to New Auburn.[90] Three hundred families were made homeless in the Twin Cities, and the majority of these were Franco-Americans from the two riverside neighborhoods.[91] Many homes were either under water or even washed away altogether.

The Great War

The outbreak of the First World War in 1914 placed Franco-Americans in an unusual position. The conflict laid bare their multiple identities and

loyalties engendered by their ancestral roots and adoptive homelands—to France, French Canada and the United States. While the three groups would eventually be fighting side by side in the trenches, the situation, especially in 1914, was not so clear-cut. The United States did not enter the war until 1917 while many French Canadians in Canada opposed the war and resisted the Anglo-Canadian government's calls to enlist.

Zépherin Lessard, who was born in Limeton, Quebec (1883), but was a resident of Lewiston, was visiting relatives across the border in 1917 when he was stopped by officials looking for draft dodgers. As Lessard wrote home to his father, "They caught me with no papers on me and they left me no choice but to enlist." However, he took his enforced enlistment philosophically. "I don't care, because I would have had to join the [U.S.] Army later anyways," he concluded.[92]

Lessard's experience demonstrates the difficulty of inhabiting multiple worlds in a time of war, but it is also indicative of the differences between Franco-Americans and their French Canadian cousins. Plenty of Franco-Americans volunteered to enlist once the United States entered the war. Among them was Albert Béliveau, (1883–1971), a Lewiston native who moved to Livermore Falls and then Rumford as a child. There he became a

The funeral of Edmond Leblond, reportedly the first local Franco-American to be killed in the First World War, at St. Louis Church in Auburn, 1918. The undertaker was Louis Poisson. *Courtesy University of Southern Maine, Franco-American Collection.*

lawyer and, in 1917, enlisted in the U.S. Army. On account of his profession and his bilingualism, he was commissioned as a lieutenant in the surveyor general's office. He served in France, resolving legal disputes between landowners and the French government occasioned by the war.[93] According to a contemporary source, more than half of those who served in the U.S. Army were Franco-Americans.[94] If accurate, this means that Franco-Americans in the Twin Cities signed up in numbers that were at the very least in proportion to their share of the total population and probably in greater numbers.

Un-American

However, the American patriotism exhibited by many Franco-Americans during the war was not universally recognized. In fact, nationwide, the First World War and the Russian Revolution of 1917 became catalysts for widespread anti-immigrant feeling, and the Franco-Americans of Lewiston-Auburn felt this as well. In the early hours of the morning of August 10, 1924, residents of Lewiston-Auburn were awakened by the sound of an explosion loud enough to rattle the windows in nearby houses. Looking out of their windows, they would have been able to see a twelve-foot-high burning cross, the symbol of the Ku Klux Klan, atop David's Mountain, the highest point in the Twin Cities. The Klan was celebrating what would prove to be the height of its success in Maine—the nomination of its preferred candidate, Ralph Owen Brewster, for the Republican Party's gubernatorial ticket.[95]

By 1924, the Klan had become a powerful political force in Maine, and although its numbers are hard to estimate (historians have suggested there were anywhere between 15,000 and 200,000 members and supporters), the Maine Klan was thought to be one of the largest in New England, if not anywhere outside the former Confederacy.[96] While best known as a white supremacist organization, the Klan targeted not only African Americans but also anyone it thought of as un-American—including immigrants and Catholics. Maine's large Franco-American population was therefore a prime target.

It is difficult to know exactly how popular or influential the group was in Lewiston-Auburn, but in addition to the early morning explosion of August 10, evidence of the Klan's presence in the Twin Cities can be seen in the newspaper reports of Klan meetings, which were regularly described as having large crowds. The first meeting of the KKK in Lewiston-Auburn

was held on March 21, 1923, and at a subsequent gathering, the names of prominent Klansmen were revealed and reported in the local press. They included the ministers of several local protestant congregations.[97] Members of Lewiston's police force also attended meetings, with the sanction of the police chief.[98] On September 7, 1923, the *Boston Herald* reported that Lewiston and Auburn were each home to one thousand Klan members. It seems likely that the Klan was stronger in Auburn, whose population was more Yankee, more rural and more Republican. The charter of the Androscoggin Klavern (local branch) survives and indeed indicates that of the officers, at least, most were residents of Auburn rather than Lewiston. Additionally, they appear to have been Yankees to a man, of families with roots in Maine and primarily working class.[99]

Unlike elsewhere in the country, the Maine Klan is not known to have waged a campaign of violence but rather one of political influence and intimidation. The Klan's impact in the Twin Cities appears to have been limited, especially in Lewiston, where the Franco-Americans in city government were able to block the group's activities. For example, the Klan was denied the use of Lewiston's city hall for its events and held meetings in fraternal organization halls instead.[100] Indeed, statewide, its success was short-lived, and the group was in decline by 1926. However, the KKK's activities were emblematic of wider trends at a national and local level—an anti-immigrant feeling that manifested itself in several other ways.

State Language Laws

Where the KKK enjoyed electoral successes in Maine, notably in the election of Governor Brewster in 1924, it was on a platform of "defending" the public school system and opposing the parish schools. As Eugene Farnsworth said at an Auburn meeting of the group: "The nigger, the Jew, the Catholic, all spend their money with themselves…if they are teaching Americanism in Parochial schools they are false to Rome. If they don't they are false to America. The time will come when every child in America must and will attend the public schools."[101]

While the Klan and some Maine Republicans aimed to prohibit parochial schools from receiving public funds and, eventually, to eliminate them entirely, they did not succeed in doing so. Where they were more successful, however, was in making English the only language of instruction. In 1919,

Hard Times (1914–1941)

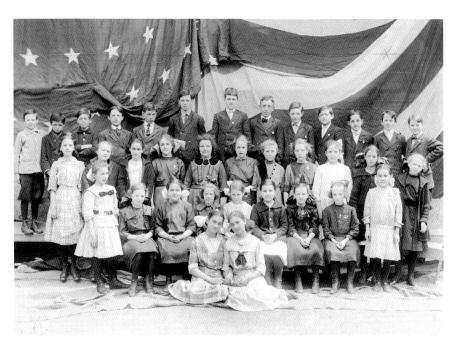

St. Peter's School, class of 1910. Note the use of "The Star-Spangled Banner" in a Franco-American parochial school. *Courtesy University of Southern Maine, Franco-American Collection.*

the Maine state legislature passed a law prohibiting children and teachers from speaking French in public schools.[102]

This law, which was repealed only in the 1960s, was part of a nationwide Americanization program for immigrants to the United States (similar laws were passed in Louisiana and other New England states) and was part of the same agenda as the Klan's efforts to remove Catholics from local school boards. Pressure for Franco-Americans to lose their language came from Yankee society at large. Faust Couture, Jean-Baptiste's son, remembered as a child in the 1910s being reprimanded by a stranger for addressing his aunts in French. He was told, "Speak American, you little bastard."[103] Further action by the state legislature reinforced the assimilatory drive—an amendment to the state constitution that made voting contingent on passing a literacy test. This provision, enacted in 1891 as Chapter 109, stated, "No person shall have the right to vote…who shall not be able to read the Constitution in the English language and write his name."[104] The efforts of leaders in the Franco-American community like Martel to offer English classes to new arrivals blunted the effects of this law in Lewiston-Auburn. However, the law was an important statement by the political elite.

The Maine Law

Nationally, the post–World War I years were characterized by the passage of the Eighteenth Amendment to the U.S. Constitution, which banned the "manufacture, sale, or transportation of intoxicating liquors" and ushered in the era of national Prohibition. The passage of the Volstead Act arose from a number of national concerns, including a moral resurgence and the need to address domestic violence, but it was also a law that was seen as being anti-immigrant—specifically, anti-Catholic (in fact, temperance was a key plank in the Klan's platform). In much of the country, the law was supported precisely because it would ruin the brewing industry, dominated by German Americans, and reform the supposed drunkenness of Irish Americans. Those same suspicions extended to Franco-Americans. On the opening of St. Peter's Church, a Yankee visitor pressed Father Hévey to confirm that he preached against drunkenness and the consumption of whiskey.[105] Maine, in fact had been a leader in the temperance movement, becoming the first dry state in 1851. The Prohibition law became known as the "Maine Law." A riot in Portland, led by Irish immigrants, in 1855 led to the law's repeal in 1856, but it was reinstated as an amendment to the state's constitution in 1883. The unpopularity of the law among Franco-Americans in Lewiston-Auburn can be seen in the account of the 1925 Snowshoe Convention (see Chapter 2).

Franco-Americans' status as a border people made them perfect "bootleggers"—smugglers of illicit liquor from Canada to the United States. Many of them had relatives across the border and traveled to and fro regularly. Additionally, Maine's border with Quebec was long and impossible to police heavily. In the west, the region was mountainous and densely forested, and in the north, the Francophone communities on either side of the border were so oblivious to geopolitical niceties that settlements and even buildings frequently straddled both countries.[106]

Alcohol was also produced in Lewiston, particularly by immigrants (of all ethnic groups). Anthony Karahalios (born in 1919), a Greek American, described a network of bootleggers throughout the city: "They used to have car loads of grapes come in…you had a lot of bootleggers going on. And the areas where the Irish bootleggers were from Main Street to Cross Street, and the French bootleggers took over all the way to Cedar Street. The Irish, and the English took over again down in the River Road…most of the people made wine."[107]

One known example of a Franco-American rumrunner was Albert Ducharme of Lewiston, whose family, including his father and brother,

Hard Times (1914–1941)

A beer advertisement from a Quebec snowshoe club. Lewiston's Jacques Cartier Club "acquired" this during a visit. *Courtesy University of Southern Maine, Franco-American Collection.*

transported illicit alcohol produced on both sides of the border. His daughter recalled that the revenue this activity brought afforded the family a relatively comfortable living during the Depression. The Ducharmes spent summers vacationing—as the children saw it—at camps in Maine and Canada (in fact, the men in the family were collecting shipments). This lifestyle ended abruptly, however, when Albert was caught in Lévis, Quebec, and jailed in Canada for five years. He was released on compassionate grounds only when his wife died, leaving his children potentially parentless. Upon his return, and with the end of Prohibition, he ran a bar in Auburn.[108]

The Elbridge Jacques Murder

A seamier side of the Prohibition era in Lewiston-Auburn comes to light in the 1931 murder of Elbridge Jacques, the Franco-American proprietor

of Jack's Taxi who operated from a stand at the corner of Lisbon and Pine Streets. A call came in on Wednesday evening, October 21, 1931, to both the taxi stand and Jacques' home around 7:40 p.m. requesting a "taxicab" at the upper railroad station. Locals would have said only "taxi." A little while later, Jacques let his wife, Lottie, know that he had to make a trip that would take forty-five minutes, but he never returned. Lottie contacted the police; when questioned, she indicated that she thought bootleggers had killed her husband but later denied having made the allegation. The taxi was reported as found on River Street in Little Canada. There was blood inside. Witnesses, including a patrol officer, reported sighting the vehicle earlier that evening with three male passengers.

On the evening of March 12, 1932, a collie on the Gurkdounis farm in the neighboring town of Webster (present-day Sabattus) brought a part of a human leg and foot, still in a sock and shoe, to his master. A search produced the badly decomposed remains of Jacques, which had been buried in mud, ice and branches. An autopsy determined that Jacques had died of blunt force trauma to the head with a weapon the size of a pint bottle. His skull had been fractured, as was his jaw.

Shortly thereafter, François "Frank the Pipe" Lachance, another Lewiston taxi driver, was arrested in Quebec and charged with the crime. The alleged motive was the theft of three dollars. Lachance admitted he had been in the taxi that night with another man, a woman and "an Irishman" but reported that he was in the front seat of the taxi and Jacques' left-handed assailant was in back. He also admitted driving the taxi back to Little Canada. Lachance later confessed to manslaughter and was sentenced to eight to sixteen years in prison. The judge praised Lachance's attorney, A.F. Martin, for his representation of the defendant. The prosecuting attorney for the county was Harold L. Redding, who later wrote up the story for a detective magazine, *Dynamic Detective*.

The official story has many inconsistencies but none more glaring than the possibility that Lachance, who was slight in build, could have single-handedly killed the brawny taxi man and dragged his body from the vehicle to the spot thirteen feet from the road where it was found. According to family lore, Jacques was shot in Franklin Pasture, where his taxi was discovered, not in Little Canada.

No one in Jacques' extended family was especially surprised to hear he had disappeared. The "boys from Boston" had warned Jacques to stop transporting bootleg liquor on their turf, but that did not deter the big, burly taxi man. He and his wife were well fed and well heeled. Besides, not only

did he pay local law enforcement officers, but they were also allegedly some of his best clients.[109]

In contrast to the matter-of-fact version of the Jacques family, news reports about the case in English and in French are full of high drama: colorful local characters like Bruno "Peewee" Albert, wanted for police questioning; a group of three strangers, one with a bandaged head, talking by the river where the taxi was found; beer houses in Sabattus; mysterious sedans with Massachusetts plates; a raid on a bootlegging operation at Danville junction; testimony from a dentist and a cobbler; traffic in illegal liquor in New Auburn and Little Canada; and a troubling conflation of poverty and criminality.

LA SURVIVANCE

The Survivance movement, designed to protect the language, faith and cultural identity of Franco-Americans, grew stronger in the face of discrimination and pressures to assimilate. On the frontlines of this battle for the souls, hearts and minds of Franco-Americans were the national parishes and their schools, which remained bilingual. *Le Messager* continued its defense of the French language, but the language in question became that of the local population. Editorials attacked "the stupid legend of Parisian French" and promoted pride in the French presence in North America.[110]

A prime example of the complexities of the Survivance movement and its relationship to France is the visit of the French ambassador to the United States, renowned poet and playwright Paul W. Claudel, to Lewiston-Auburn in 1930. Claudel was invited to the Twin Cities by the Lewiston chapter of the Union Saint-Jean Baptiste d'Amérique, a regional association of Franco-American national societies. The welcoming committee included the officers of the USJB, as well as local leaders in the Franco-American community—Robert Wiseman, Charles Lemaire, J.B. Couture and F.X. Marcotte, among others.

Claudel was well aware of French-speaking communities in the United States. He had made a point of visiting Louisiana and the Cajun and creole communities there; indeed, as early as 1893, while serving as the regional vice-consul for the French government, he had already visited the Twin Cities. In 1930, the ambassador was greeted with due pomp and circumstance and invited to tour all the major Franco-American institutions of the city, from St. Mary's Hospital to the churches. At a reception at city hall, in which he was greeted by the Fanfare Ste. Cécile and a so-called color

guard of children from the Healy Asylum, Claudel recognized the children as "a new crop of French for the future." Father Gauthier, the pastor of St. Mary's, assured the ambassador that he was "not in a strange country here [but] in Old France."[111]

These references to "Old France" were part of the Survivance narrative, which defended the different customs and language of Franco-Americans by emphasizing the so-called purity of these traditions and their basis in the France of the Ancien Régime, the name given to French society before the French Revolution. On the occasion of the ambassador's visit, *Lewiston Evening Journal* reporter Charlotte Michaud, herself an amateur poet, was granted an interview with Claudel. Her interview was, to some Franco-Americans, notable for one question in particular. Asked whether he agreed with the assertion that the local French dialect was in some way inferior to his own speech, Claudel replied that the difference was no greater than regional differences found within France itself—an answer that was a great vindication to many.[112]

La Jeune Franco-Américaine

Another powerful example of the discourse of la Survivance comes in the unlikely form of a romance novel written by a young woman of twenty-five and published by the press at *Le Messager* in 1933. Alberte Gastonguay wrote her romance novel, *La Jeune Franco-Américaine* (*The Young Franco-American*) in 1931, dedicating it to her deceased parents. It was only a year before Gastonguay's own marriage to Joseph Sasseville, another Lewiston native. The novel is the story of Jeanne Lacombe, a fictional descendant of the Carignan family who must find the proper husband in a society full of men of foreign heritage and faith. The discourse of the Survivance movement marks the text from beginning to end and gives readers a clear sense of the values preached to young people in the 1920s and '30s. Jeanne must never forget that "the blood of heroes proud of their faith" flows through her veins, for her ancestors proved themselves worthy in the eyes of God on both sides of the Atlantic.[113] It is no coincidence that Jeanne's namesake is Joan of Arc (Jeanne d'Arc), the medieval French heroine newly canonized in 1920, when Gastonguay was fourteen. Saint Joan had preserved France from English domination, a theme that resonated well among French-speaking Catholics surrounded by the dominance of the English language and its speakers.

Hard Times (1914–1941)

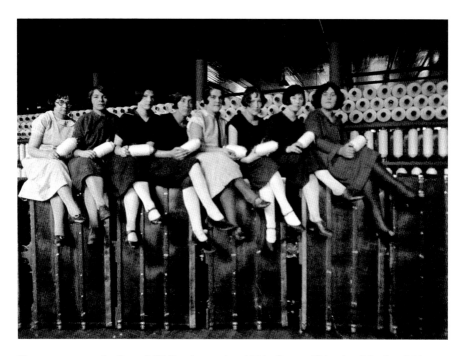

Young women at the Bates Mill, Lewiston, circa 1920. *Courtesy University of Southern Maine, Franco-American Collection.*

The novel makes clear that Jeanne is a modern, independent young woman. She is bilingual and has graduated from college, attributes that eventually help her land a prestigious position in a library in New York City. Jeanne must continually define herself as a Franco-American woman, in large part by resisting liaisons with men of other faiths and backgrounds who are not worthy of her "race," as it called in the novel. The term is significant for it shows to what extent Franco-Americans, who had been marked as racially different by groups like the Ku Klux Klan, took up a similar discourse in rebuttal. Gastonguay's work makes it clear that racial and moral purity are as important to Franco-Americans as to people who denigrate French-speaking Roman Catholics as inferior. Nevertheless, Gastonguay does not paint all people who are different with the same brush, nor does she condemn them. Her heroine is a forward-looking young woman who, despite her father's concerns, thrives in the American context where she meets people of many nationalities. Still, it is not surprising that the morally corrupt characters in the novel are never of French blood or faithful Roman Catholics. In the end, Jeanne and her husband, the son of a French woman and an American man, are able to create a family unit that is at once Franco and American.

Franco-American Dreams

If there is a single factor that most contributed to the community's success in resisting pressure to assimilate in this period, it is probably the investment in its parochial schools. Upon the founding of each parish, a school staffed by nuns followed. Classes were taught in French for at least half the day, but English was also taught and sometimes lessons were duplicated in both languages.[114] Many French Canadian immigrants, boys and men in particular, had to go to work on farms or in logging camps before they completed schooling beyond the sixth, seventh or eighth grade.[115] However, some of these first-generation Franco-Americans placed a particularly high value on education, not only as a means to work their way up the social ladder but also as a form of self-fulfillment.

Thomas Grenier came to Lewiston-Auburn in about 1921 at the age of twenty because he was frustrated that he could barely survive on the family farm in Quebec, even with seasonal work as a log driver. He moved from work in grocery stores to the shoe shops and then married a fellow shoe shop worker, Bernadette Gouletborn, in Somersworth, New Hampshire. The newly married couple moved to Boston, Massachusetts, where work in the shoe industry was plentiful. While there, Thomas earned his high school diploma (Bernadette, although never credentialed beyond the eighth grade, was an avid reader and lifelong learner in both French and English). The Greniers returned to Lewiston in the '30s and raised eighteen children, all of whom attended parochial schools. One of the youngest of their children, Ginette Grenier Gladu, remembers the importance the family placed on education: of the eighteen, half went to college, including schools like Assumption College and the College of the Holy Cross, both in Worcester, Massachusetts, a city with a high concentration of Franco-Americans. Among the Grenier children there were many nurses, a doctor and an astrophysicist.[116]

As such Franco-Americans moved up the economic ladder, some chose to send their children not to public high school but to preparatory schools in Canada like those that had produced some of the community's most important doctors and civic leaders in the previous century. This strategy was not simply a matter of Survivance in terms of faith and language, but also an economic decision. The *collèges*—not colleges in the American sense but secondary schools that prepared students for university training in specific fields—offered a broad liberal arts education via the *cours classique* that was far less costly than their American counterparts. They included

Hard Times (1914–1941)

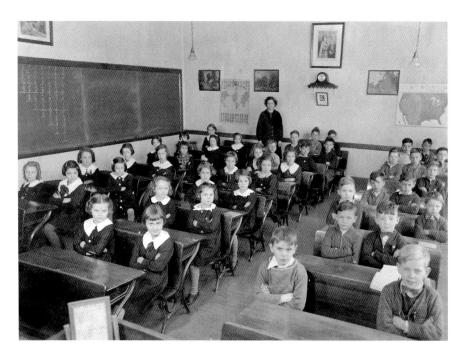

St. Peter's School, fourth grade, Lewiston, 1937. *Courtesy University of Southern Maine, Franco-American Collection.*

study of Latin, Greek, French literature, philosophy and religion, among other subjects. Longtime Lewiston resident Dr. Lionel Tardif Sr., a native of the Petit Canada in Manchester, New Hampshire, gave cost as the primary reason he went to a *collège* in Trois-Rivières, Quebec.[117]

The story of Armand Dufresne Jr., an Auburn native who rose to become the chief justice of the Maine Supreme Judicial Court, illustrates the ways in which Franco-Americans were able to succeed in mainstream America while fully retaining their cultural heritage. Born on January 7, 1909, Armand Dufresne Jr. was the eldest son of one of the first-generation entrepreneurs in Auburn, Armand Dufresne Sr., who started his career as a baker at the Dupont Bakery in New Auburn. Armand Sr. later became co-owner of the Maine Baking Company in Auburn.

Judge Dufresne's story illustrates many of the classic pieces of the Franco-American experience.[118] His paternal grandfather was a farmer in Lévis, Quebec, whom he barely knew, since the elder Dufresne died prematurely. His father was a younger son and immigrated to find work, becoming a baker with the Walton and then the Dupont Bakeries. Armand Sr. was a master baker and decided to open his own enterprise, considering opportunities in

Livermore Falls, Maine; Newburyport, Massachusetts; and Saskatchewan, where he had an older brother. He followed the most promising opportunity and moved his family to Massachusetts, where Armand Jr. attended an English-language parochial school while still speaking French with family and friends. The family returned to Lewiston in 1922, and Armand Sr. went into partnership with his brother-in-law, Philippe Couture, in the Maine Baking Company. Judge Dufresne called the move a kind of "miracle." He would never have attended college without a scholarship from the Union St. Jean Baptiste; in Maine, there were several awarded scholarships as the result of testing, but in Massachusetts that year, there was only one and much more competition from Franco-American population centers like Worcester and Fall River. His statement underscores the fine line between the upward mobility and the mass of working-class Franco-Americans.

This "miracle" allowed Armand Jr. to attend the St. Charles Boromée Seminary in Sherbrooke, Quebec. However, despite his fluency in French, he was not fully prepared to study at the upper level in French because the vocabulary and methods in subjects like mathematics were so different than the English-language education to which he was accustomed in Newburyport. It took an entire year's immersion in Quebec before he was ready for the *cours classique* of the French Canadian *collège*. He spent Christmas and the New Year holiday on his grandmother's farm in Lévis. His experience points, somewhat conversely, to the significance of the parish schools in Lewiston and other cities with similar high concentrations of French-speakers because, lacking formal education in a variety of subject areas taught in the French language (see Chapter 4), Dufresne needed an additional year of courses to prepare him for university. Dufresne specifically refers to courses in mathematics, which French-speakers approach differently than English-speakers. (Tellingly, Dufresne describes this difference as a difference in *esprit*. The word *esprit* in French includes the meanings spirit, mind and soul.) Lionel Tardif attests to far more ease in switching codes from French to English and back because his early school experience was bilingual.

Armand Dufresne Jr. completed his last two undergraduate years at the University of Montreal at the seminary of philosophy. His career choice remained unclear until he stepped off the train in Lewiston, where he had an epiphany in the glow of a sunset: he'd become an attorney. When he told his mother, she cried. Attorneys in Quebec made so little that to supplement their income, they shoveled snow in the winter. Her reaction was in part the result of a difference in culture: attorneys in her homeland were not as important as notaries unless they were trial lawyers.

Hard Times (1914–1941)

Dufresne was the only Franco-American in his class at Boston College Law School. Lack of funds meant that he had to take a year off to work at the family bakery. Like so many Franco-Americans, he met his future wife in the workplace. He finished law school during the Depression, set up practice on Lisbon Street in June and saw his first client in November, making four dollars. His mother, however, had no need to worry. Through connections within the community, many of them within the Union St. Jean Baptiste and the Democratic Party, he became corporation counsel for the City of Lewiston, was appointed assistant county attorney (the equivalent of assistant district attorney in those days) and then ran for county attorney when his mentor, Eddie Beauchamp (the first Franco-American to hold the office), vacated the seat. He later ran for judge of probate. His background in French served him well, for he could give political speeches in either language. In a dispute in a probate case, a French-speaking woman's will read that she had wanted to leave a large sum to her church to build a "hotel," but the judge quickly recognized that what the woman had wanted was to gift the church with an altar, or *autel* in French. Dufresne rose to practice on the circuit of the Superior Court. In 1965, he was appointed to the Maine Supreme Judicial Court, following in the footsteps of Albert Béliveau, who, in 1954, had been the first Franco-American so appointed. In 1970, after considerable political wrangling between Republicans and Democrats, Dufresne was appointed, by Governor Kenneth M. Curtis, chief justice of the Maine Supreme Judicial Court, the highest office in the judicial branch of state government.[119]

Political Associations, Corruption and Reform

The election of Robert Wiseman as mayor of Lewiston marked the beginning of a long period of political domination by Franco-American Democrats in that city. This ascendancy was achieved and maintained through the efforts of political groups. The Alliance Civique, founded in 1914, was instrumental in Wiseman's 1916 victory. Its mission was "to increase our influence, our prestige and to enhance the name of French Canadian." In practice, this meant two major activities: to continue the work of encouraging French Canadian immigrants to naturalize (and thus be eligible to vote) and to seek out and support Franco-American candidates for office.[120]

The success of Franco-Americans and their close ties to the Democratic Party, however, contributed to a period of widespread corruption at city hall

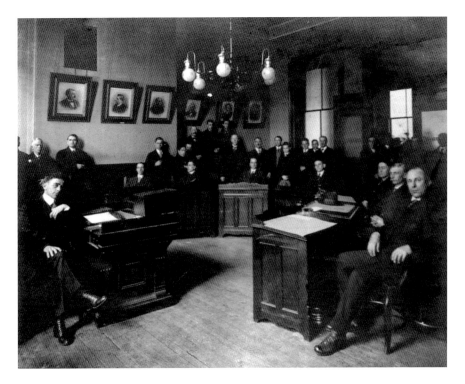

Mayor Charles Lemaire (left) and Lewiston city aldermen at Lewiston City Hall, 1918. *Courtesy University of Southern Maine, Franco-American Collection.*

in the 1920s and '30s. The city's Democratic Party caucus became more important to the success of candidates than the citywide election. As a result, the mayor and aldermen became less accountable, and the city government saw cases of embezzlement and misappropriation of federal funds.[121] In 1938, six current and former members of city government were arrested and convicted of soliciting or conspiring to solicit bribes. Five of the six were Franco-Americans.[122] During this period, the city's finances were also in a bad way, and the state had taken control of both the school board and the police department as a result of mismanagement.[123]

In an effort to reform the city government, a group of prominent Franco-Americans formed the Association des Vigilants in 1936, with the aim of "promoting the general interests of French-speaking Americans…to protect and defend [their] rights."[124] The organization, which described itself as "secret but non-political," was limited to a membership of 150 (originally 175) by invitation only.[125] It had close links to *Le Messager*—its founders included the paper's treasurer Valdor Couture, son of Jean-Baptiste, and

Louis-Philippe Gagné, the paper's editor. Their first meeting was held in *Le Messager*'s Lisbon Street offices.[126]

Although the society would go on to promote a number of Franco-American causes, including cultural activities and citywide projects, such as industrial development, its initial raison d'être was political reform, namely the drafting of a new city charter for Lewiston. This charter, which the Vigilants proposed in 1938, greatly reduced the nominating power of the party caucus by mandating a nonpartisan ballot for the elections, followed by a runoff vote. The charter came into force in 1939, following a successful ballot measure. The measure was supported by a number of Franco-American leaders and organizations. However, the opposition, led by incumbent mayor Donat Levesque, claimed the new charter would result in less power for the city's Franco-Americans.[127]

The Decline of Manufacturing and the Great Depression

By the 1920s, the old infrastructure in New England's textile mills had become obsolete. The development of electrical machinery meant that the industry was no longer dependent on New England's rivers for power. It was easier to produce cotton cloth in the South, where labor, transportation and energy were far less expensive. The mills in Lewiston were in danger of closing. They gained some respite from the development of technology to generate hydroelectric power from the falls but would not regain profitability until they were awarded government contracts during World War II.[128]

Despite the lackluster local economy, opportunities for work in the factories in Lewiston-Auburn continued to draw French Canadians, especially as Canada fell into recession after 1920. Immigration into Lewiston-Auburn followed the traditional patterns of geographical mobility often tied to kinship networks. Efforts by the federal government to restrict immigration met with limited success along the porous northeast border. Stories like that of Germaine Letourneau, who was born in Lewiston in 1917 to French Canadian parents, underscore the precarious existence of many Franco-Americans in this period. Her father succumbed to the influenza epidemic the following year, and Germaine's mother moved back to Canada with her infant daughter, an American citizen. Germaine lost her mother to illness a mere three years later. An aunt and uncle lived in Lewiston. They had one

daughter but after were infertile, so they made Germaine a part of their family. The family eventually returned to Canada. When she was sixteen, with few prospects for earning a living there, Germaine, an American citizen by birth, returned to Lewiston to live with her grandmother and aunt and found work in the cloth room in a textile mill. She eventually married and raised a family, living at times in Auburn and at times in Lewiston in homes built by her carpenter husband.[129]

In similar fashion, Françoise Cloutier came from Sherbrooke, Quebec, to Lewiston at the age of seventeen in 1933 following her father, who had been laid off from the railroad. Because her father was born in Pennsylvania, he was able to enter the United States and, along with his son, found work at the Bates Mill while his wife remained at home. Françoise lived with other unmarried girls in her aunt's boardinghouse.[130]

The Franco-Americans of the Twin Cities remained, for the most part, workers who lived paycheck to paycheck. When the stock market crashed in 1929, those who had money in the bank lost their savings. There were slow downs at the mills, and money was tight. Antonio Pomerleau (born in 1907 in St. Méthode, Quebec) began work in 1929; he and his father worked seasonally as woodsmen and at an Auburn box factory in the winter. The onset of the Depression reduced Antonio's wages from $15.82 to $7.00 a week; his father's pay sank from $21.00 a week to $10.00 before the shop closed.[131] People often bartered possessions or services rather than paid with cash. It was difficult to pay rent, and extended families sometimes moved in to a single apartment. Beds often had to be shared. When other family members were out of work, those who were working supported the "loafers," not by choice. Men would often do odd jobs in order to earn extra money, and women would take on additional laundry or ironing to supplement the family income. Children in this generation, as in the previous ones, often left school and went to work as soon as they could, handing over their pay envelope to their parents and receiving small portions for pocket money.

Many Franco-Americans who lived through the Depression recount that they and their families "managed."[132] Mothers stretched family budgets by cooking inexpensively. Water could be added to soup, and ragouts were made with several kinds of meat, water, onions, cinnamon and cloves. *Creton* spread on a pot of boiled potatoes and homemade pickled beets could satisfy children. Families raised their own vegetables and livestock (even in the city). Old clothes were remade into new garments; even cloth flour sacks made durable underwear, curtains and dishrags. The poor relied on the charity of their neighbors and churches.

Hard Times (1914–1941)

Schoolyard sports at St. Peter's School in Lewiston, 1906–07. *Courtesy University of Southern Maine, Franco-American Collection.*

The most destitute of all—including the handicapped, the elderly whose children did not have the means to support them and migrants who rode the rails into town—often sought food and shelter at the Lewiston and Auburn Poor Farms. The poor farm was a rare example of government support for the needy in this period, before the implementation of social security, unemployment or food stamp programs. The poorest in society were fed and housed in exchange for work. The Lewiston Farm was run in this period by a Franco-American couple, the Landrys. Everyone who could was required to contribute—elderly women made quilts—and the farm became self-sustaining under the Landrys.[133]

The New Deal

President Franklin Delano Roosevelt was wildly popular with the majority of Franco-Americans in Lewiston-Auburn. His New Deal brought two popular programs, the WPA (Works Progress Administration) and the CCC (Civilian

Conservation Corps). The WPA provided work for the unemployed. The CCC did not operate in the Twin Cites, but young men from the area often found work in the camps in other parts of the state, building roads and dams or ridding forests of pests like the gypsy moth or white pine rust. A key program of the New Deal, the National Recovery Administration (NRA), which set minimum prices for goods, minimum wages and maximum hours for workers, was the brainchild of Auburn businessman Wilfrid Bourassa, who owned the American Bobbin Company and wrote FDR several times about the idea before the latter's inauguration as president.[134]

For people accustomed to working long hours to get the largest weekly paycheck possible, these changes were not always welcome. New Social Security taxes also diminished take-home pay, and while the shorter workweek meant employment for more people across second and even third shifts, it also resulted in changes in the way workers were paid. Textile mills and shoe shops adopted a piecework system, in which workers were paid by the number of products they made rather than the hours they worked. Those

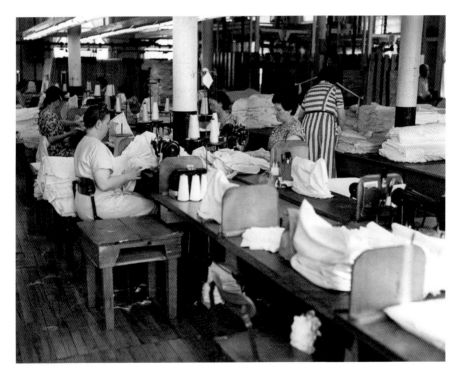

Pillowcase stitchers at the Pepperell Mill in Lewiston, 1940. *Courtesy University of Southern Maine, Franco-American Collection.*

who could not produce in sufficient quantity—regardless of quality—risked losing their jobs. In addition to low wages, unsafe conditions persisted. Before the Social Security Administration was established, a single accident at the factory could end a worker's career. While the mill or shoe shop might take responsibility for initial medical treatment, there were no long-term benefits for workers permanently disabled. Workers in the textile and shoe industries had little job security for other reasons. Employment depended on whom you knew, not what you knew. If a particular boss left or was fired and replaced by someone else, the workers under him might also lose their jobs, which would go to new workers who came with the new boss. Other abuses, like bribery demanded by the boss or sexual harassment of women, occurred on a regular basis (according to oral accounts). In many cases, workers would simply move to another mill, shoe shop or city.

After a brief stint in a textile mill, Florida Charest and a sister sought work as stitchers in the Cushman Hollis factory in Auburn, stitching shoes. Florida saw this as a step up because the piecework in the shoe shop was more like a trade or skilled labor. When she started in 1923, she made one dollar a day. When she retired at the age of sixty-two in 1969, she was making just eight dollars a day, or forty dollars over a five-day workweek. With only a sixth-grade education in Canada and very little English, she had few choices for work. She made shoes because it was the only thing she knew. If the boss entered a lesser number of pieces than she had made, she was unable to challenge him because she could not express herself fully in English and he spoke no French.[135] This was the reality many workers faced.

Organized Labor

If discrimination by the dominant culture created solidarity among Franco-Americans, class and ideology fractured this cohesion, especially amid the economic pressures created by the Great Depression. It is commonly known that Franco-Americans were prized as a workforce for their strong work ethic and their docility. This is one of the chief reasons given for the recruitment of French Canadians for New England factories. Catholic clergy supported the paternalism of the factory owners and opposed the organization of labor on the grounds that it represented a form of atheistic communism. Nonetheless, there is ample evidence of a long history of working-class consciousness among Lewiston and Auburn Franco-Americans. They

participated in strike activity from as early as 1886, when at least one French Canadian participated in a protest of a loom fixer at the Bates Mill who was rumored to be a member of the Knights of Labor.[136] As Mark Paul Richard has shown, *Le Messager* covered news of strikes and encouraged Franco-Americans to support their own in labor issues.[137] While a full history of labor in the Twin Cities is beyond the scope of this work, it suffices to say that strikes occurred at regular intervals in Lewiston-Auburn industries. These included occurrences at the National Shoemakers of Auburn (1905–06), the electric railroad in Lewiston (1906) and Lunn and Sweet, another Auburn shoe shop (1913). Another major shoe strike occurred in Auburn in 1932, and the United Textile Workers of America went on strike in 1934.

In 1906, American Federation of Labor president Samuel Gompers visited the Twin Cities and spoke against a particular local issue: child labor. There was also an outcry against child labor within the Franco-American community itself. Dr. Joseph-Amédée Girouard,[138] an amateur poet, penned verses on the plight of young children in the mills. As a physician, he was well aware of effects of conditions in the workplace, especially on children and women. His poetry, in French, is clearly addressed to the Franco-American

A child at an unknown textile mill in Lewiston, circa 1900. *Courtesy University of Southern Maine, Franco-American Collection.*

community itself—or, at least, to the elite who read poetry. Nonetheless, child labor was essential to the economic survival of many families. Although as early as 1887 there were statutes regulating hours for girls under eighteen and boys under sixteen and others prohibiting children under twelve from working, these were not strictly enforced. (The minimum working age was raised to fourteen in 1915.) Social photographer Lewis Wickes Hine of the National Child Labor Committee documented the children of Lewiston's mills in 1909. Authorities often used laws against truancy from school rather than sanctions against child labor to police children in the mills and shoe shops. Truant officers would demand birth certificates and permits from young workers in order to determine their age, but certificates, if they existed, were easily altered; a sibling's papers could also be used. Lucien Rancourt of Lewiston (born in 1904) recalled working more than his permitted hours at age fourteen and being told by his boss to hide in the men's bathroom when the school inspector, a woman teacher, came visiting.[139]

The Great Shoe Strike of 1937

The largest strike in the Twin Cities took place in 1937 and made national headlines. Earlier that year, the Congress of International Organizations had sent organizers to unionize Auburn's many shoe shops. By mid-March, at least half the workers in the shoe industry had applied for membership in the union. Then the shop owners were invited to meet with union representatives, which was their right under the Wagner Act.

The shop owners refused to respond. At another open meeting on the night of Wednesday, March 24, a resolution to strike was brought forward, and those in the hall were asked if they were willing to participate. The uproar that resounded was taken as a vocal affirmative, but there was never a written poll taken. The next day, shoe workers walked out of the shops and set up picket lines. Reaction was swift. Auburn police chief Harry Rowe interdicted picketing within five hundred feet of factories, and those who defied the ban were arrested, immediately charged and fined; local CIO leaders and those from out of state were charged with conspiracy; Catholic priests denounced strike activity; and new workers were hired to replace workers who had walked out.

In the end, despite the Wagner Act, an Auburn judge declared the strike illegal and issued an injunction against it. On April 20, an indignant crowd

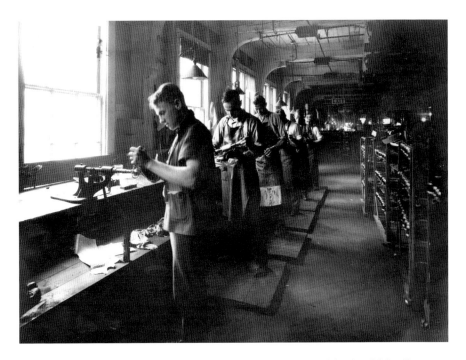

An unidentified Auburn shoe shop, circa 1930. *Courtesy University of Southern Maine, Franco-American Collection.*

marched across the bridge from Lewiston to Auburn, where it was met with force. Someone threw a rock at an Auburn policeman, and violence erupted as strikers were clubbed and dragged. Governor Lewis Barrows sent in the National Guard; its precautionary measures included a machine gun nest near the North Bridge.[140]

The leaders of the strike, who held yet another meeting, were charged with contempt of court for violating the injunction against all strike activity and were held without bail until June 28. The strike was over, brutally crushed. The triumphant Auburn Shoe Manufacturers Association agreed to bargain with a local union, the Lewiston Auburn Shoe Workers Protective Association, which the manufacturers themselves controlled. The contempt charge against the union leaders was overturned by the Maine Supreme Judicial Court in 1939, but locals and out-of-state organizers alike each served a six-month sentence for conspiracy.

The 1937 strike divided residents of the Twin Cities and even individual families. Strikers cared deeply enough about their cause to risk their livelihoods. Meanwhile, others felt they had little choice but to continue to work to support

their families. By some reports, half the strikers went in to work before the strike was over.[141] They felt the strikers "brought trouble" while those on strike saw those who continued to work as "scabs" or "rats." Others, not wanting to scab but needing money, simply left and found work in neighboring towns.[142] Effects of the strike lingered for years. Nonetheless, this did not quell union activity in the Twin Cities. In 1940, textile workers staged a successful strike that lasted a mere two weeks but led mill owners to negotiate.[143]

The Church Built on Nickels and Dimes

The many blows that hammered the Franco-American people of Lewiston-Auburn during the tough interwar years were met, as we have seen, with resistance and even resilience. These years also witnessed an enduring triumph not only for Franco-Americans but also for Lewiston-Auburn. The cathedral-like Church of Sts. Peter & Paul, so long the stuff of dreams, became a reality. The magnificent upper church was finally completed in July 1936 and dedicated on October 23, 1938.

Construction of the new church had been delayed for several reasons. The creation of new parishes by Bishop Walsh had been funded through the building fund of Sts. Peter & Paul, but the parish had also undertaken the construction of a new building for St. Peter's School, which opened in 1925. The initial design for the new building was undertaken by Noel Coumont, a Belgian architect and resident of Lewiston, but he was fired after the excavation of the foundation was begun in the wrong orientation. To this day, the church's central aisle contains a kink—sometimes attributed by parishioners to the cant in Christ's neck as he hung on the cross.[144] The advent of the Depression only slowed fundraising efforts further. Nonetheless, the $625,000 necessary to complete the structure was found, primarily through small contributions by individual parishioners, even as they were struggling with their own economic hardships. As a result, the church became known for having been built on "nickels and dimes."

The church, with a capacity of 1,800 (plus 1,200 in the lower church), is the second largest in New England and was constructed by Malo Brothers from 515 wagonloads of granite from North Jay. Its medieval Gothic style is proudly French in origin (the rose window is said to have been inspired by that of the cathedral in Chartres while the structure itself was inspired by the Cathedral of Saint Peter in Nantes). Among its most prized possessions

Sts. Peter & Paul Church under construction on Ash and Bartlett Streets in Lewiston, 1935. *Courtesy University of Southern Maine, Franco-American Collection.*

Opposite: The interior of Sts. Peter & Paul Church, circa 1940. *Courtesy University of Southern Maine, Franco-American Collection.*

HARD TIMES (1914–1941)

is an organ constructed by the famed Casavant Brothers of Montreal.[145] It remains today the single most recognizable landmark of the Lewiston-Auburn skyline, and its completion was a moment of triumph and vindication for the cities' Franco-Americans.

4

New Horizons

Acculturation, Negotiation, Affirmation (1941–1970)

The period after the Second World War saw Franco-Americans exposed to many of the same forces as other Americans in the mid-twentieth century, many of which were global in nature. These phenomena, whether the rise of television, the civil rights movement, church reform or worldwide conflict, offered both opportunities and challenges to Lewiston-Auburn's Franco-Americans. This was a period of acculturation and negotiation with American culture but not complete assimilation. In this era, a renewed emphasis was placed on the "American" in Franco-American identity. Language patterns changed, and more Franco-Americans grew up speaking English. Exposed to more mainstream American culture, more Franco-Americans saw that as their primary identity. On the other hand, the beginnings of the global era offered new opportunities to Franco-Americans for travel and work—not just outside the Twin Cities and Maine but also overseas.

Military Service

As in the First World War, citizens of Lewiston and Auburn proudly served in the armed forces of the United States during the Second World War and subsequent twentieth-century conflicts. Their service and sacrifice were means of proving their patriotism and identity as Americans. At the same

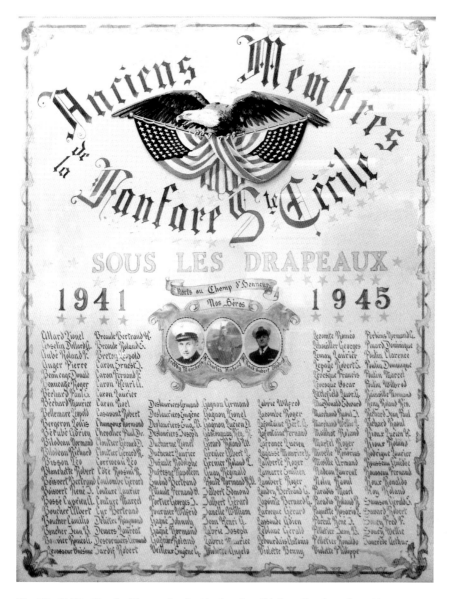

The World War II roll of honor for the Fanfare Ste. Cécile, a Lewiston-based boys' marching band, circa 1945. *Courtesy University of Southern Maine, Franco-American Collection.*

time, military service offered the opportunity for foreign travel—a rarity in the 1940s. This was especially relevant for those Franco-Americans who served in the European theater and in France; many were affected by their first visit to their ancestral homeland.

New Horizons

The Pine Tree Warriors at the Capitol Building in Washington, D.C., 1976. *Front, center*: Governor James Longley (left) and Bert Dutil (right). *Courtesy Bert Dutil.*

Moreover, the armed services often valued Franco-Americans' French-language skills in an era in which they were being discouraged in their civilian lives. In the Korean War, Bert Dutil of Lewiston was transferred from the infantry to serve as an interpreter once his commander realized he spoke French. He was assigned as a translator to high-ranking French, Belgian and West African commanders and witnessed the signing of the Korean armistice in Panmunjon. In addition to these official duties, he also entertained at the officers' club by singing French songs.[146]

The war in Vietnam, a former French protectorate, offered a different context in which Franco-Americans served. Here, Franco-Americans could interact with the civilian population more easily than other U.S. servicemen. Roger Nadeau of Lewiston formed a friendship with a Vietnamese laundress and her baby. He and his wife, Muriel, childless themselves, sent toys and clothes from the United States for the girl. As Nadeau recalled, "It was something that changed your mind…it wasn't war, war, war all the time."[147]

Increasingly, women as well as men participated in these conflicts. Some, like Marie Sturtevant of Lewiston, were inspired to serve because they recognized the forces' need for French-speakers. A registered nurse in

civilian life, Sturtevant enlisted as a member of the Army Nursing Corps and treated injured servicemen in Okinawa.[148]

Doris Guenette of Lewiston also served in Vietnam, having followed her family and many uncles into the army. She remained a professional soldier and participated in Operation Desert Storm in the 1990s. Once again, her French was a valued asset. She and the other Franco-Americans she knew were often employed as translators since French was a common second language in Saudi Arabia. Every patrol included a French-speaker if possible. Aside from combat tours, she used her native tongue to train Canadian recruits in her role as a truck driving instructor.[149]

Despite occasional "dumb Frenchman" jokes and other forms of discrimination that were still prevalent in civilian life,[150] for the most part, recruits found that their time in the forces validated their Franco-American identities. Additionally, the army offered opportunities for advancement. The GI Bill provided access to both high school and college education to many Franco-American veterans after World War II. Some, like Roger Nadeau, helped offer further educational opportunities to Twin Cities residents. Nadeau dropped out of high school at fifteen to work at Falcon Shoe in Auburn. Having gained his GED during his military service, he rose to become personnel manager at Falcon and later initiated an adult education program that helped dozens of staff members, many of whom were Franco-Americans, get their own GEDs.[151]

Father Drouin and St. Dominic High School

An important milestone for the education of Lewiston-Auburn's Franco-Americans was the founding of the community's first parochial high school, St. Dominic, in 1941 by Father Hervé-François Drouin. Drouin (1901–1986) arrived as pastor to Sts. Peter & Paul in 1940. Born in Ottawa, Drouin was a Dominican theologian and gifted orator who had studied in Ottawa and Fribourg, Switzerland.[152] Father Drouin soon gained a reputation as a devoted and caring community leader, who balanced competing forces during his time leading the parish. While he encouraged young Franco-Americans to seize opportunities in the wider society, Drouin was first and foremost a spiritual leader, and he remained fully devoted to traditional Roman Catholic spirituality. This informed his work in the schools and community. In his time as pastor, stained-

New Horizons

Father Drouin inspects plans for the new Central Maine Youth Arena, Lewiston, 1957.
Courtesy University of Southern Maine, Franco-American Collection.

glass windows were installed at the new church depicting scenes from the joyful, sorrowful and glorious mysteries of the life of Christ, moments that the faithful reflect on while saying the prayers of the rosary. At the same time, Drouin embraced ecumenism, maintaining good relationships with the pastors of the various protestant churches in the Twin Cities, as well as Rabbi David Berent, with whom he was close friends.

The young pastor brought forward movement to the Twin Cities in a time of rapid change. His chief concern was that Franco-Americans, whose opportunities had often been limited by the lack of diplomas, receive a high school education. With the help of Brother Emilien of the Brothers of the Sacré Coeur (Sacred Heart), who taught at St. Peter's School, Drouin first secured permission in 1941 to offer the *cours supérieur* (the equivalent of the first two years of high school) for students who wanted to continue beyond St. Peter's School. Drouin asked the Association St. Dominique for its building on Bartlett Street, and the association graciously gave it up, disbanding at

this time. Furniture and typewriters were purchased; Brothers of the Sacred Heart Fernand and Fulbert taught the fifty-seven boys who enrolled that first year. Most were from St. Peter's, but some were from other local parishes and even from the St. John Valley. St. Dominic High School was born soon after, when, in 1941, classes for the junior and senior years were added. Brother Médéric, of the Brothers of the Sacred Heart, was the first principal. The Dominican sisters made high school classes available to girls in 1946. Young men and women remained segregated in separate classes, but Franco-American youths now had the possibility of earning diplomas outside the English-only public schools in a private, bilingual learning environment.[153] Drouin's aim was to "keep…children in schools [and] get them away from the mills," a goal that was resisted by some parents. Nonetheless, the fledgling high school proved a success.[154]

Drouin not only promoted education and the use of English as well as French but also encouraged forward thinking in other domains. He helped create the Catholic Bureau of Social Services (now Tri-County Mental

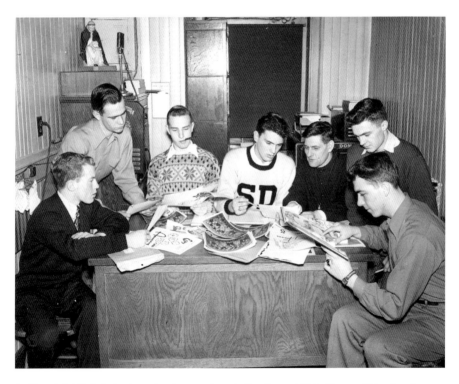

St. Dominic High School yearbook committee in Lewiston, 1950. *Courtesy University of Southern Maine, Franco-American Collection.*

Health) and served as its first president. While his predecessors had been ambivalent about the role of unions in the textile mills, Drouin's response to a visit by representatives of the CIO was "Oh, God, what took you so long?"[155] He also established the St. Peter's Credit Union.[156] (Credit unions had a long association with the Catholic Church, and the first credit union in the United States was founded in Manchester, New Hampshire, in 1908 by Father Hévey, the erstwhile pastor of St. Peter's.) Drouin's pastorate was characterized by his dedication to raising the social status and aspirations of Franco-Americans.

Young Franco-American men increasingly began to attend colleges and universities in the United States. Maurice Dubois was the first Franco-American from the Twin Cities to study at Providence College (a Dominican institution), for example.[157] In most families, college education was considered more important for men. Attendance lagged for women. The thinking was that it did not take a bachelor's degree to change diapers or warm baby bottles.[158] Up until this era, young women who preferred not to marry sometimes found entry into a Catholic religious order a pathway to both spiritual and professional fulfillment.

Lucille Paré (1923–2007) went to live with the Dominican sisters at their convent in Sabattus around the age of seven or eight when her father went west to find work during the Depression. Despite her initial loneliness, she later reflected that the experience there, at the Ave Maria Academy, gave her a better-quality education than she would have received in an ordinary parochial school. Upon graduation, she initially entered the workforce, holding a number of factory and office jobs, but was frustrated by the lack of intellectual stimulation. At age twenty-six, she made the decision, like many of her peers in the same situation, to join the Dominican Order.

As Sister Marie-Sylvie, she studied at the international novitiate in France. In fact, Lucille cited the international and "exotic" nature of the Dominicans as a motivation for choosing it over other, more local, orders. There she received a French baccalaureate from the University of Paris. Having taken final vows, she returned to the States and was prioress of the Lewiston convent from 1961 until 1966 before being assigned elsewhere when the Dominican sisters left Lewiston in 1968.[159] She was later able to earn a master's degree and a doctorate.

Paré recalled that her return to Lewiston after nine years in France was a culture shock in part because the Lewiston convent imposed stricter rules on its nuns compared to the French counterpart—the Lewiston branch was "stifling" in Paré's words. Over the course of her life, Lucille witnessed

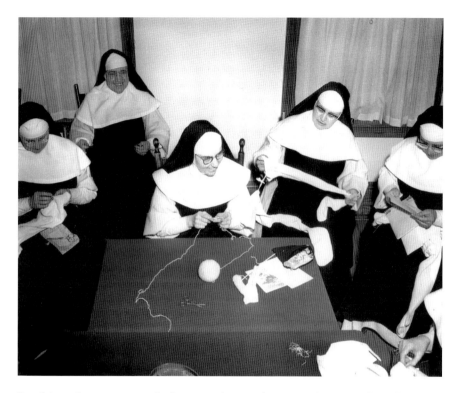

Dominican sisters congregate in the convent's recreation room, circa 1965. *Center*: Sister Marie-Sylvie. The image was originally captioned "Having Fun!" by the sisters. *Courtesy University of Southern Maine, Franco-American Collection.*

changes in the lives of women in religious orders, from small comforts like the installation of running water or the convent's first television (purchased to watch President Kennedy's funeral in 1964) to the elimination of the role of lay sisters in serving the more senior nuns. Paré recalled that practicality often trumped religious discipline: "The Dominican habit was…a white floor length dress, long sleeves with a scapula…we had a wimple…and a long shirt with long sleeves that was very tight at the wrists…Six of us from Brookline, Massachusetts [went] to Phoenix in the end of July…As we drove along, the sleeves were gone, the stockings left…oh, it was impossible, it was so hot!"[160]

If they did not enter the convent, young women with career aspirations in the fields of teaching and nursing, for example, often attended Catholic women's colleges and schools like St. Mary's School of Nursing, founded in 1908. By the late 1950s, some Franco-American families were actively encouraging their daughters to attend college. Susan (Dallaire) Lagueux recalled that her father always expected his daughters to continue their

educations beyond high school. After she graduated from Lewiston High School in 1963, she went on to attend Bates College while her sister Lorraine chose to study for a brief period in Miami.[161]

Hockey

Father Drouin also left a significant mark on the sports scene in Lewiston-Auburn. Hockey, a sport with its origins in French Canada, was first recorded in Lewiston in a match between the Association St. Dominique (ASD) and the Metropolitan Life Insurance Company of Auburn on January 26, 1916. Both teams were composed almost exclusively of Franco-American players. The association would be at the center of the Twin Cities' hockey culture for the next half century, but it was joined by several other teams. With the exception of the local high school teams (and, later, the Bates College team), Lewiston-Auburn's hockey players were overwhelmingly Franco-American. Amateur teams included the Cyclones (founded 1924), who became rivals to the ASD; the Maple Leafs; Derby; Montagnard; and Mowhawks. The Bates Manufacturing Company even sponsored its own team, sometimes known as the Fabrics, as did the Pepperell Company.

Hockey brought success and pride to the Franco-Americans of Lewiston-Auburn. The Cyclones won a state championship in their inaugural season, setting the tone for the cities' reputation as the state's hockey center. As in other parts of the United States, Franco-Americans were instrumental in popularizing the sport among the general population.

Until 1950, hockey was played on outdoor rinks, including the St. Dominic High School team coached by Brother Leonard. On the initiative of Father Drouin, and with the support of businessman Ray Cloutier, Lewiston's first indoor rink was built, largely with volunteer labor, for the Catholic high school. It was an unheated building that enclosed natural ice and bleacher seats. On January 10, 1951, the first game on artificial ice in Maine was played there. Later, better seating and a natural hardwood floor for other sports were added.[162] St. Dominic High School had a successful team that won its first state championship in 1946 and the next twelve years later. The team won the New England finals in 1958.

Amateur and high school hockey were particularly well regarded since the National Hockey League comprised a mere six teams until the 1967–68 season. In the mid-twentieth century, St. Dominic, Lewiston High, the

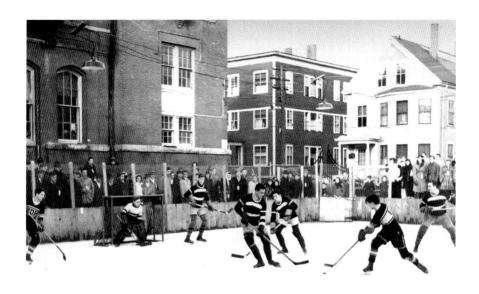

A hockey game in Lewiston, circa 1940. St. Dominic High School is playing an unidentified team. *Courtesy Madeleine Brodeur.*

company teams and Maine's college teams all regularly competed against one another. The sport did not yet have enough competition to differentiate between different leagues.

One of the earliest games played at the new arena was the U.S. championship game between the Bates Manufacturing team, which had won the New England championship in 1950, and the Rochester Mustangs of Minnesota. Later in 1951, the team would enter Twin Cities legend by touring Europe on its way to the world championship in Paris. This was the first and only time that the United States was represented at the amateur world championships by a group of players who regularly played together for the same team—an initiative of Boston Bruins manager Sam Brown. All but one of the fifteen players had Franco-American names, among them Parent, Poirier, Brodeur, Martineau, Dubois, Moreau and Marcotte. They were coached by Larry Charest. In one match, "little" Pete Theriault tipped in the goal that put them ahead of the big Finns. A French reporter remarked that they could be "ours" ("*des notres*") with their Norman peasants' accents.[163] The Canadian national team, tournament favorites, was composed entirely of Anglo-Canadians, causing some confusion among

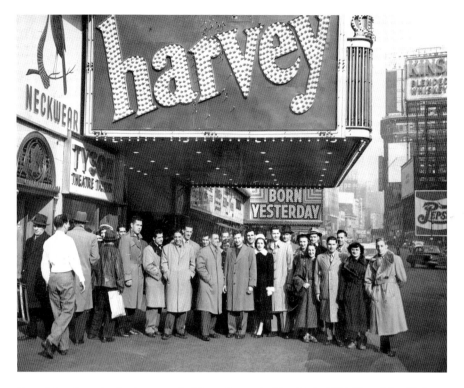

Bates Manufacturing hockey team in Times Square in New York, 1951. From New York, the team sailed the *Queen Mary* for Europe. *Courtesy Madeleine Brodeur.*

the international press, which assumed someone had switched the Canadian and American team rosters because French names were not associated with American teams. The *"Français aux Amériques"* (American French) were also called the "Yankees" in a somewhat ironic twist. The tour not only exposed the French and international press to the existence of Franco-Americans, but also, like the Second World War, it offered many of the players a chance to visit the land of their families' place of origin for the first time.

The Bates Manufacturing team's victory also imbued the Twin Cities with a sense of pride. The team's success was regularly described as a "Cinderella story," and the achievements of a group of amateur players who worked on the line at the textile mill were important to their home community.[164] After one victory, Amédée Béland stated that the mayor, the pastor and even the (Yankee) boss at the factory would be really happy with the result.[165]

Sporting success helped deflect the painful economic realities in the Twin Cities as industrial decline began in the 1950s. When the arena was

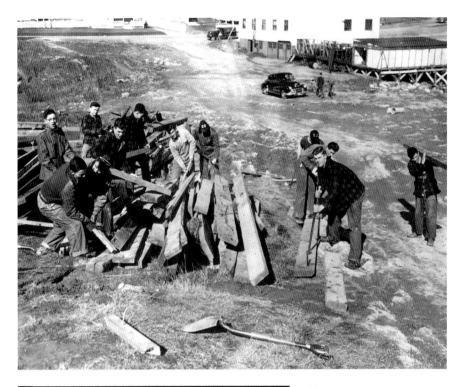

Above: Students from St. Dominic High School clear debris after the fire at St. Dominic's Arena, Lewiston 1957. *Courtesy University of Southern Maine, Franco-American Collection.*

Left: St. Dominic High School hockey players Richard Lecompte (left) and Michael Parent in Lewiston, 1963. *Photo by Raymond H. Philbrick. Courtesy Dan Philbrick.*

destroyed by fire in 1956, Michael Parent recalled, "It was like St. Peter's Church had just gone up in flames." The arena would be rebuilt, however, and remain in the hands of the Dominican Order until 1989. Parent was later a member of the St. Dominic High School team, which won the New England championship in 1964 (also coached by Larry Charest). In his fictionalized memoir, *A Beautiful Game*, Parent recalled that while plenty of towns across New England were suffering economically, at least Lewiston could boast of being "the Champs."[166]

Boxing

Just as sport brought Franco-Americans to a world beyond their own, so it also brought outside attention to the Twin Cities. In 1965, promoters for the World Boxing Heavyweight Championship could not hold the fight between champion Sonny Liston and his challenger, Muhammad Ali (who had recently converted to Islam and changed his name from Cassius Clay), in Boston as planned. In searching for a venue, they found a small Maine city where boxing had long been a popular sport, especially among Franco-Americans.

Some, like Maurice "Lefty" Lachance (1931–1994), a state and regional champion, took up the sport as a teenager, earning some much-needed cash during the Depression years, and participated in service tournaments during World War II. Their professional careers took them all across the country.[167] Meanwhile, the reputation of Lewiston as a boxing town brought many fighters to the armory and, later, the arena, including many Franco-Americans and French Canadians.

Lewiston fighters also enjoyed some notable successes. Paul "Junior" Labbe (1907–1995) won all but 13 of the 489 matches in which he fought in the 1920s through the '40s. Although he never won a world championship match, he came close many times, including against world welterweight champion Chalky White in front of eighteen thousand people at the Boston Garden in April 1940. When he retired in 1944, he was ranked seventh among the world's lightweight boxers. Labbe served as a reserve judge for the Ali-Liston fight.[168]

Auriel "Shiner" Couture (1923–2000), made his way into the record books with a 10.5-second knockout (including the 10.0-second count) of Ralph Walton in Lewiston on September 24, 1946. More recently, Joey

Al "Shiner" Couture (right) and an unknown opponent in Lewiston, circa 1940. *Courtesy University of Southern Maine, Franco-American Collection.*

Gamache (born in 1966) became World Featherweight Champion in 1991 and Lightweight Champion in 1992. He remains the only Maine boxer to win a world championship title.[169]

The Ali-Liston fight took place on May 25. Ringside seats cost $100, double the average weekly wage of local millworkers. Robert Goulet, who

was born in Lawrence, Massachusetts, to French Canadian parents (his mother, Jeanette Gauthier, was born and raised in Lewiston) and raised in Quebec, seemed a perfect choice to sing "The Star-Spangled Banner"; however, he was lampooned for singing the wrong lyrics, and some thought he was off-key. Goulet himself would later explain that he had never sung the anthem before and reflected that he came to Lewiston a "hero" as a French-speaking Franco-American but, after the debacle, left a "bum."[170] The fight itself was over in less than two minutes. Some saw Ali throw a lightning-fast right to Liston's jaw, but others saw nothing. The knockout came to be known as "the phantom punch." Ali was declared the world champion. The fight brought in $111,000 in profits. The Dominicans reaped $2,500 for the arena's rental.[171]

French-Language Retention

In the aftermath of the Second World War, the push to assimilate was strong. In the era of radio, it had been easy to establish parameters between the outside world of English and the inside of family homes, where everyday life was lived in French. Even the popularity of Hollywood movies could be confined to the movie theaters. Franco-Americans in the Twin Cities also adapted la Survivance to the era of radio with the creation of WCOU, a French-language station that was founded by J.B. Couture and broadcast from space above the offices of *Le Messager*. The building also housed EAB Studios, one of the best-known recording studios north of Boston. Its proprietor, Eddie Boucher, cut records for New England and Canadian artists, as well as a number of local Franco-American performers.

In the era of television, on the other hand, the English language invaded the space of family life. Franco-American children became fully bilingual, often spending half of the school day speaking English and the other half French if they attended parochial school, as many did for at least part of their schooling.

The French-speaking population of Lewiston and Auburn remained dense, and this saturation in French language and in long-standing cultural traditions slowed language loss. Franco-Americans in the Twin Cities, as a people, had been able to maintain their community over several generations and negotiated an identity that still retained the markers carried from the border crossings of the past, reinforced by Canada's proximity and the

relative ease of travel. It was always possible to return to visit relatives and sites of cultural memory (*lieux de mémoire*), and no passport was required. Many Franco-Americans who grew up in the war years and postwar years remember extended visits to Canada, where good company and food were plentiful. Even for those Franco-Americans who were born and raised in the United States, there was nevertheless a sense of Canada being their home.

During the 1940s, efforts to promote the French language included song competitions organized by the Vigilants. Students performed traditional French Canadian songs from the songbook *La Bonne Chanson* by Reverend Charles-Émile Gadbois of St. Hyacinthe. Gadbois had promoted the songbook at the 1937 Congrès de la Langue Française (Congress of French Language) in Quebec City. Lewiston hosted the Festival de la Bonne Chanson in 1940 and 1946, with attendees coming from the New England states and Quebec.[172] At the 1946 festival, boys from the Healy Asylum, coached by the Sisters of Charity, won first prize for their performance of a traditional love song. Representatives from the French parish schools

Petits Chanteurs de St. Pierre with Miss Marie-Jeanne Laurendeau at Poland Spring, Christmas 1954, for a television broadcast. *Courtesy University of Southern Maine, Franco-American Collection.*

also attended festivals elsewhere. *La Bonne Chanson* series of songbooks were widely popular with families in their homes and are still in use today.[173] Many of the familiar songs, including "Partons la Mer est Belle," "Un Canadien Errant," "V'là l'Bon Vent" and "À la Claire Fontaine," are still performed in the Twin Cities to this day. They certainly represent an important element of French Canadian culture, but the sanitized, family-friendly songs selected for inclusion in *La Bonne Chanson* (and, to a lesser extent, the earlier *Chants Populaires des Franco-Américains*) exclude many songs that have subsequently fallen out of favor.

Language Discrimination

However, even as these efforts at language retention continued, other forces resulted in net language loss among the population. The monumental change within the Roman Catholic Church through the Second Vatican Council (also known as Vatican II, 1962–65) was one such force. Nuns and brothers had long served in local parochial schools for very little since they had taken religious vows of poverty. Changes in the organization of religious orders mandated by the council made private education in parish schools more costly. Parents might be able to afford to send children to elementary school, where French was still a part of the curriculum, as was religion. When it came time for middle and high school, however, the cost meant that only the children of the socioeconomic elite could attend the parochial schools; others attended public schools.

While students who were able to attend St. Dominic High School benefitted from a bilingual education, many families could not afford to send their children to a private school that charged a large tuition. Franco-American students who attended public high schools or elementary schools were forbidden to speak French except in language class because of the "English-only" law (see Chapter 3). Students who spoke French at school were often punished, and the stigma of being different became more pronounced.

Even in French class, teachers who had studied abroad in France considered the colloquial forms of the language heard at home or on the street inferior to the French learned in the classroom, even if the teachers themselves had been raised within the community.

The widely held view that the local language was a radically different tongue than that spoken in the capital of France persisted, despite attempts

to correct the perception going back to the turn of the twentieth century. Regional differences in accent and vocabulary do distinguish Maine French from standard or even Canadian French. One of the most obvious terms is *moulin* (literally a mill) for factory (*fabrique* or *usine*). French Canadian immigrants often had no experience of factory work before arriving in New England and therefore adopted a literal translation of the local English term "mill." However, the notion of an entirely different language, for example in grammar use, was largely due to a lack of French-language education for Franco-Americans. Hélène Sylvain, longtime officer of the local Survivance Française club, explained, "People here don't speak French perfectly because our ancestors weren't educated."[174] She pointed out that French grammar is universal if people use it well. A century earlier, F.X. Belleau, a lawyer, drew the following analogy: "There is a difference between the English spoken by President [Charles] Eliot [of Harvard University] and an American sailor...but the educated American speaks the same English language spoken by all other Americans."[175]

In English, the situation was even worse. Young children are readily able to vocalize sounds in a second language that do not exist in their first language. However, adult native speakers of French, unlike children who attended English-only schools and played outside in English, had difficulty mastering the pronunciation of "th" in English since it does not exist in French. Instead, they used the dental consonants *t* and *d* so that "thirty-three" sounded like "tirty-tree." One woman, who was bilingual at the age of five remarked, "I was very fortunate. I didn't have the "dis" and "dat" and "dem" and "dose."[176] These linguistic markers gave rise to the stereotype of the "dumb Frenchman." Franco-American parents sometimes refused to speak English with their children in an effort not to transmit their own errors in pronunciation and grammar.

Once, it had been possible to conduct business entirely in French. All the stores in downtown areas, including Peck's, the large department store on Main Street in Lewiston, had personnel who spoke French with customers more comfortable in that language, but Lionel Guay remembers shopping with his mother on Lisbon Street as a boy growing up in the 1940s and '50s. Because she spoke a heavily accented English, in one store the clerks gave her little respect, whispering to each other behind her back. Although his mother appeared not to notice their ridicule, he certainly did.[177]

Many children of this generation recall the prejudice they encountered when they entered public schools. Susan Lagueux remembers a teacher who, on Lagueux's first day of high school, told students from Catholic schools

that they had to refer to the names of the schools in English only. He would not tolerate "Sainte Famille." It had to be "Holy Family."[178] Others were convinced that because of their accents and turns of phrase in English, or simply their names, teachers treated them as less capable than their English-speaking counterparts. Franco-American identity was associated by some with a lack of education, unskilled labor and lower-paying jobs.[179]

One woman noted a change when she married outside the community and, as was common, took her husband's name:

> *I did notice one thing and I have to admit this: that Suzanne Thompson seems to be more received amongst English people than Suzanne Bouchard was. Because Suzanne Bouchard was French, Suzanne Thompson is not. A lot of people don't know I'm French. I went to New Hampshire, and was talking to a woman there and she says, "Oh, you're from Lewiston," and she said, "Well at least you're not one of those dumb Frenchmen that works on the 'tird shift.'"*[180]

In the face of such denigration, it is no wonder some Franco-Americans internalized the negative perceptions about their identity and reacted by distancing themselves from it. Albert Poulin, a poet and translator, was born in 1938 in Lisbon, a town just outside Lewiston. He described the alienation and denial those in his generation experienced in visceral terms: "[W]e spent the better part of our adolescence and early childhood working feverishly hard at negating and trying to erase all traces of our Québecois [sic] heritage. First the accent, then the language, then the faith, the customs, the manners—anything that could be scraped, shaved or singed off."[181]

Constructing American Identities

The turn away from ethnic identity sometimes involved a new construction of identity, considered more American than Franco. Rita Côté, a popular country and western singer, performed using the stage name Betty Cody. Born in Sherbrooke, Quebec, the sixth in a family of twelve children, Côté came to Auburn as an infant in 1922. Her mother was a fine soprano and her father, although he had no formal education, designed buildings and made his own fiddles in his spare time. While at St. Louis School, she began to sing in the choir and perform in French at first in plays and then at parish

The Franco-Americans of Lewiston-Auburn

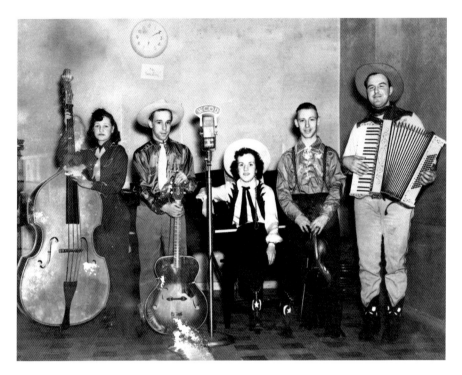

Sylvia and Rosaire Roy at WCOU Studios on Lisbon Street in Lewiston, circa 1945.
Courtesy University of Southern Maine, Franco-American Collection.

events. Her father suggested she perform at some of Lewiston's many Franco-American social clubs located on Lincoln and Lisbon Streets, but Rita objected to the idea of the raucous venues.[182] She also learned to yodel like country singer Patsy Montana. She started performing in English at the age of fifteen for WCOU. She became the female singer for Hal Lone Pine's band, the Mountaineers; married Lone Pine (Harold J. Breau) at nineteen; and had four children. In her stage persona, she wore cowgirl outfits, and her first hit with RCA records, "Tom Tom Yodel" (1952), echoed the voice of a cowboy.

Côté admitted that at first she tried to rid herself of her accent as she toured and performed with famous country stars like Chet Atkins, but she was encouraged not to change the accent that made her unique. When the band toured Canada, Côté was welcomed home—she never became a naturalized American citizen—and sang in French. On the brink of stardom—with a contract offered from the future manager of Elvis Presley—Côté gave up her career to take care of her sons, returning to Auburn to

work in a shoe shop after her divorce. She continued to perform in Maine, sometimes with her son, musician Denny Breau. (She was predeceased by another son, Lenny, a noted jazz guitarist.)[183]

Rita Côté adopted a new identity as part of a stage act. Yet every day, Franco-Americans found that they, too, could perform, acting out an identity more in line with the dominant culture and escape the stigma of being different. Unlike other minority groups in the United States, Franco-Americans were identifiable primarily by a characteristic that it was possible for them to modify or conceal: their language. Thus, it became a mark of shame for many Franco-Americans to possess a French accent—something that identified one as a "Canuck" or a "dumb frog." Some families made it even easier to assimilate by giving their children more English-sounding first names and changing the family name. This could be a simple spelling change—from Rivière to River, for example—or by translating the name entirely, from Roy to King or Rousseau to Brooks.

As Suzanne Thompson's story shows, women who married non-Franco-American husbands were also free to position themselves differently and be removed from pain and shame. Some even embraced their new spouse's cultural heritage, even if it conveyed an ethnic identity such as Italian or Irish American.[184] Even though interethnic marriage was not an attempt to escape the stigma of Franco-American identity, it often facilitated language loss, as English became the family language. In situations where all but one person spoke French, it was considered more polite and inclusive for a family or group to speak English, sometimes to the exclusion of older French-speakers.

By the 1970s, the economy of the Twin Cities was in decline. Textile and shoe manufacturing industries, which had lured French Canadians to Lewiston-Auburn, were no longer the attractive job prospects they once were, and Franco-American parents were dreaming of a better future for their children—one that did not involve the long hours and manual labor of the mills.[185] In order for them to advance up the social ladder, the reasoning went, they needed to learn English. Under pressure from some parents, even the parochial schools, once bastions of French language and French Canadian culture, also began to reduce their once unwavering commitment to French. It remained an academic subject studied earlier than in public school, but it was not the language used across the curriculum.

The decline in the number of French-speakers in Lewiston and Auburn led to the closure of *Le Messager* in 1966. As one of the oldest and longest-running French newspapers in New England, with a peak circulation of fourteen thousand, it had been a pillar of the Franco-American community in

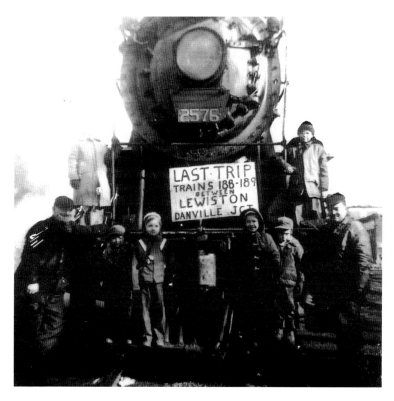

The last train to Danville Junction from the Grand Trunk Railway Depot in Lewiston, 1956. *Courtesy University of Southern Maine, Franco-American Collection.*

the Twin Cities for almost a century, and without it, Franco-Americans lost another medium in which to preserve their French. Language loss coincided with the rise of television news, and falling subscription numbers simply made the venture unprofitable. As early as 1954, a group of shareholders had unsuccessfully attempted to place the company in receivership due to its failing financial situation.[186]

Franco-American identity was also challenged by a decline in the numbers of immigrants arriving from Canada. Political and economic changes in Quebec had reduced the desire of French Canadians to emigrate, and the Twin Cities' own economic difficulties reduced its appeal for new arrivals. In 1956, the Grand Trunk Railway ceased passenger service to Lewiston. Competition from the automobile (for passenger traffic) and trucking (for freight) added to the company's woes and led to a drastic decline in demand for the railroad. With its closure, a convenient route to French Canada for Lewiston-Auburn's Franco-Americans also disappeared.

By 2010, only one in four Franco-Americans in the Twin Cities spoke French at home. However, the Lewiston-Auburn community fared better than many others in Maine. Statewide, only one in eight Franco-Americans were French-speakers. Such a statistic speaks to the ultimate resilience in the Twin Cities' Franco-Americans, who, even without large numbers of new arrivals, remained a significant population block. The later decades of the twentieth century would also see a renewed interest in slowing, and even reversing, the trend of language loss.[187]

CIVIL RIGHTS AND CULTURAL AWAKENING

Just as assimilatory forces threatened to drive Franco-American language and traditions underground, other developments led, in fact, to something of a rediscovery and renaissance in Franco-American culture. At the same time, industrial and economic decline was setting in to the Twin Cities. The textile mills and shoe shops closed one by one, forced out of business by competition in the South and abroad. Only a few vestiges remain from the days when they were side-by-side Spindle City and Shoe City. The outlook for a vibrant cultural life was bleak.

Franco-American identity had been renegotiated in the face of pressures to assimilate and vast social changes within the community and outside it.

Lewiston's Little Canada, April 1977. St. Mary's Church, the Dominican Block and the Continental Mill are visible. *Courtesy University of Southern Maine, Franco-American Collection.*

The integral connection between language and culture had been loosened and in some cases severed. Franco-American culture had been transformed but persisted, as did a significant population of French-speakers. With the advent of Alex Haley's *Roots*, racial and ethnic heritage had become chic, and despite radical changes, Lewiston-Auburn's Franco-American roots were strong and deep. They had not been eradicated.

5

Renaissance and Reinvention
(1970–2014)

Through the late twentieth and twenty-first centuries, American society at large gained a new appreciation for ethnic diversity, the virtues of bilingualism and the value of multiculturalism. For Lewiston-Auburn's Franco-Americans, this shift in thinking came at just the right moment to preserve and reinvigorate much of the culture that their ancestors had brought from Canada and nursed through more than a century of pressure to assimilate and Americanize. This cultural renaissance was not, however, without its difficulties, and the Franco-American identity that emerged in the early twenty-first century was not identical to that carried by their forebears in the mid-nineteenth.

New Identities

The spirit of this era can be attributed to three movements of the late 1960s and early 1970s—the civil rights movement in the United States, Quebec's Révolution Tranquille ("Quiet Revolution") and the United States Bicentennial in 1976. The civil rights movement, while focused on the rights of African Americans, did lend a sense of empowerment to other disenfranchised minority groups in the United States. It also coincided with Quebec's Quiet Revolution, which saw an upsurge in Québécois nationalism and self-awareness. Some Québécois explicitly

The skyline of Little Canada, looking toward Auburn, circa 1980. St. Mary's Church is clearly visible. *Courtesy University of Southern Maine, Franco-American Collection.*

drew parallels between race and ethnicity, equating the status of French Canadians (and by extension, Franco-Americans) to that of African Americans. Michèle Lalonde's 1969 poem "Speak White" is one such example that had an influence on some of Lewiston-Auburn's Franco-Americans. The analogy, while limited by the very different historical positions of Franco-American immigrants and African American slaves, did underscore the level of discrimination faced by Franco-Americans in the Northeast and led to an era of heightened consciousness toward anti-Franco-American prejudices and stereotypes.

This backlash against the long-standing discrimination aimed at Franco-Americans is illustrated by the collapse of Maine senator Edmund Muskie's 1972 presidential ambitions. While campaigning in the New Hampshire primary (another state with a large Franco-American presence), a letter published in the *Manchester Union Leader* accused Muskie of referring to Franco-Americans as "Canooks." Although the letter was later revealed as a forgery and much of the backlash against Muskie focused on his emotional response, the incident sent a message to Franco-Americans that use of such discriminatory language was now unacceptable.

Renaissance and Reinvention (1970–2014)

The effects of both the civil rights movement and the Révolution Tranquille were felt in Maine's political scene as well. One direct impact was the repeal of the amendment to the state constitution that imposed an English-language literacy test on voters. The amendment was struck down by a judicial decision in 1983, a result of the passage of the 1970 and 1975 amendments to the Federal Voting Rights Act.[188]

In 1969, the 1919 prohibition against education in French was also reversed, with the initiative coming primarily from the St. John Valley region of Maine. Some opponents simply objected to the introduction of a language other than English into the curriculum. Others equated bilingual education with nationalism and separatism and worried that permitting French-language education would encourage separatism among Franco-Americans in Maine.[189]

For the most part, however, Québécois nationalism did not strike a chord with Franco-Americans in Maine. They saw themselves as full Americans but wanted to acknowledge their French Canadian heritage at the same time. For them, it was "not a question of perpetuating the French-Canadian…what we can have is a good bilingual American." Others reflected that "the Franco-American realizes that Quebec has left him behind…what we have to do here is find a local identity."[190]

There were a number of efforts to define this modern Franco-American identity and to unify the many disparate Franco-Americans to increase the strength of their collective voice. Emblematic to both is the creation of a Franco-American flag by Lewiston native Robert Couturier (1940–2011). Couturier was a prominent leader in the Twin Cities Franco-American communities. He became

The Franco-American flag (bottom), designed by Lewiston attorney Robert Couturier, flies at the Veterans' Memorial Park on Main Street in Lewiston. *Courtesy James Myall.*

mayor of Lewiston in 1965 after just a year in politics and, at twenty-four, was the nation's youngest mayor. After a career in politics, he became an attorney by profession and a continual advocate for Franco-American causes. His contributions to local Franco-American culture included a column in *l'Unité*, a successor to *Le Messager*, and a French-language musical program on radio stations WCOU and WPNO. As mayor, he broadcast weekly addresses by television—a novelty in the 1960s—and in later life, he established Radio Transcription Service, a venture that recorded, among other events, many Franco-American speakers and musical groups for history. For this work, Couturier was recognized by the French government as a Chevalier de l'Ordre des Arts et des Lettres in 2000.

The Franco-American flag designed by Couturier was adopted in 1983 by the Assemblé des Francophones du Nord Est. Its design reflects the hybrid identity of Franco-Americans—blue and white are colors found in the flags of Quebec, France and the United States while the fleur-de-lis and star on the flag represent French and American culture, respectively.

Heritage

Meanwhile, American folk traditions gained a new appreciation in this period, which extended to Franco-American traditions and the integral connections between the music and percussive dance of the English, Irish, Scots and French settlers in North America. Jacqueline Giasson Fuller's short story "Lucy Cowgirl" portrays the relationship of a mother who dresses as a cowgirl to perform country and western music and the daughter who, in counterpoint, chooses to underscore her French and American Indian heritage in Native American dress while dancing to the same music.[191] Singer Rita Côté's reaffirmation of the significance of her own identity parallels other voyages of rediscovery undertaken by assimilated Franco-Americans.

The build-up to the United States bicentennial of 1976 prompted a renewed interest in American history, especially at the local level. Maine's communities were also excited by the state's sesquicentennial celebration of 1970. Cities like Lewiston established local historical commissions to investigate their often-neglected histories. The work of the Lewiston Historical Commission, established in 1969, became a catalyst for the rediscovery of Franco-American history in the Twin Cities, which had often been overlooked in traditional narratives.

Renaissance and Reinvention (1970–2014)

Lewiston Historical Commission at Lewiston City Hall, 1969. *Center*: Mayor John Beliveau; *right*: Louise Forgues and JoAnne Lapointe. *Courtesy University of Southern Maine, Franco-American Collection.*

Serving on the historical commission were JoAnne Lapointe and Louise Forgues, two teachers at St. Dominic High School, who directed members of the senior class to collect traces of the area's Franco-American history. The response from the community was overwhelming, and the teachers were soon inundated with historic material. The need for a systematic effort to collect and preserve this history was clear.

Lapointe and Forgues were among the founding members of the Centre d'Héritage Franco-Américain (Franco-American Heritage Center) in 1972, with the assistance of St. Francis College of Biddeford. The center's aim was not only to preserve Franco-American history and culture through the collection of historic materials but also to promote the value of bilingualism and perpetuate Franco-American culture in the community. In addition to maintaining a library, the center organized public lectures and discussions, held an annual cabaret and sponsored theatrical performances (which revived some of the productions popular

Trustees of the Centre d'Héritage and the *Tit Pitte*, or *Paysan Québécois*, sculpture, Capitol Building, Augusta, 1976. *Courtesy University of Southern Maine, Franco-American Collection.*

in the 1910s and '20s). It received assistance for its work from the government of Quebec, which donated books to the library, sponsored a film festival and arranged a multistate tour of a significant piece of folk art known as the *Paysan Québécois* (*Québécois Countryman*).

Another sign of Franco-Americans' renewed interest in their heritage was the formation of a Franco-American genealogical society in Auburn. The Leo E. Begin Chapter of the American-Canadian Genealogical Society, named for Father Begin, a Dominican who built up a genealogical library over his lifetime, was founded in 1980 and now operates as an independent nonprofit, the Maine Franco-American Genealogical Society.[192] Meanwhile, attempts were made to reverse the effects of continued industrial decline, through repurposing empty structures. The Grand Trunk depot, placed on the new National Register of Historic Places in 1979, was sold by the Lewiston-Auburn Railroad Company and while both city governments were ambivalent about the need to save the structure, several plans were proposed to repurpose it, one of which suggested it become a museum.[193] While this proposal never came

Renaissance and Reinvention (1970–2014)

Grand Trunk Railway Station in Lewiston. *Courtesy Mary Rice-DeFosse.*

Dominican Block on Lincoln Street in Lewiston. The building has been renovated by a property developer. Note the Continental Mill housing to its rear. *Courtesy James Myall.*

to fruition, Museum L/A was established in 1996 (following Lewiston's bicentennial celebrations). It has initially occupied part of the former Bates Mill Complex and plans to establish a permanent home at the former Camden Yarns Mill.[194] Another erstwhile museum site, the empty Dominican Block, was purchased and renovated by property developers.

Raoul Pinette and the Bates College Symposium

An early president of the Centre d'Héritage was Raoul Pinette. The son of Napoléon Pinette, Raoul continued the family mortuary business and became a notable community leader. In reaction to what he called "the gray American with no identity,"[195] he promoted the colorful mosaic of the United States and celebrated ethnic diversity. In 1978, he organized the "First International Symposium: Franco-American Presence in America," held in Lewiston at Bates College on April 7–9, under the auspices of the Centre d'Héritage Franco-Américain. It was funded by the Maine Council for the Humanities and Public Policy, as well as the college and the center. The presence of speakers and participants from the Huguenot Society of America, including secretary Hans French, made the gathering especially unique. The conference placed the Franco-American experience in the larger context of the presence of French-speakers in the New World.[196]

The collaboration between French Roman Catholics and the Protestant Huguenots in organizing the event reinforced the spirit of ecumenism that Father François Drouin had introduced two decades before, but it also uncoupled ethnicity from faith, emphasizing that both Protestants and Catholics of French heritage share a culture. The symposium thus moved beyond questions of faith to focus on ethnicity as a unifying principle. Professor Madeleine Giguère presented on French and American connections while Dominique H. Salman, a retired professor from the University of Montreal, spoke on biculturalism. Evening entertainment included a *soirée canadienne* (a French Canadian evening) in the form of a musical variety show on Saturday night that featured the choirs of Holy Family and Holy Cross churches, harkening back to an early tradition of musical groups associated with the church performing in secular spaces.[197]

In a 1981 interview, Raoul Pinette insisted that he was an "American first" but one with ancestors in France and Canada: "My heart is in America first. I fought for this flag. So I'm not confused at all." Pinette believed that within

the American context, you could succeed "if you develop the talents your genes give you." Pinette promoted an American pluralism of genetically distinct ethnic and racial groups that cooperate among themselves to produce a healthy whole. "The suspicions go to pieces. We begin to respect ourselves. We begin to respect the other people around us."[198] While Pinette's emphasis on genetic distinctions is open to question, his broader vision departs considerably from the exclusionist discourse on either side of the struggle between assimilation and Survivance.

Festivals

Another example of cultural reinvention in this era comes from the changes to the tradition of celebrating Franco-American identity through festivals. While the St. Jean-Baptiste Day festivities, organized by the Institut Jacques Cartier and the various Franco-American parishes, came to an end, celebration of Franco-American pride continued in new form. The Festival in the Park, a weeklong celebration of Franco-American heritage in Lewiston's Kennedy Park (formerly City Park), debuted in 1976. The festival was supported by the city governments and L'Unité Française, an umbrella group for local Franco-American organizations established by former Lewiston mayor Roméo Boisvert. The Festival in the Park was the first in Maine to showcase Franco-American culture and one of the largest ethnic festivals in New England. The central tent was the Café C'est Si Bon (It's So Good Café), which served traditional foods like *crêpes* and *tourtières*. The festival orchestra, headed up by singer Ray Chouinard, sported the same name as the café. There were arts and crafts, a children's day and a senior's day, but in addition to food, the mainstay of the festival was musical acts from Quebec and France, as well as local talent. There were also carnival rides. Each year, a young local woman was chosen as festival queen. In its first year, the organizers were Ronald Bissonnette and Connie Côté. Côté would remain a prime mover for the festival for all its existence.

Connie Côté was already a well-known figure in the Twin Cities and remains a familiar face at Franco-American events. Even as a girl, she had played the organ, first accompanying the children's choir of St. Peter's School and then playing at Masses at Sts. Peter & Paul and St. Patrick's. Her mother encouraged her musical aspirations, and her father was a tenor with l'Orphéon.[199] She and her husband, Bert, later played organ and piano,

"Ms. Festival" in Lewiston, 1977. *Courtesy University of Southern Maine, Franco-American Collection.*

respectively, on the *Bert and Connie Show* on WCOU. The couple introduced the first musical productions at the Community Little Theater, an amateur theater company with strong ties to the Franco-American theatrical legacy in the Twin Cities. She also directed stage productions of perennial favorites in the Twin Cities, *La Veuve Joyeuse* (1975) and *Les Cloches de Corneville* (1983, see Chapter 2) at the Centre d'Héritage Franco-Américain, where she was also coordinator for three years.

Renaissance and Reinvention (1970–2014)

La Veuve Joyeuse in Lewiston, 1976. This revival of the perennial favorite was sponsored by the Centre d'Héritage. *Courtesy University of Southern Maine, Franco-American Collection.*

Côté remains best known as a radio personality. In a career spanning decades on several stations, beginning in 1967 and continuing today, she has broadcast a Sunday show in French. Though now regarded as a symbol of French-language survival, Côté, like others of her generation, was not fluent in French when she began broadcasting, despite it being her first language. She later recalled that in 1967, she "hadn't spoken French in 20 or 25 years" and that "most people didn't' realize" that she spoke French.[200] Appropriately enough, the presence of her show would allow listeners to retain and rediscover their own French language.

Côté was also active in politics; she served twelve years (six terms) in the Maine House of Representatives, a public service that overlapped with her work on the Festival in the Park. She was also an Androscoggin County commissioner.

The Franco-Americans of Lewiston-Auburn

Festival Triumphs and Troubles

Côté's direction of *Les Cloches de Corneville*, with a cast of more than sixty, at the 1983 festival was an important milestone that showed its integral connection to the past. By that time, the operetta had been performed multiple times in the Twin Cities in productions by the Club Musical-Littéraire (1896), the St. Louis Church Choir (1912, 1925) and the Philharmonic Club (1929). It had also been performed at the Music Hall on Lisbon Street in 1942. Marie Louise Nadeau, who had played the female lead in the 1924 production and in a production of *La Fille du Tambour Major* (see Chapter 2), was still

Alexis Côté, May 1950. Côté provided musical direction for St. Louis Parish, l'Orphéon and the Centre d'Héritage. *Courtesy University of Southern Maine, Franco-American Collection.*

living, as was her sister, Lorette, also a former player. Marie Louise gave a commentary on the play to the *Lewiston Daily Sun*.[201]

At its peak, crowds at the Festival in the Park approached 175,000 people from year to year;[202] in 1977, when the economy was weak, the event did not break even, and the city covered the relatively small overage in its budget (about $2,900).[203] In a throwback to early views of French Canadians, when festival organizers sought a seven-day license to sell beer and wine from the state legislature, a measure was presented as emergency legislation by Representative Paul Nadeau. Organizers had previously circumvented the three-day limit by operating under a borrowed license. The proposal was not without controversy. Reverend Benjamin Bubar, a member of the Christian Civic League, criticized the proposal, saying, "Since when does promoting a booze bash constitute an emergency?" and suggesting that drinking was the main reason for festivals.[204] The legislation, however, passed. The café, which had been open only to adults after 8:00 p.m. since 1981, generated an important part of the festival's revenues.

The Centre d'Héritage's Musée en Marche (Museum on Wheels) at the Franco-American Festival, Lewiston, 1977. *Courtesy University of Southern Maine, Franco-American Collection.*

The Festival in the Park's open-air venue posed a challenge for security. Its atmosphere was criticized as carnival-esque. Altercations broke out in 1984,[205] and after one last year in the park in 1985, the event was held at the Central Maine Youth Center (as St. Dominic's Arena had been rebranded). However, the new venue made access more difficult, and attendance dropped precipitously, as did revenues. The festival owed the city $5,000 after the 1986 festival, and the 1987 festival was cancelled.[206]

Festival de Joie

After a hiatus of seven years, the festival was reinvented as the Festival de Joie by Council 106 of the Knights of Columbus. The *Lewiston Sun Journal* applauded the return, stating in an editorial, "The community needs and deserves a celebration of its linguistic and cultural roots."[207] The Festival de Joie was first held in 1993 in the Central Maine Civic Center (the renamed CMYC, under new ownership) and on the adjoining Drouin field. Businessman, and later mayor of Lewiston, Lionel Guay became its chief coordinator, stepping in when illness and injury sidelined others. However, like its previous incarnation in the park, countless community members were involved as organizers or as volunteers. A prelude to the festival, introduced in 1998, included a parade, sidewalk cafés and performers that reinvigorated Lisbon Street.[208] In later years, the festival was held at Railroad Park, now Simard-Payne Park, on the river in Little Canada. The C'est Si Bon Café and Band were still integral parts of the event. The Festival de Joie, according to Guay, required a planning process that began within a month of the last festival. The festival became even more dependent on fundraising, as the proceeds of the gate alone were insufficient to pay for multiethnic entertainment at the event's multiple stages, as many as five. Still, the Franco-American heritage remained the reason for the festival.[209]

Higher Education

In the wake of the failure of the 1987 festival, the Centre d'Héritage disbanded and transferred its historic material to the University of Maine System, which, in 1988, opened its long-awaited campus in the state's second-largest metropolitan

area. The historic materials continued to be organized as the Centre d'Héritage Franco-Américain but would eventually become known as the Collection d'Héritage Franco-Américaine and then the Franco-American Collection, or Collection Franco-Américaine. The first director of the collection at its new home (which would eventually become the Lewiston-Auburn College of the University of Southern Maine) was Madeleine Giguère (1925–2004), a noted sociology professor at USM who had been among the first trustees of the center back in 1972.

Giguère became known as the *marraine* (godmother) of Lewiston-Auburn's Franco-Americans. A Lewiston native, Giguère taught at USM for more than twenty years, beginning in 1967. During that time, she developed a reputation as an expert on the U.S. census and the demographics of Franco-American populations in the Northeast. She was influential in the Census Bureau's decision to ask respondents about their ancestry for the first time in 1980—crucial for studying Franco-Americans, who were often neither immigrants themselves nor the children of immigrants (the two groups enumerated by the existing questions). Her studies of census data examined language maintenance, economic status and political affiliations among the contemporary Franco-American population, often for the first time.[210]

Madeleine Giguère, circa 1990. *Courtesy University of Southern Maine, Franco-American Collection.*

Her work was not, however, purely academic. Giguère was an advocate for the rights of Franco-Americans and women at USM and more broadly. Her efforts to recognize Franco-Americans at USM coincided with those of others at the University of Maine in Orono—though they sometimes disagreed on methods. Giguère's expertise was widely recognized, and she served on numerous state and federal committees, including the U.S.

Members of the Lewiston MAINEiacs hockey team visit USM's Franco-American Collection, 2006. *Back*: collection coordinator Donat Boisvert. *Courtesy University of Southern Maine, Franco-American Collection.*

Advisory Commission on Civil Rights in 1979. In 1992, she was honored by the Library of Congress for her work in preserving Acadian culture.

Giguère oversaw the Franco-American Collection at USM until 1997 but continued to be a strong supporter of the institution. Upon her death in 2004, she bequeathed an endowment to the collection, which assisted in its long-term operations and offered a scholarship to local students of Franco-American history and culture. The collection established a program of French North American studies at USM, under collection scholar professor Barry Rodrigue, and worked to integrate Franco-American history and culture into curricula across the university. The collection continues to sponsor a number of public events—conferences, exhibits, a monthly French-language sing-along, book readings and academic lectures.

Renaissance and Reinvention (1970–2014)

Catholic Church and School Consolidation

One of the many supporters of a public university campus in Lewiston-Auburn had been Father Drouin, the longtime campaigner for education for Franco-Americans.[211] Drouin was reassigned from the pastorate at Sts. Peter & Paul to the Dominican University in Ottawa in 1952 but returned to Lewiston in 1975 as a spiritual advisor to the parish. At a farewell party in 1952, the ever-modest pastor joked that he had been "canonized before [his] death."[212] This turned out to be close to the truth. His funeral in early January 1986 was held the day after a blizzard yet was attended by more than one thousand people, including Governor Joseph Brennan, who called him "a leader in the fight for social justice, in educational, recreational and economic opportunity."[213]

Drouin's funeral was held in the upper church of Sts. Peter & Paul—a rare occurrence by that time, since the cost of heating and maintaining the vast space had forced the Dominicans to hold most services in the basement. Increasing costs and declining enrollment in the order as a whole meant that soon after the death of Father Drouin, the Dominican Order relinquished the parish to the diocese after 105 years of ownership. St. Dominic High School was likewise transferred to the diocese, and the arena would be sold in 1989.

The diocese and parish soon faced the difficult decision of the church's fate. When the church was dedicated in 1938, the parish had sixteen thousand members; by 1991, that number had declined to four thousand. The building required not only deferred maintenance repairs but also modernization to meet both legal requirements (e.g. fire alarms) and liturgical ones—the altar had not yet been modified to allow the priest to face the congregation as required by Vatican II.[214]

In the end, a fundraising campaign was launched to save the building, partly due to the immense cost of demolition ($1.5 million). The sale of the arena allowed for an endowment for future maintenance, and the diocese contributed $200,000, but $2 million was still required of the parishioners, who fulfilled that goal in an effort reminiscent of the original building campaign. The church's Franco-American roots were key to the fundraising efforts, and the campaign was entitled "A Journey of Faith/*Marchons Ensemble dans la Foi.*"[215] Their efforts were rewarded in 2004, when the Vatican bestowed the rare status of minor basilica on the church—the only such example in northern New England and one of a few dozen in the United States.

Dwindling numbers of both parishioners and priests would continue to trouble Catholic parishes across Maine, particularly in cities like Lewiston-

Auburn. In 1996, the ill health of the two priests at St. Patrick's provided the catalyst for a twinning of that parish with Sts. Peter & Paul, an arrangement whereby the two parishes shared personnel. This model, which had already been established elsewhere in Maine, was also applied to St. Mary's, which was twinned with St. Louis after the retirement of its pastor.

Further changes were to come. In 2000, dwindling numbers of parishioners at St. Mary's, Lewiston's second-oldest church, forced the Roman Catholic diocese of Portland to announce the closing of the parish. The closing of St. Mary's Church was merely the beginning of a reorganization of parishes that was to continue for over a decade. Parishes in Auburn were consolidated as Immaculate Heart of Mary parish in 2006;[216] the last Mass at St. Louis Church took place on August 29, 2013, because of the building's structural instability.[217] The remaining Lewiston parishes became the Prince of Peace parish,[218] the St. Joseph's Church building was sold to Central Maine Medical Center and St. Patrick's was sold to a developer.

Franco-American parish schools likewise experienced dwindling attendance, and forecasts based on baptisms suggested that enrollments would continue to decrease. In the 1950s, at their height, the parochial school enrollment was 1,000 in Auburn and 4,500 in Lewiston—more than that city's public school enrollment.[219] By 2010, total enrollment had declined to 600. In addition to the increased costs incurred by the Vatican II changes, the various religious orders had difficulty maintaining the numbers needed to staff the schools. In 1968, within the same week, both the Dominican and Ursuline sisters announced their departure from Lewiston, resulting in the closure of St. Mary's School. Some of the Dominican sisters retreated only to the convent in Sabattus, where some still live today.[220] In 1973, Holy Family School closed because there were no longer sufficient numbers of clergy members to teach and the cost of salaries for lay teachers was prohibitive.[221] Other closings followed. The remaining schools—Holy Cross, Saint Joseph's and St. Peter's–Sacred Heart—were first combined in the Trinity Catholic School in 2006. All the Catholic schools in Lewiston-Auburn would soon be subsumed into the upper and lower levels in St. Dominic Academy in 2010, with prekindergarten to sixth grade at the former Holy Cross School in Lewiston and middle and high schools at the Saint Dominic High School campus in Auburn,[222] where the high school had moved in 2002.[223] Parishes attached to a single ethnic identity were now a distant memory.

Renaissance and Reinvention (1970–2014)

Franco Center for Heritage and the Performing Arts

When the first church closing was announced, there was a groundswell of feeling that St. Mary's Church, in the heart of the neighborhood once known as Little Canada, was too precious a part of the community to lose. Lionel Guay organized a committee who asked the diocese to sell them the grand old church for $1. The plan was to create a site for the preservation of Franco-American history and traditions in the deconsecrated church. The Franco-American Heritage Center was established as a nonprofit organization for this purpose. The name was a nod to the Centre d'Héritage Franco-Américain that ignored the archive of the same name at Lewiston-Auburn College. The new center's first task was to raise the funds necessary to repair the building, especially its stonework, and later to renovate the nave of the church and create a performance hall. Under executive director Rita Dubé, who moved from her original role as a board member, the center received substantial support from a $1 million state bond package sponsored by senate president pro-tem Michael Michaud, Senator Peggy Roundo and Representative Richard Mailhot; a U.S. Department of Agriculture rural development grant of a $367,500 in 2004; and gifts from over one thousand donors in that same year, as well as support from numerous local businesses.[224] Over $6 million has been raised through the efforts of Dubé; her successors, Louis Morin and Mitchell Clyde Thomas; and the center's board and community members.

At least 25 percent of the programming at the center is dedicated to the cultural heritage of Franco-Americans. One of the most important series in this programming is la Rencontre (the Get-Together), a monthly noonday meal for French-speakers followed by entertainment. Those who lapse into English must pay a quarter each time they do so. The event is, in fact, a continuation of French Fridays, a practice established in the 1990s among a group of up to forty French-speakers who met for lunch in the backroom of Marois Restaurant on Lisbon Street or at Rolandeau's Restaurant in Auburn. At the center's beginning, la Rencontre took place in the upper part of the former church, but now it takes place in the renovated lower level, known as the Heritage Hall, which it fills to capacity (275).[225]

As the Franco Center for Heritage and the Performing Arts, the organization focuses primarily on performance, continuing the legacy established by the Club Musical-Littéraire and others. True to its mission, it also offers reacquisition classes in the French language and classes for children. It has participated in

Performance Hall, Franco Center for Heritage and the Performing Arts, Lewiston, 2014. The former St. Mary's Church has undergone a significant transformation. *Courtesy Franco Center.*

the Maine French Heritage Language Program in Auburn schools. It hosts a program each year to mark la Semaine de la Francophonie (the Week of the Francophone World). The event is usually attended by dignitaries from the Québécois, Canadian and French governments, as well as state and local officials.

New Media

The establishment of the Franco Center represents a resurgence of Franco-American cultural institutions following a period of long decline. The gap was particularly noticeable following the extinction of *Le Messager* in 1966. A gathering of local Franco-Americans in 1974 examined the question of communication among the community and laid bare a disagreement about the necessity of maintaining the French language as a cornerstone of Franco-American identity.

Le Messager had become economically unviable in large part because of the decline of the French language in Lewiston and Auburn, so while some

on the 1974 panel called for the reestablishment of a French paper in the Twin Cities, the prospects were poor. An alternative, to include a French-language column in one of the two English newspapers, was dismissed on technical grounds by an editor at the *Lewiston Evening Journal*, Paul Paré, since the English press had no means of producing the accent marks necessary for French printing. Paré maintained that Franco-Americans, even in Lewiston-Auburn, "lived in an Anglo world" and that Franco-American voices within the English-language media were required.[226]

This debate revived many old concerns. While *Le Messager* had, somewhat ironically, called for Franco-Americans to learn English from its very establishment, the Survivance movement was promulgated on maintaining French culture through its language. But in the late twentieth century, the institutions that supported that effort—newspapers, schools and social clubs—were disappearing, and Franco-Americans faced a choice between defining themselves solely in linguistic terms or embracing a Franco-American identity without the French language. In an effort to appeal to a wider audience and avert decline, some organizations chose the latter, with the parochial schools and many of the social clubs changing their organization to allow for the admission of English-speakers.

At the 1974 panel, Robert Couturier (whose brother Ronald had been among the last editors of *Le Messager*) asserted that the Franco-American press was "nearly 100 per cent dead" and proposed that future efforts focus on radio and especially television. The advent of cable TV offered the Twin Cities' Franco-Americans access to the newly resurgent culture of Quebec. In the 1970s and '80s, the Lewiston-Auburn area was the only market in Maine to receive two French-language cable television channels, CHLT and CKSH, both broadcast from Sherbrooke, Quebec. Popular programming included historical documentaries, music shows and hockey matches.

In 1986, the local cable provider, Adams-Russell, decided to drop one of the channels (CHLT) to make room for other English-language offerings (the inclusion of two French channels had originally been due to the difficulty in broadcasting the signal from Quebec, since two channels meant a greater likelihood that one would be broadcast). Many local Franco-Americans expressed dismay at losing a link to their culture, heritage and language. They petitioned both the cable company and the Lewiston City Council, asking it to intervene with Adams-Russell since the company was operating under a contract with the city. While the 1980 contract included no requirement to maintain French-language TV, Mayor Alfred Plourde appointed a committee to study the possibility of creating a city-owned cable

franchise to offer French programming. Public pressure succeeded in forcing the cable company to reinstate CHLT.[227]

In 1999, a third Francophone channel was added to the lineup—TV 5 Monde, an international French-language channel. Lewiston-Auburn was the first American market for the channel, and this time, the city did include the provision of French-language programming in the negotiations for the company to be awarded the local franchise.[228] The continued demand for French-language television in Lewiston-Auburn, not to mention the long-running success of radio broadcaster Connie Côté, demonstrates a feature of French-language survival in the region. While French is sometimes heard on the streets or in the stores of Lewiston and Auburn, it is a language especially in use in the privacy of one's home or within families. This trend is reflected in religious life as well. While the French-language masses have declined in number (though not ceased entirely), for many Franco-Americans, French remains the language of prayer.

The advent of the Internet age has offered possibilities for building a wider Franco-American community. Social media sites offer Franco-Americans a way to connect with one another and their shared heritage across the continent. Groups like the Franco-American Women's Institute, founded in 1996 by Rhea Côté Robbins of Brewer, Maine, have found homes online,[229] offering them a global reach with minimal overhead costs. This medium allows small groups to thrive and allows Franco-Americans to share their experiences beyond their traditional home regions.

Forum Francophone des Affaires

A bilingual population with geographic proximity to French-speaking Canada has been recognized as an economic asset on numerous occasions by community leaders.[230] In January 1997, the United States became the thirty-seventh country to establish a chapter of the Forum Francophone des Affaires ("Francophone Business Forum"), a global trade network that creates and promotes opportunities for business partnerships in French-speaking countries.[231] In September of that year, board members determined, in a competitive selection process, that the U.S. headquarters for the organization would be in Lewiston.[232] Lewiston mayor John Jenkins, Norm Renaud of the chamber of commerce and project coordinator Ray Lagueux played significant roles in securing the Twin Cities' position as a

vibrant center of Franco-American heritage despite competing bids from other Maine cities such as Bangor, Augusta and Biddeford. Both Lewiston and Auburn City Councils pledged funds to support the headquarters, as did local businesses. In 2000, the forum merged with the Maine International Trade Center.[233] Lewiston's selection as home to the FFA was a significant moment in the Franco-American renaissance and a signal that the region's Franco-American heritage could be an economic advantage.[234]

Frenchie

A growing assertiveness by Franco-Americans in the Twin Cities to promote their value as a community was accompanied by an increased willingness to speak up in their own defense. In 1993, a furor erupted around Ernie Gagne of Auburn, who for seven years had been calling a Portland-based radio station, WBLM, in character as Frenchie, an uneducated Franco-American janitor with a pronounced accent. To many, Frenchie perpetuated a number of derogatory stereotypes about Franco-Americans. In January, a complaint was filed with the Maine Civil Rights Commission, drawing attention to the character. The Association Canado-Américaine, a mutual assurance group headquartered in Manchester, New Hampshire, led calls to remove the segment from the air, threatening to file a complaint with the Federal Communications Commission. Opposition to Frenchie included many prominent politicians and leaders in the Lewiston-Auburn Franco-American community like Robert Couturier (who served as attorney for the ACA) and Madeleine Giguère.

However, not all Franco-Americans objected to Frenchie's skits. Some supported what they characterized as "light-hearted humor" and derided an abundance of "political correctness." Their defense noted that the initial complaint came not from a Franco-American but from Jed Davis, an attorney and director of the Holocaust and Human Rights Center in Augusta. A group called Francos for Frenchie, led by Louis-Philippe Gagne, a cousin of Ernie (and namesake and grandson of the former *Le Messager* editor and snowshoer), defended Gagne and called for the character's reinstatement after Gagne voluntarily retired Frenchie in February. Though short-lived, the affair garnered international attention, with coverage in the *New York Times* and on National Public Radio and the Canadian Broadcasting Corporation.[235]

Political Shifts

Just as Lewiston-Auburn's Franco-Americans were divided in their reactions to Frenchie and his retirement, they were becoming more politically diverse as a community. For most of the twentieth century, the status of Lewiston as a Democratic stronghold endured, thanks in large part to the loyalty of the Franco-American community. This allowed the careers of several prominent Franco-American lawmakers to flourish, none

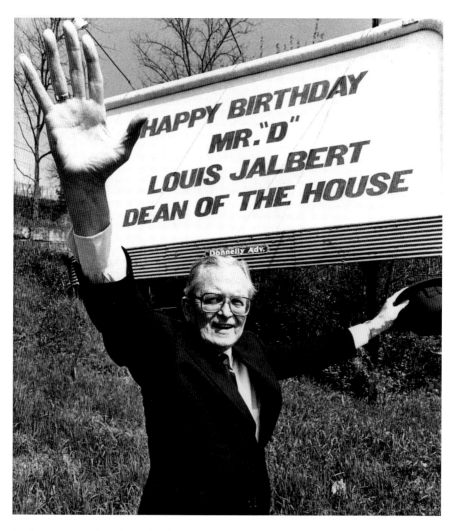

Louis Jalbert on Water Street in Hallowell, 1975–84. This sign was erected by clerk of the House Ed Pert. *Courtesy University of Southern Maine, Franco-American Collection.*

more so than Louis Jalbert, a Lewiston lawyer whose record thirty-eight-year stint in Augusta (1945–84) earned him not only the honorific title of "Dean of the House" but also the commonly applied nickname "Mr. Democrat." Jalbert used his influence to bring state funds to the Twin Cities—notably for the establishment of Central Maine Community College in Auburn and the construction of the Veterans' Memorial Bridge linking the two cities.

The Twin Cities' political landscape also led to a brief moment of national attention. Senator John F. Kennedy made Lewiston the final stop of his 1960 presidential campaign on November 6. Lewiston was not only important as a Democratic city in a swing state but also as Maine's Catholic stronghold for the man seeking to be the nation's first Catholic president. It's also possible that the need for an Irish American to win over Franco-American voters was not lost on the Massachusetts senator. A long delay meant that Kennedy's speech at the bandstand in the City Park did not begin until midnight. Nonetheless, eight thousand of the earlier crowd of fourteen thousand remained in the freezing weather for him. After the president's assassination, the park was renamed for him in commemoration of the visit.[236]

Some recent Lewiston lawmakers have, however, gained a reputation for independent-mindedness. A prime example is the career of Democratic state representative Georgette Beauparlant Bérubé (1927–2005) of Lewiston. During her twenty-six years in the legislature (1970–82, 1984–96 and 1998–2000), Bérubé built a reputation as a politician who was willing to challenge party orthodoxy. In 1978, she and Madeleine Giguère publically endorsed the Republican candidate for the U.S. Senate, William Cohen, which led to her dismissal from the Androscoggin Women Democrats.[237] In 1982, she quit the legislature to run against incumbent governor Joseph Brennan in the Democratic primary, making her not only the first woman to run for governor in Maine but also the first Franco-American to do so.[238] She was a keen promoter of Franco-American pride. Bérubé was closely involved with the Centre d'Héritage and, in 1973, gave an address in French on the floor of the Maine House of Representatives to mark St. Jean-Baptiste Day.[239]

In recent decades, some political observers have seen Franco-Americans as a key swing voting group in Maine's elections. The drift of Franco-Americans away from the Democratic Party is partly attributed to the elimination of straight ticket voting (also known as the Big Box) but also to some innately Franco-American characteristics—strong affiliations with groups and local communities, as well as entrepreneurialism—which could be identified as Republican values. Nationally, the presence of

Catholic voters as part of the New Deal–era Democratic coalition has come into doubt as some of these voters prioritize the Republican Party's conservative stance on social issues.[240]

Given this shift in Franco-American politics, what would once have been unthinkable becomes less surprising—that Maine's first Franco-American governor would be a Republican. Paul LePage, born in Lewiston in 1948, emerged victorious from a hotly contested election season in 2010.

Although LePage was mayor of Waterville at the time of his election, his upbringing in Lewiston's Little Canada, though not necessarily typical of Franco-American life in the 1940s and '50s, became a key part of his campaign narrative. One of eighteen siblings, Paul LePage spent many of his formative years in an apartment block on Lisbon Street that, by his own recollection, housed eighty-eight children. His father, Gerard, was an abusive alcoholic, and Paul ran away from home at age eleven to spend several years on the streets of Little Canada until taken in by a Franco-American couple, Eddie and Pauline Collins, owners of Theriault's Café.[241] Theriault's was a neighborhood hub—the Collinses, for example, allowed families to bring pots of beans to bake overnight in their still-warm bread ovens.[242] This combination of a hardscrabble childhood and help from his neighbors would shape LePage's political outlook.

The difficult upbringing was also consistent with LePage's image as a blunt-spoken, anti-establishment candidate, connected with his working-class roots. At a 2011 reception at the Franco-American Heritage Center in Lewiston, the governor joked that he had spent many hours in the former church's confession box and offered an anecdote in which, as a teenager, he hid in the building's side alley to ambush smaller children for their candy on Halloween.[243]

Lewiston-Auburn was a particular focus for the LePage campaign, and the candidate won the vote in the traditionally Democratic stronghold. Commentators ascribed this both to the strong campaign waged locally and to the candidate's Franco-American background.[244] During his first term in office, the governor, while not defining his tenure by his Franco-American ethnicity, made no secret of the fact and indeed openly invoked it on several occasions—for example, in trade negotiations with Quebec's Premier Pauline Marois[245] and during the 2014 State of the State Address, during which he conversed in French with an Acadian student from Bowdoin College.[246]

In the 2014 Maine gubernatorial race, two Franco-Americans were on the ballot—a first anywhere in the United States. LePage's challenger, Democratic congressman Michael Michaud, launched his gubernatorial bid at the Franco Center in Lewiston. Michaud and LePage, while sharing Franco-American

upbringings, developed differing political outlooks. Both are seen as fiscally conservative, but while LePage became a business consultant, Michaud's pre-congressional career was as a forklift operator at the Great Northern Paper Company in East Millinocket. Both Michaud and LePage were raised as Catholics, but Michaud's views on social issues have "evolved" from conservative to more liberal positions on both abortion and same-sex marriage during his time in office. The 2014 gubernatorial campaign began with a surprise when Michaud announced he was gay, putting him in a position to be the first openly gay governor to be elected in the United States.[247]

Michaud, the first openly Franco-American candidate elected to federal office in Maine, has been popular in Lewiston-Auburn since his first campaign for Congress in 2002. Like LePage, he has seen his ancestry as an electoral asset rather than the liability it would have been only a generation or two earlier. LePage defeated Michaud to win reelection in 2014 in a campaign that saw him again promote his Franco-American origins and win Lewiston by a good margin. He took New Jersey governor Chris Christie on a tour of Lewiston's Little Canada and held his victory rally in the Franco Center. In another first, Michaud was succeeded as congressman by Republican Bruce Polliquin, another Franco-American. The ability of Franco-Americans to not only win election to statewide and federal office but also to make their heritage an electoral advantage marks a milestone in the community's history in Maine.

A New Immigrant Story

Franco Americans are now, for the most part, among the longest residents of the Twin Cities. While they were followed in the late nineteenth and early twentieth centuries by groups of Eastern European Jews, Poles, Italians and Lithuanians (among others), there was little significant immigration to Lewiston-Auburn in the period after World War II. This changed in 1999, when it was announced that a group of Togolese refugees, fleeing violence in their homeland, were to be resettled in Lewiston-Auburn by Catholic Charities of Maine.[248] These new arrivals were a small group of French-speaking Catholics, and they were paired with local partners who helped them adjust. A more difficult adjustment happened when a larger population of Somali refugees, also resettled by Catholic Charities, came to the Twin Cities in 2001. Their numbers were larger (though still relatively small compared to French Canadian immigration), and their language, religion

(Islam), dress and race were noticeably different. In effect, they represented the same kind of differences that French Canadians had presented a century or so earlier (in an era when French ancestry was seen as a racial difference).

However, the circumstances for new arrivals were also different: the role that Catholic missionaries had played in support of the French Canadians had been replaced by government support of those who needed the same kinds of services once provided by, for example, the missionary orders of Dominican priests and nuns and Sisters of Charity. Like other religious orders, most of the Sisters of Charity have departed,[249] but the institutions they founded continue as resources for the community, including new immigrants. St. Mary's Regional Medical Center is now a contemporary nonprofit organization.

The Somalis' welcome was not always ensured; support for this new group was a divisive issue for the community, Franco-Americans included. This is in part because people interpret the Franco-American story and the current situation very differently. In 2006, when a columnist in the *Sun Journal* compared contemporary immigrants to those who came from Canada and Europe, L. Fernand Bussière responded in a letter to the editor that articulates this point of view: "The immigrants back then chose to settle here and took jobs in the mills and shoe shops, built schools and churches, and paid their taxes. They were not after any aid of any kind…We worked hard to accomplish what we have, and we are proud of it."[250]

Former Franco-American mayors Laurier (Larry) Raymond and Laurent (Larry) Gilbert, both Democrats, have shown very different attitudes toward the Somali influx. Raymond sparked a fierce debate with the publication of an open letter to the Somali community, asking them to tell their compatriots to "exercise some discipline and reduce the stress on our limited financial resources and generosity."[251] While even critics of his approach confirmed that Raymond's intentions were not racist, the comments were controversial. Gilbert, Raymond's successor, made a conscious effort to draw positive comparisons between the Franco-American and Somali communities.[252] Most recently, French-speaking refugees and immigrants from places like Djibouti, Rwanda, Chad and the Congo can be heard on the streets surrounding Kennedy Park and places like the Lewiston Public Library.[253]

A century and a half after its beginnings in Lewiston-Auburn, the Franco-American community in the Twin Cities has preserved its sense of identity and connection to its heritage. Yet as the twenty-first century begins, Franco-Americans find themselves redefining what it means to be a Franco-American and an immigrant and continue to negotiate their relationship with the wider American world.

Notes

Abbreviations:
BDN: *Bangor (Maine) Daily News*
BFA: Bates College Franco-American Oral History Project, Bates College, Lewiston
FAC: Franco-American Collection, University of Southern Maine, Lewiston-Auburn College
LDS: *Lewiston (Maine) Daily Sun*
LEJ: *Lewiston (Maine) Evening Journal*
LSJ: *(Lewiston, Maine) Sun-Journal*
MASC: Edmund S. Muskie Archives and Special Collections Library, Bates College, Lewiston. Edmund S. Muskie Oral History Collection
PPH: *Portland (Maine) Press Herald*

Chapter 1

1. James Myall, *Franco-Americans in Maine* (Lewiston, ME, 2012), http://usm.maine.edu/franco/state-maine-task-force-franco-americans.
2. Charlotte Michaud, "Early Franco-American Medical Men," *LEJ*, April 10, 1970.
3. James G. Elder, *A History of Lewiston, Maine*, edited by David and Elizabeth King Young (Bowie, MD: Heritage Books, 1989), 15.

4. James Leamon, *Historic Lewiston: A Textile City in Transition* (Auburn: Central Maine Vocational Technical Institute, 1976), 8–10.
5. Ibid., 10–14.
6. Geo. Varney, *History of Lewiston, Maine from A Gazetteer of the State of Maine* (Boston: B.B. Rusell, 1886), http://history.rays-place.com/me/lewiston-me.htm.
7. *Historical Sketch of Auburn, Maine* (Boston: Mercantile Publishing Co., 1889), http://history.rays-place.com/me/auburn.htm.
8. Lewiston School Department Records 1913–14, Manuscript, MASC, MC110.
9. Elder, *History of Lewiston*, 107–08. See also *Album Souvenir du 75e Anniversaire de la Paroisse Saint-Pierre et Saint-Paul de Lewiston, Maine* (Lewiston, ME, 1946).
10. *Album Centenaire Paroisse Saint-Pierre et Saint-Paul* (Lewiston, ME, 1971).
11. Yves Frenette, "La Genèse d'Une Communauté Franco-Canadienne en Nouvelle-Angleterre: Lewiston, Maine, 1860–1880" (doctoral thesis, Université Laval, 1988).
12. *Lewiston (Maine) Saturday Journal*, "At Your Door: The Little World They Call 'Little Canada,'" October 24, 1891, 8.
13. Ibid.
14. George R. Blouin, "The Franco-American Foundations of Lewiston: An Historical Sketch (1900)," manuscript (Lewiston, ME, 1975), 13.
15. Frenette, "Genèse d'Une Communauté Franco-Canadienne," 185.
16. Célestine Lavigne, interview with Suzanne Roy, Lewiston, ME, July 7, 1977, FAC.
17. Maurice Labrie, interview with James Myall, Lewiston, ME, July 25, 2013, FAC.
18. Frenette, "Genèse d'Une Communauté Franco-Canadienne," 184.
19. Ibid., 192–93.
20. "Recensement de la Paroisse Saints Pierre et Paul, " manuscript, Lewiston, ME, 1893, FAC, Sts. Peter & Paul Papers. Authors' analysis.
21. U.S. Census Bureau, U.S. census (Washington, D.C.: Government Printing Office, 1910). Authors' analysis.
22. Frenette, "Genèse d'Une Communauté Franco-Canadienne," 193–94.
23. Camille Lessard-Bissonnette, *Canuck* (Lewiston, ME: Le Messager, 1936). See also Janet Shideler, *Camille Lessard-Bissonnette: The Quiet Evolution of French Canadian Immigrants in New England* (New York: Peter Lang, 1998), 8–20.
24. Frenette, "Genèse d'Une Communauté Franco-Canadienne," 196.
25. Amédée Fournier, interviewed by Suzanne Roy, July 5, 1977, FAC.
26. Blouin, *Franco-American Foundations*, 30.

27. *LEJ,* "New French Catholic Church," May 5, 1873, 3.
28. Elder, *History of Lewiston,* 72.
29. Germaine Martel Hebert, interview with Sharon Halperin, Lewiston, ME, 1978, FAC.
30. Susan Pearman Hudson, *The Quiet Revolutionaries: How the Grey Nuns Changed the Social Welfare Paradigm of Lewiston, Maine* (New York: Routledge, 2006).
31. Plourde, *Album Centenaire,* 20.
32. Blouin, *Franco-American Foundations,* 42.
33. Louis Mothon, "La Mission de Lewiston," *L'Année Dominicaine* 396–8 (1893): 241–51, 304–19, 349–58.
34. Blouin, *Franco-American Foundations,* 50.
35. "Jean-Baptiste Couture: A Biography," manuscript, FAC, Jean-Baptiste Couture Papers.
36. *Lewiston (Maine) Saturday Journal,* "The New Hospital of the Sisters of Charity in Lewiston," May 12, 1900, 13.
37. Mothon, "La Mission de Lewiston," 311.
38. Marguerite Stapleton, interview with Mary Rice-DeFosse, June 1, 2011, BFA.
39. Leda Tancrel Raymond Martel, "Successful 19th Century Immigrants," manuscript, FAC, Tancrel Family Papers.
40. Marthe Rivard, interview with Sarah Buss and Kate Harmsworth, June 28, 2006, BFA.

Chapter 2

41. Determining the exact size of the Franco-American population in Lewiston-Auburn is difficult, and figures vary accordingly. The authors' analysis of the 1910 U.S. census puts the Franco-American population of Lewiston at 13,511, or 51.5 percent of the city's population. The 1893 census of Sts. Peter & Paul's Parish lists 10,695 communicants. Taking into account the nearly 800 people living in Auburn, this represents up to 46.0 percent of Lewiston's population at this time. Frenette, "Genèse d'Une Communauté Franco-Canadienne," 340, estimates the French-speaking population of Lewiston at 40.0 percent in the period between 1895 and 1905.
42. Fournier, interview.
43. *LDS,* "F.X. Marcotte Dies at 83," October 23, 1942, 1, 6; "Marcotte Leaves $10,000 for Boys' School Here, $11,300 More Bequests," November 16, 1942, 1, 9.

44. *Le Messager*, September 29, 1887.
45. Roger Mailhot, interview with Don Dufour, April, 22, 1994, FAC.
46. "Napoleon Pinette (1891)," manuscript, FAC, Pinette Family Papers; R.J. Lawton, *Franco-Americans of the State of Maine* (Lewiston, ME: H.F. Roy, 1915), 36.
47. Roger Bouffard/Ray Perrault, interview with Mary Rice-DeFosse, June 25, 2014, BFA.
48. *LEJ*, "The Franklin Company's Brick Yard," July 1, 1872, 3.
49. *LEJ*, "The Brickmaking Family of Morin," November 6 1971, 1.
50. Priscilla Howe Kendrick, "Americans in Process" (undergraduate thesis, Bates College, 1942).
51. U.S. Census Bureau, U.S. census, 1910. Authors' analysis.
52. Courtney Burnap, "Franco-Americans in Lewiston, Maine" (undergraduate thesis, Bates College, 1938), 21.
53. *1871–1946 Album Souvenir du 75e Anniversaire de la Paroisse Saint-Pierre et Saint-Paul de Lewiston, Maine* (Lewiston, ME, 1946), 21
54. *LDS*, "St. Louis Catholic Church, Auburn," May 28 1966, 6.
55. Blouin, *Franco-American Foundations*, 67.
56. *Paroisse Canadienne-Française de Lewiston, Maine: Album Historique* (Lewiston, ME: Les Pères Dominicains, 1899), 51.
57. Kendrick, "Americans in Process," 40–41.
58. Marcel Chaloux, interview with Mary Rice-DeFosse, Lewiston, ME, June 9, 2012, BFA.
59. Susan Pearson Hudson, interview with Mary Rice-DeFosse, Lewiston, ME, May 6, 2011, BFA.
60. See Hudson, interview; Chaloux, interview. See also Linda Burgess, interview with Amy Jacks, Auburn, ME, May 12, 2011, BFA; Linda Connelly, interview with Amy Jacks, Lewiston, ME, May 20, 2011, BFA.
61. "Diary of a Dominican Sister," manuscript, Lewiston, ME, n.d. FAC, Dominican Sisters Papers.
62. Plourde, *Album Centenaire*, 19.
63. Mark Paul Richard, *Loyal But French: The Negotiation of Identity by French Canadian Descendants in the United States* (East Lansing: Michigan State University Press, 2008), 98.
64. Plourde, *Album Centenaire*, 39.
65. Fournier, interview.
66. Ibid.
67. *LDS*, "St. Louis Catholic Church, Auburn," May 28, 1966, 6.
68. Ibid., "St. Mary's Catholic Church, Lewiston," September 21, 1966, 5.

69. *Le Messager*, "Le 24 Juin à Québec," March 31, 1881, 2. Authors' translation.
70. *La Célébration du 100e Anniversaire de L'Institut Jacques-Cartier de Lewiston, Maine: Programme-Souvenir 1872–1972* (Lewiston, ME, 1972).
71. "À Préserver Chez les Nôtres l'Amour de la Langue Française à Maintenir les Traditions et le Caractère Distinctif de Notre Race et à Developer Chez Nous le Goût du Beau," *50e Anniversaire: Club Musical-Littéraire* (Lewiston, ME, 1938).
72. Lawton, *Franco-Americans*, 36
73. For the full list of members, see *50e Anniversaire: Club Musical-Littéraire*. Occupations of members are derived from *Lewiston City Directory* (1889).
74. Lawton, *Franco-Americans*, 36.
75. "Lewiston est l'Athènes de l'Amérique Française" in Robert Rumilly, *Histoire des Franco-Américains* (Montreal, QC: Union St-Jean-Baptiste d'Amerique, 1958), 166.
76. Henri Roy, *Le Dernier Mot* (Lewiston, ME: Echo Publishing, 1925).
77. Louis-Philippe Gagné, Untitled (Speech to the 1950 Snowshoe Convention), manuscript, Lewiston, ME, 1950, FAC, Louis-Philippe Gagné Papers.
78. *LDS*, "Canadians Had Good Time and Saw That Homefolk Did Also," February 8, 1925.
79. Ibid.
80. Bert Dutil, interview with Kathleen Mundell and Cindy Larock, Lewiston, ME, 2010, FAC.
81. Authors' translation.
82. *Le Messager*, "Les Débuts de Lewiston," September 14, 1961, 3, 9; Lawton, *Franco-Americans*, 46.
83. *LDS*, "Miss Isabella Wiseman to Note 90th Birthday," October 15, 1949, 3.
84. U.S. Census Bureau, U.S census, 1900. They later moved to 81 Pine Street, where Wiseman maintained his practice.
85. *Le Messager*, "Dr. R.J. Wiseman Elu," March 4, 1914, 1.
86. Ibid., February 27, 1914, 1, 4.
87. Ibid., "Dr R.J. Wiseman Elu," 1.

CHAPTER 3

88. *LEJ*, "A Little Trip Thru le Petit Canada," July 21, 1917, 7.
89. Ibid., "Downtown New Auburn Fire," May 15, 1933, 1.
90. Ibid., "Lewiston-New Auburn Bridge Breaks in Two," March 20, 1936, 1.

91. Ibid., "Lewiston's Homeless Placed at Over 400," March 20, 1936, 1.
92. Zépharin Lessard, Letter to André Lessard, November 1917. FAC, World War One Papers, courtesy Madeleine Roy.
93. Séverin Béliveau, "Voyageur: Albert Béliveau," *Centre Franco-Américain, Université du Maine,* http://www.francomaine.org/Francais/Histo/Grand_Trunk/Grand_Trunk_Travelor.html (accessed September 30, 2014).
94. *LEJ*, "Tribute to Franco-Americans and Their Work in Lewiston," November 2, 1930.
95. *LDS*, "College Authorities May Seek Prosecution Local Klan Celebrants," August 11, 1924, 1.
96. For 40,000, see Edward Bonner Whitney, "The Ku Klux Klan in Maine 1922–1928" (PhD diss., Harvard University, 1966), ii. For 150,000, see C. Stewart Doty, "The KKK in Maine Was Not OK," *BDN*, June 11–12, 1994.
97. These were Reverend George S. Robinson of Trinity Episcopal Church in Lewiston and Reverend Nathaniel French of Auburn; *LEJ*, "Lewiston Rector Addresses KKK," March 24, 1923, 1; *LDS*, "Names of Local Klan Agents Disclosed in Meeting in Auburn," April 19, 1923, 1.
98. *LEJ*, "Next Ku Klux Meeting Wed.," March 24, 1923, 1.
99. "Androscoggin Klan Charter," manuscript, Sampson Center for Diversity, University of Southern Maine, African-American Collection of Maine.
100. *LDS*, "Names of Local Klan Agents Discussed in Auburn," April 19, 1923, 1.
101. *LEJ*, "Lewiston Rector Addresses KKK," 1.
102. *Acts and Resolves Passed by the Legislature of the State of Maine, 1919* (Portland, ME: Loring, Short and Harmon, 1919), 147.
103. Ann Laughlin, "French Heritage Interest Rekindled," *Montreal Gazette*, July 17, 1973, 7.
104. *Resolves of the State of Maine from 1891 to 1893, Inclusive* (Augusta, ME: Burleigh and Flint, 1893): 214.
105. *LEJ*, "New French Catholic Church," May 3, 1873, 3.
106. See Irving Isaacson, interview with Don Nicoll, Rob Chavira and Stuart O'Brien, Lewiston, ME, June 24, 1998, MASC, MOH 027.
107. Tony Karahalios, interview with Andrea L'Hommedieu, Lewiston, ME, April 21, 2000, MASC, MOH 175.
108. Georgette Durcharme Menealy, interview with Joshua Gauthier and James Myall, Lewiston, ME, August 2014, FAC.
109. Sue Reny, interview with Mary Rice-DeFosse, July 24, 2014, BFA; *LDS*, "Charge Lachance with Murder of Elbridge Jacques," March 18, 1932,

1, 18; "Lachance Names Albert, Mrs. Nadeau, and an Irishman," April 2, 1932, 1, 8; Redding, Harold L. and Bud Merton, "Case of the Vanishing Taxi Driver," *Dynamic Detective*, May 1937.

110. *Le Messager*, "La Stupide Légende" in "La Légende du 'Parisian French,'" January 14, 1944.

111. *LDS*, "Hundreds Join in Honoring Ambassador Paul Claudel," October 21, 1930, 1, 6.

112. Donat Boisvert, "Looking Back: Ambassador Backed Local Accent During 1930 Visit," *Maine Sunday Telegram*, September 6, 1992.

113. Alberte Gastonguay, *La Jeune Franco-Américaine* (Lewiston, ME: Le Messager, 1933), 15.

114. Ginette Gladu, interview with Sarah Buss and Kate Harmsworth, June 20, 2006, BFA.

115. See Rita Dubé, interview with Mary Rice-DeFosse, Lewiston, ME, August 7, 2014, BFA and Ginette Gladu, interview for examples.

116. Gladu, interview.

117. Lionel Tardif, interview with Emily Rand, Lewiston, ME, March 10, 2006, BFA.

118. Judge Armand Dufresne, interview with Barry Rodrigue, Lewiston, ME, March 28, 1994, Northeast Archives of Folklore and Oral History, mfc_2351_c1370.1, c1370.2.

119. *LSJ*, "Former Head of High Court Dead at 85," April 21, 1994, 1, 8.

120. "L'Alliance Civique: Une Belle et Forte Organisation Politique," *Le Petit Journal (Lewiston, ME)*, June 1914.

121. Geneva Kirk and Gridley, *A History of City Government* (Auburn: Central Maine Vocational Technical Institute, 1982), 4.

122. *LDS*, "Indict Lewiston Officials," September 20, 1938, 1.

123. Kirk and Barrows, *History of City Government*, 4

124. "Constitution et Règlements de l'Association des Vigilants," manuscript, Lewiston, ME, n.d., FAC, Association des Vigilants Papers.

125. *LDS*, "Vigilants Organization Observes Its Fifth Anniversary," April 21, 1941.

126. *Le Messager*, "Historique des Vigilants," September 14, 1961.

127. Kirk and Barrows, *History of City Government*, 5–7.

128. Leamon, *Historic Lewiston*, 28–40.

129. Anne D. Williams, ed., *The Experience of the Great Depression in Lewiston-Auburn, Maine: A Report by First Year Seminar 187* (Lewiston, ME: Bates College, 1996), 93–101.

130. Williams, *Experience of the Great Depression*, 1:41–48.

131. Antonio Pomerleau, interview with Ralph Roy, Lewiston, ME, April 22, 1994. FAC.
132. Williams, *Experience of the Great Depression*, 1:65.
133. Ibid., 2:84–102.
134. FAC, *Wilfrid Bourassa Papers*.
135. Florida Charest, interview with Marcella Sorg and Steffan Duplessis, Lewiston, ME, January 29, 1981, Northeast Archives of Folklore and Oral History.
136. Richard, *Loyal But French*, 61.
137. Ibid., 113–17.
138. Richard Santerre, *Anthologie de la Literature Franco-Américaine de la Nouvelle Angleterre*, Vol. 4 (Bedford, NH: National Materials Development Center for French, 1980).
139. Lucien Rancourt, interview with Julie Hardacker and Rose Hamilton, Lewiston, ME, April 8, 1994, FAC.
140. Leonard Daley, interview with James Myall, New Gloucester, ME, July 2014, FAC.
141. Rancourt, interview.
142. Ibid.
143. Willams, *Experience of the Great Depression*, 2:40–42.
144. Edgar Allen Beem, "Magnifique Eglise Gothique SS. Pierre Et Paul: The Restoration of Lewiston's Franco-American Mother Church," *(Portland) Maine Times*, May 17, 1991.
145. Ibid.

Chapter 4

146. Dutil, interview.
147. Roger Nadeau, interview with Tina Sirois, Lewiston, ME, December 14, 2012, FAC.
148. Marie Sturtevant, interview with Murielle Guay, Lewiston, ME, May 3, 1996, FAC.
149. Doris Guenette, interview with Angela Stuart, Lewiston, ME, May 18, 1996, FAC.
150. Sturtevant, interview.
151. Nadeau, interview.
152. *Ottawa Evening Citizen*, "Very Rev. François Drouin Prior of Dominican Order," September 6, 1952, 2.

153. Marie P. Badeau et al., *SS Peter and Paul Parish, Lewiston, Maine, 1870–1996* (Lewiston, ME: Sts. Peter & Paul Parish, 1996), 19; *LEJ*, "Brothers of the Sacred Heart," June 10, 1978, 6A, 8A.
154. Roberta Scruggs, "His Dream Endures but Parish Dwindles," *LDS*, April 22, 1984.
155. Ibid.
156. *Lewiston (Maine) Journal*, "Father Drouin Dies," February 6, 1986, 17C.
157. Maurice Dubois, interview with Sarah Buss and Kate Harmsworth, Lewiston, ME, June 14, 2006, BFA.
158. Dubé, interview.
159. *LDS*, "Dominican Sisters Leave Lewiston but Memories Linger," February 4, 1969, 54A.
160. Lucille (Sr. Marie Sylvie) Paré, interview with Madeleine Roy, Lewiston, ME, February 15, 1999, FAC.
161. Susan and Raymond Lagueux, interview with Mary Rice-DeFosse, Lewiston, ME, August 20, 2017, BFA.
162. Badeau, *SS Peter and Paul Parish*, 26.
163. André Bozon, "Pete Theriault à Permis aux 'Français d'Amérique… de Battre les Jeunes et Ardents Finlandais," *L'Equipe* (Paris), March 13, 1951, 1.
164. Ibid.
165. Ibid.
166. Michael Parent, *A Beautiful Game* (Portland, ME, 2010), DVD.
167. Fred Gage, "Boxing Great 'Lefty' Lachance Dies in Lewiston," *LSJ*, May 2, 1994, 1.
168. Fred Gage, "Lewiston Has Strong Boxing Tradition," *LSJ*, July 17, 1993, 31–32.
169. Ibid.
170. Barry Lindenman, "An Interview with Legendary Singer Robert Goulet," Cyberboxingzone.com, December 2002.
171. *Reading (Pennsylvania) Eagle*, "Lewiston Debacle Regarded as Plus," May 25, 1975, 56.
172. Richard, *Loyal But French*, 210.
173. Gladu, interview.
174. Hélène Sylvain, interview with Nora Brouder and Meredith Greene, Lewiston, ME, March 29, 2010. *"Les Gens Ici ne Parlent pas Toujours Partfaitement Français parce que Nos Ancêtres n'Avaient pas d'Instruction."*
175. *LEJ*, "The Same Language," October 26 1909, 6.

176. Jessica Marvin Lindoerfer, "L'Histoire Orale et l'Héritage Culturel Franco-Américain: Une Étude des Mémères, Mamans, et Filles" (undergraduate thesis, Bates College, 1998), 166.
177. Lionel Guay, interview with Mary Rice-DeFosse, Lewiston, ME, June 2, 2014.
178. Lagueux, interview.
179. Araceli Duran, "Beaucoup Plus qu'Une Langue" (undergraduate thesis, Bates College, 2014).
180. Lindoerfer, "L'Histoire Orale," 182–83.
181. A. Poulin, "Poetry and the Landscape of Epiphany," in Anne Hébert, *Selected Poems*, translated by A. Poulin (Rockport, NY: BOA Editions Ltd., 1987), 152.
182. Betty Cody (Rita Cote), interview with Ann Breau, Auburn, ME, April 10, 2000, FAC.
183. Ibid.; Hoey, Dennis, "Acclaimed Maine Country Singer Betty Cody Dies at 92," *PPH*, July 3, 2014.
184. Lindoerfer, "L'Histoire Orale," 189, 214–15.
185. Reny, interview.
186. *LEJ*, "Le Messager Still Publishing Despite Restraining Order," September 2, 1954, 15.
187. U.S. Census Bureau, American Community Survey, *2010 American Community Survey 5-Year Estimates*, Table DP02, generated by James Myall using American FactFinder, http://factfinder2.census.gov.

Chapter 5

188. Marshall J. Tinkle, *The Maine State Constitution* (New York: Oxford University Press, 2013), 67. As late as 1979, a ballot measure to repeal the amendment failed.
189. *Legislative Record of the One Hundredth and Fourth Legislature of the State of Maine, 1969,* 1,353–56, 1,494–97, http://www.maine.gov/legis/lawlib/lldl/legisrecord.htm.
190. Ann Laughlin, "French Heritage Interest Rekindled," *Montreal Gazette* 17 (1973): 7.
191. Jacqueline Giasson Fuller, "Lucy Cowgirl," *Lives in Translation*, edited by Denis Ledoux (Lisbon, ME: Soleil Press, 1990), 21–25.
192. "History of MFAGS," Maine Franco-American Genealogical Society, www.simplesite.com/mfgswebsite/137296477 (accessed September 30, 2014).

193. Glen Chase, "Grand Trunk Depot Proposals Sought," *LDS*, June 13, 1985, 13; John Schott, interview with Kelly Pelletier and Barry Rodrigue, Lewiston, ME, June 14, 2001, FAC.
194. Scott Taylor, "Museum L-A Offers Glimpse of Future Home," *LSJ*, July 12, 2012.
195. Raoul Pinette, interview with Raymond Pelletier and Mark Silber, Lewiston, ME, May 14, 1981, Northeast Archives of Folklore and Oral History.
196. *LDS*, "Franco Americans Symposium Termed a Tremendous Success," February 6, 1979, 32.
197. *LDS*, "Raoul Pinette Names Musical Coordinator," March 27, 1978, 3.
198. Ibid.
199. Connie Côté, interview with Ann Breau, Auburn, ME, December 10, 1997, FAC.
200. Ibid.
201. *LDS*, "History Repeats Itself in Franco American's Les Cloches de Cornville [*sic*]," April 26, 1983, 3.
202. Dennis Hoey, "City to Swell for Franco Festival," *LDS*, July 17, 1980, 17.
203. James Kiley, "Festival Deficit Paid by City, Some Members Reappointed," *LDS*, September 15, 177, 19.
204. Edmund MacDonald, "Franco Festival Future May Hinge on Drinking Bill," *LDS*, February 3, 1983, 9.
205. *LDS*, "Trouble at Festival," July 27, 1984, 13.
206. Jennifer Sullivan, "Changes in Festival Urged," *LDS*, July 14, 1987, 9.
207. *LSJ*, "Rebirth of Festival," February 16, 1993, 4.
208. Jonathan Van Fleet, "Bigger, Better Festival de Joie Keeps Growing," *LSJ*, July 31, 2000, A1, A5.
209. Guay, interview.
210. FAC, Madeleine Giguère Papers.
211. Barry Mothes, "Rev. Drouin Left Lewiston Spirited Legacy," *Lewiston (Maine) Sunday Journal*, January 5, 1986.
212. *Father Drouin Farewell Gathering*, WCOU Radio, 1952, FAC.
213. Mothes, "Rev. Drouin Left Lewiston Spirited Legacy."
214. Beem, "Magnifique Eglise Gothique."
215. "Q&A," Marchons Ensemble dans la Foi, manuscript, Lewiston, ME, 1991, FAC, Sts. Peter & Paul Papers.
216. *LSJ*, "Priest Shift Comes to L-A," May 18, 2006.
217. Ibid., "Saint Louis Final Mass," August 29, 2013.
218. Ibid., "Church Administrator to Discuss Future," September 17, 2008.

219. Cliff Hodgman, "Schools Expect Record 14,073 Crop of Pupils," *LEJ*, August 28, 1957, 1A, 10A.
220. Rose O'Brien, "Dominican Sisters Leave Lewiston but Memories Linger," *LDS*, February 4, 1969, 54A.
221. Paul K. Watson and Yvette Lachapelle, *The Churches of Lewiston and Auburn: A Pictorial History, 1795–1995* (Lewiston, ME: Lewiston Bicentennial Committee, 1995).
222. *LSJ*, "The History of Catholic Education in Lewiston," January 29, 2011.
223. Joline Girouard, "We Are Dedicated to Excellence," *LSJ*, January 29, 2011.
224. *LSJ*, "U.S. Dept. of Agriculture $367,500," June 16, 2004; "Franco Heritage," May 22, 2002, A6.
225. Guay, interview; Dubé, interview.
226. *LEJ*, "Communications Subject of Institute's Session," May 1, 1974, 12.
227. John Lovell, "TV Link to Franco Roots Cut," *(Portland) Maine Sunday Telegram*, December 7, 1986.
228. Dan Hartill, "Cable TV Adds Third French Channel," *LSJ*, October 26, 1999, B1.
229. Franco-American Women's Institute, www.fawi.net.
230. Karen Nadeau-Drillen, et al., *Final Report of the Task Force on Franco-Americans*, Maine State Legislature, 2012, www.maine.gov/legis/opla/reportsnew.htm.
231. *BDN*, "Harpswell Woman Named Executive Director," March 24, 1998, B1, 6.
232. *BDN*, "Maine on the Way to Making Ultimate French Connection," January 22, 1997, A1-2.
233. *LSJ*, "Budget," May 1, 2000, A7.
234. Ibid., "Wallace," August 13, 1997, 28.
235. Barbara Proko, "Frenchie Speaks: Character Grew Out of Joke," *LSJ*, March 6, 1993, 1, 8; *New York Times*, "A Stereotype Bids Farewell to His Public," February 14, 1993.
236. Doug Hodgkin, "Kennedy Park Bandstand/Gazebo," Lewiston, Maine website, 2011, www.lewistonmaine.gov/DocumentCenter/Home/View/1150.
237. Nancy Grape, "Membership in Demo Club Denied Two Hathaway Foes," *LEJ*, October 18, 1977.
238. "Une Franco, Gouverneur du Maine?" *L'Unité* (Lewiston, ME) 6, no. 4 (April 1982), 1.

239. "Rep. Georgette Berube Recalls St. John's Day Bilingually in House" *LEJ*, June 30, 1973, 18.
240. For a full discussion, see Jacob Albert, Tony Brinkley, Yvon Labbé and Christian Potholm, *Contemporary Attitudes of Maine's Franco-Americans* (Orono, ME: Franco-American Centre, 2012), 27–34.
241. Matt Byrne, "The Early Years: Paul Lepage," *PPH*, July 20, 2014.
242. Lagueux, interview.
243. Mark Laflamme, "LePage Wows Franco Crowd in Lewiston," *LSJ*, March 17, 2011.
244. Maxwell Mogensen, "LePage's Win in Lewiston Due to Several Factors, Political Watchers Say," *LSJ*, November 4, 2010.
245. "LePage Travels to Montreal to Encourage Economic Growth in Maine," *Maine Office of the Governor*, April 23, 2013.
246. Matthew Gutshenritter, "Grégoire Faucher '16 Converses with LePage in State of the State," *Bowdoin Orient (Brunswick, ME)*, February 6, 2014, 2.
247. Randy Billings, "The Early Years of Mike Michaud," *PPH*, July 6, 2014.
248. Michael Gordon, "Refugee Issue Stirs Questions," *LSJ*, December 21, 1999, A1, A8.
249. Douglas McIntire, "Last Grey Nun Continues Legacy of Showing God's Love" *LSJ*, June 28, 2014.
250. L. Fernand Bussiere, "Proud of Accomplishments,"*LSJ*, October 11, 2006.
251. "Appendix A" in Kimberly Huisman, Maize Hough, Kristin M Langellier and Carol Nordstrom Toner, eds., *Somalis in Maine: Crossing Cultural Currents* (Berkley, CA: North Atlantic Books, 2011), 299–300.
252. Laurent F. Gilbert, "Mayor's Corner: A Response to No Comparison Between Somalis and Franco's [*sic*]," *Twin City Times (Auburn, ME)* , March 31, 2010.
253. Andrew Cullen, "Struggle and Progress: 10 Years of Somalis in Lewiston," *LSJ*, December 18, 2011.

INDEX

A

Ali, Muhammad 115, 116, 117
Association St. Dominique 44, 59, 61, 107, 111
Auburn Shoe Manufacturers Association 98

B

Bacon, Bishop David Weller 21
Bates Manufacturing
 company 111
 team 112, 113
Bates Mill 11, 21, 92, 96
Beauchamp, Eddie 89
Begin, Father Leo 132
Béliveau, Albert 76, 89
Belleau, F.X. 120
Bérubé, Georgette Beauparlant 151
Bleachery Hill 20, 44
Boisvert, Roméo 135
Bonne Chanson 118, 119
bootleggers 80
Boucher, Eddie 117
Bourassa, Wilfrid 94

boxing 115
Breau, Denny 123
Breau, Harold J. 122
Breau, Lenny 123
Brooks, Joseph 14

C

Canuck 19, 32
Carignan, Clarisse 14
Carignan, Emily Perrault 14
Carignan, Georges 14, 84
Carignan, Noé 28
Cause Nationale 49, 52
Central Maine General Hospital 30
Centre d'Héritage Franco-Américain 131, 134, 136, 140, 141, 145, 151
Cercle Canadien 61, 67
Cercle Crémazie 60
Cercle des Amateurs 61
C'est Si Bon
 café 135, 139, 140
 orchestra 135, 140
Charest, Florida 95
Charest, Larry 112
Chouinard, Ray 135

INDEX

civil rights movement 127, 129
Claudel, Ambassador Paul W. 83, 84
Clay, Cassius. *See* Ali, Muhammad
Cloutier, Françoise 92
Cloutier, Ray 111
Club Musical-Littéraire 61, 138, 145
Cody, Betty. *See* Côté, Rita
collèges, 86
Community Little Theater 136
Congress of International Organizations 97
Continental Mills 13, 19
Corporation Sole controversy 52, 53
Côté, Bert 135
Côté, Connie 135, 137, 148
Côté, Rita 121, 122, 123, 130
Côté Robbins, Rhea 34, 148
coureurs de bois 15, 59
Courrier du Maine 51, 52
cours classique 86, 88
Couture, Ariel "Shiner" 115
Couture, Faust 79
Couture, Jean-Baptiste 28, 29, 30, 51, 52, 53, 61, 62, 63, 83, 117
Couture, Philippe 41, 88
Couture, Valdor 90
Couturier, Robert 129, 130, 147, 149
Couturier, Ronald 147
Cyclones 111

D

Dallaire, Reverend J.A. 52
Dames de Sion 44, 45, 49
Défenseurs 62
DeWitt Hotel 16
Dominican
 Block 28, 38, 45, 49, 60, 71, 134
 Fathers 26, 27, 49, 50, 51, 52, 53, 63, 64, 117, 132, 143, 154
 Order 26, 50, 51, 115, 143
 Sisters 49, 108, 109, 144, 154
Drouin, Father Hervé-François 106, 107, 108, 109, 111, 134, 143
Dubé, Rita 145

Dubois, Maurice 109
Ducharme, Albert 80
Dufresne, Armand, Sr. 41, 87
Dufresne, Judge Armand, Jr. 87, 88, 89
Dupont bakery 40, 41, 75, 87
Dupont family 56
Dupont, Phillippe 40
Dutil, Bert 69, 105

E

École du Petit Canada 24
Enfants de Marie 64
English-language law 79

F

Fanfare St. Dominique 60
Fanfare Ste. Cécile 60, 83
Festival de Joie 140
Festival in the Park 135, 137, 139, 140
foodways 34
Forgues, Louise 131
Fortin, Régent 42
Forum Francophone des Affaires 148, 149
Fournier, Amédée 20
Franco-American Collection 141, 142
Franco-American Heritage Center 145, 146, 152
Franco Center. *See* Franco-American Heritage Center
Franklin Company 11, 16, 17, 43, 44
Franklin Pasture 82
Frenette, Yves 16, 18
funerals 43, 47
F.X. Marcotte Furniture 39

G

Gadbois, Reverend Charles-Émile 118
Gagne, Ernie 149
Gagné, Louis-Philippe 64, 65, 91, 149
Gamache, Joey 116
Garcelon, Alonzo 10, 30, 31
Gas Patch 17, 20
Gastonguay, Alberte 84, 85

INDEX

Ghuilbault, P.S. 29, 30
Giasson Fuller, Jacqueline 130
Giguère, Madeleine 134, 141, 142, 149, 151
Gilbert, Laurent 154
Girouard, Dr. Joseph Amédée 96
Gladu, Ginette Grenier 86
Gompers, Samuel 96
Goulet, Robert 116
Grand Trunk 16, 17, 25, 38, 65, 124, 132
Great Depression 91, 95, 115
Grenier, Thomas 86
Grey Nuns. *See* Sisters of Charity of St. Hyacinthe
Guay, Lionel 120, 140, 145
Guenette, Doris 106

H

Healy Asylum 45, 46, 47, 84, 118
Healy, Bishop James Augustine 26, 45, 50, 52
Hévey, Reverend Pierre 21, 23, 24, 25, 26, 80, 109
Hill Mill 11, 31
Hine, Lewis Hickes 97
hockey 111, 147
holidays 36
Holy Cross
 parish 53
 school 144
Holy Family
 parish 53
 school 121, 144

I

Institut Jacques Cartier 23, 24, 50, 51, 57, 61, 67, 70, 135
Irish 13, 17, 18, 20, 21, 44, 50, 52, 59, 70, 80, 123, 130, 151

J

Jacques, Elbridge, murder of 81
Jalbert, Louis 151

Janelle sisters 40
Jenkins, John 148

K

Kennedy, John F. 151
Know-Nothings 21
Ku Klux Klan 77, 78, 79, 80, 85

L

Labbe, Paul "Junior" 115
La Bonne Chanson 118, 119
Lachance, François "Frank the Pipe" 82
Lachance, Maurice "Lefty" 115
Ladies of Zion. *See* Dames de Sion
Lagueux, Raymond 148
Lagueux, Susan 110, 120
La Jeune Franco-Américaine 84
Lalonde, Michèle 128
Landry family 93
Lapointe, JoAnne 131
Lavigne, Célestine 18
Leblanc, Joseph 14, 15
Le Montagnard 64
Lepage bakeries 41
Lepage, François-Régis 41
LePage, Paul 152, 153
Lessard-Bissonnette, Camille 19, 34
Lessard, Camille. *See* Lessard-Bissonnette, Camille
Lessard, Zépeherin 76
Letourneau, Germaine 91
Letourneau, Reverend Edouard 21
Lewiston and Auburn Poor Farm 93
Lewiston Auburn Shoe Workers Protective Association 98
Lewiston School Department 46
 census 13, 47
Liston, Sonny 115, 116, 117
Little Canada 16, 19, 20, 28, 30, 31, 32, 37, 39, 42, 44, 53, 61, 68, 69, 70, 73, 74, 75, 82, 83, 140, 145, 152
Little Canada School. *See* École du Petit Canada

INDEX

Lone Pine, Hal. *See* Breau, Harold J.
l'Orphéon 62, 135
l'Unité 130

M

Mailhot, Representative Richard 145
Mailhot, William 41
Maine Baking Company 41, 87, 88, 89
Maine Franco-American Genealogical Society 132
Maine Law 80
Maine Supreme Judicial Court 89
Maison Marcotte 39
Marchandes de Bonheur 48
Marcotte, F.X. 38, 39, 41, 42, 83
Marist Brothers 44, 49
Martel, Dr. Louis J. 23, 24, 25, 28, 56, 57, 61, 70, 79
Mathieu, Reverend Albert 50
Messager, Le 19, 24, 28, 29, 30, 39, 40, 51, 53, 56, 61, 64, 69, 70, 71, 83, 84, 90, 96, 117, 123, 130, 146, 147, 149
Metalious, Grace 34
Michaud, Charlotte 84
Michaud, Michael 145, 152, 153
Monmarquet, J.D. 28
Montagnard
 band 69
 hockey club 111
 les Dames 68
Morin Brick 43
Morin, Jean-Baptiste 43
Mothon, Reverend Alexandre-Louis 26, 44, 45, 49, 50, 51, 52
Museum L/A 134
Muskie, Edmund 128
Mutsaers, Reverend Louis 21

N

Nadeau, Marie Louise 138, 139
Nadeau, Muriel 105

Nadeau, Representative Paul 139
Nadeau, Roger 39, 105, 106
New Auburn 28, 40, 44, 74, 75, 83, 87
Notre Dame Asylum 28

O

O'Connell, Bishop William 50, 51, 52, 53
Olivier, Jean-Marie 43

P

Paré, Lucille (Sister Marie Sylvie) 109
Parent, Michael 115
Paré, Paul 147
Petit Canada. *See* Little Canada
Pinette, Napoléon 42, 134
Pinette, Raoul 134, 135
Plourde, Alfred 147
Poisson, Louis 42
Pomerleau, Antonio 92
Poulin, Albert 121
Proulx, Bishop Amédée 50
Provost Brothers 31, 39
Provost, Eugène 28
Provost family 56

Q

Quiet Revolution. *See* Révolution Tranquille

R

Rancourt, Lucien 97
raquetteurs. *See* snowshoe clubs
Raymond, Laurier 154
Renaud, Norman 148
Révolution Tranquille 127, 129
Richard, Mark Paul 52, 96
Rivard, Marthe Grenier 35
Rodrigue, Barry 142
Roosevelt, President Franklin Delano 93, 94
Rotundo, Senator Margaret "Peggy" 145
Roy, Henri F. 51, 52, 60, 63

Index

S

Sacred Heart Parish 53
Second Vatican Council 119, 143
shoe strikes 96
Sisters of Charity of St. Hyacinthe 24, 27, 30, 31, 39, 44, 45, 46, 47, 49, 118, 154
snowshoe clubs 64, 68
Social Security 94, 95
Société St. Jean-Baptiste 23, 57, 89
St. Dominic Academy 144
St. Dominic High School 106, 108, 111, 115, 119, 131, 143, 144
St. Hyacinthe 21, 23, 118
St. Jean-Baptiste Day 57, 135, 151
St. Joseph's
 church 21
 parish 21
St. Joseph's Orphanage 39, 46, 47
St. Louis
 church 54, 56, 144
 church choir 138
 parish 50, 53, 144
 school 45, 49, 53, 74
St. Mary's
 church 54, 55, 144, 145
 parish 53, 84, 144
 school 144
St. Mary's Hospital 24, 30, 45, 70
 School of Nursing 110
St. Paul's Collège 44, 49
St. Peter's
 cemetery 43
 church 44, 50, 109
 parish 24, 49, 53
 school 49, 99, 135, 144
strikes 96, 97, 98, 99
Sts. Peter & Paul
 basilica 143
 church 50, 51, 53, 55, 60, 63, 70, 99, 135, 143
 parish 26, 52, 53, 143, 144
 school 26
Sturtevant, Marie 105, 106

Survivance 56, 69, 73, 83, 84, 86, 117, 120, 135, 147
Sylvain, Hélène 120

T

Tancrel, Ozios 31, 38
Tancrel, Zénaïde 31, 38
Tardif, Dr. Lionel, Sr. 87, 88

U

Union St. Jean Baptiste 88
Ursuline Sisters 144

V

Vanier, F. Phileas 61
Vigilants 90, 91
voyageurs 15, 59

W

Walsh, Bishop Louis S. 52, 53, 99
WCOU 61, 117, 122, 130, 136
Wiseman, Dr. Robert 70, 71, 83, 89
World War I 75, 103
World War II 103, 153

About the Authors

Mary Rice-DeFosse is a professor of French and Francophone studies at Bates College. She and her students have collected oral histories from local residents as part of the department's Franco-American Oral History Project for a number of years. She serves on the boards of Lewiston-Auburn's Franco Center for Heritage and Performing Arts and the Franco-American Collection at the University of Southern Maine's Lewiston-Auburn College. She holds a PhD from Yale University and has published work chiefly about women writers of French expression.

James Myall is a former coordinator of the Franco-American Collection at the University of Southern Maine's Lewiston-Auburn College and is currently executive director of the Freeport Historical Society. He holds an MA in ancient history and archaeology from the University of St. Andrews. During his time at the Franco-American Collection, he was responsible for

preserving and promoting the Franco-American heritage of Maine and New England in a variety of ways. In 2012, he served as a consultant for the State of Maine's Taskforce on Franco-Americans.